1 3 5 7 9 10 8 6 4 2

First published in 2019 by September Publishing

Copyright © Stephen Ellcock 2019

Please also see Credits, Sources and Copyright
at the back of the book. We have made every attempt to
ascertain and contact rights holders. Please contact the
publishers direct with any comments or corrections:
info@septemberpublishing.org.

Design by Friederike Huber

Printed in Poland on paper from responsibly managed,
sustainable sources by Hussar Books

ISBN 978-1-912836-00-0

September Publishing
www.septemberpublishing.org

# A L L

## *O M N E*

# G O O D

## *B O N U M*

# T H I N G S

*COMPILED BY*

# S T E P H E N
# E L L C O C K

september

FOR JACKIE
*who has shown me a pathway*
*through the patterns*

# CONTENTS

In all Things, all Things service do to all:
And thus a Sand is Endless, though most small.
And every Thing is truly Infinite,
In its Relation deep and exquisite.

— Thomas Traherne (1636–74)

# CREATING THE INFINITE ARCHIVE

# I HAVE ALWAYS COLLECTED IMAGES, THE PROBLEM IS THAT FOR MOST OF MY LIFE I NEVER KNEW WHAT TO DO WITH THEM.

IN THE PAST I explained this compulsion away to myself as a search for pattern, meaning and a semblance of order in what has often been a ragged and disorderly existence, a defence mechanism for staving off chaos and dismay.

Like most children of the age of mass communication I became an obsessive consumer of images from the moment I learned to focus. A pre-school love of comics proved a gateway drug to the harder thrills of Marvel and DC comics and then, slightly later, the illicit, intoxicating, utopian visions of the then-thriving 'underground' press, followed closely by the dystopian grit of Punk-era fanzines. All of these multifarious publications, begged for, stolen, borrowed or bought with every last available penny of pocket money, unemployment cheque or student grant, were, however, merely grist for what was to become an all-consuming obsession. I would pore over every available item of newsprint searching for and tearing or cutting out any images that interested, inspired or startled me. I would do the same to my parents' and grandparents' news-papers and colour supplements, to my mother's copies of *She* or *Woman's Own*, my sister's *Jackie*s and *Disco 45*s, and to particular magazines my father naively assumed were discreetly hidden.

My unbridled butchery even extended to certain books.

The purpose of all of this vandalism was to provide me with the raw material for what my addled adolescent imagination initially conceived as a vast treasure store or infinite archive of images, which would be stored in hundreds, even thousands, of scrapbooks, or else assembled as gigantic, impossibly complex collages, all of which would eventually evolve into a visual map of 'Everything'.

These unnervingly megalomaniac tendencies were obviously a source of distress and deep concern for my parents and I was, at various times, threatened with psychiatrists, unspecified 'outdoor activities', Sunday school and membership of the Boy Scouts.

By the time I left home, I had accumulated dozens of boxes, suitcases and bags of all descriptions crammed with tens of thousands

of scraps and orphan images, many torn or cut from what are now incredibly valuable artefacts.

Encouraged by a couple of disapproving, deeply unimpressed girlfriends and recurrent bouts of ennui, I eventually abandoned my doomed attempt at constructing a physical version of the kind of universal, labyrinthine library that had previously only existed in the imaginations of Jorge Luis Borges, M. C. Escher or Giovanni Battista Piranesi out of old copies of *Oz*, *Howard the Duck* and *Ripped & Torn*.

Still, I had at least managed to fill a few scrapbooks and even succeeded in cobbling together a collage or two along the way.

Sadly (or, perhaps, thankfully), at some point between my first free festival and my first eviction, I had either discarded, lost or abandoned this entire mouldering stockpile of scraps.

Over the course of the subsequent, chaotic decades, my obsession with patterns may have been sublimated but it never left me, it simply manifested itself in different ways.

I managed to blag a fairly successful living as a professional musician/uni-digit keyboard prodder for a while, in spite of the fact I possessed zero technical ability and no previous experience. I did, however, discover that I possessed a natural aptitude and flair for arrangement and production, which are, after all, forms of pattern-making.

After a few years of critical, peer and industry acclaim[1] but widespread public indifference,[2] the band I was a member of split/imploded/self-destructed in the messiest possible manner. Unwilling to spend my days trapped in dank east London basements programming hi-hats and quantising bass guitars, I found a job in a bookshop where, to the consternation and bemusement of long-suffering colleagues, I became obsessed with 'merchandising', display, the arrangement and disposition of books on shelves, and so on. Once again, a deep-seated pattern – making impulse manifesting itself – and incredibly, strangely rewarding … for a year or two, at least.

Then, at a moment of crisis, I lost sight of the patterns and the pathways through the patterns and I stupidly succumbed to disarray and dissolution. What followed was a textbook careering off the rails, complete with all the cliched and tedious dependencies, addictions, depravities and degradations that feature in the lexicon of boring mid-life dissipation.

When the inevitable crash and burn occurred I was homeless, alone, seriously ill and, according to eyewitnesses, 'blue'. Bedbound in unfamiliar homes for several months, I eventually succumbed to the constant encouragement and exhortations from sisters and exceptionally kind and well-meaning 'friends' I could barely recall, and signed up to Facebook.

I didn't own a laptop or computer at the time and the emerging world of social media revealed through the prism of my ancient mobile phone was, for all its vaunted possibilities, bland and terribly mundane. Gradually, however, I began to create a network of connections and, as I did so, the realisation dawned on me that social media is as much a visual as a verbal medium.[3]

From that point on I decided to forget all about attempting witty badinage with total strangers and concentrate instead on visual communication and, most importantly, the creation of themed albums which can now feature thousands of related images.

Nothing could have prepared me for the astonishing and overwhelming response I have received over the course of the past ten years from hundreds of thousands of 'friends', followers and sundry strangers from every conceivable continent and country, all driven to find meaning, validation and solace in images.

For all the flaws, frustrations and necessary compromises involved in participation, social media would seem to provide the perfect launch pad for an Infinite Archive, a panoramic work, dynamic and interactive, encompassing the whole of creation, containing multiple pathways that a reader can enter at any point or reread many times.

This book is the next step and cornerstone in the construction of that Infinite Archive.

The title *Omne Bonum/All Good Things* is a homage to the first attempt at creating an English-language encyclopaedia by the fourteenth-century scribe James Le Palmer. *Omne Bonum* was intended to be a vast tome, a compilation of all the knowledge available to the author in his time. In the author's words: 'Virtually all good things [are] contained herein.'

Following James Le Palmer's example and using images drawn from three thousand years of artistic creation, scientific enquiry and pan-global magical, philosophical and religious traditions, this book is designed as a visual journey from the beginning of Time to the vastness of the Eternity via all the realms of Creation: the four elements – Air, Water, Fire and Earth; the Vegetable, Animal and Human kingdoms; the wonders of Science; the Senses and the Heavens; and finally the spirit realm, Heaven, Hell and Infinity.

The images I have selected are but a few examples of our attempts to comprehend and visualise the Cosmos and our place within it. My deepest wish is to bring a little piece of Heaven down to Earth. Failing that, I would settle for giving anyone who visits these pages a glimpse of the wonder, beauty and mystery that still exist in the world around us.

Decades have passed since my manic-obsessive image-gathering days, and I and the World have experienced enormous changes, but I am still pretty much the same in many ways. I am still destitute, still pretty much unemployable, still ill, still ill-at-ease, still unwelcome in polite society and I am still collecting images, but at least I now know what to do with them …

---

1 OK, perhaps not universal 'critical, peer and industry acclaim', but still tilted towards the positive in spite of certain high-profile detractors. Let's say 75 per cent 'critical, peer and industry acclaim' for the sake of argument.

2 Honourable exceptions, the indie stalwarts of Greece, Portugal, Belgium, Japan and maybe one or two other major-label 'third-tier territories'.

3 Nobody ever seemed to suspect that, for the first eighteen months to two years I was posting on Facebook, I was using such an antediluvian phone (when I was out of my then office), that I literally could not see any of the links or images I was posting. It was pure guesswork (particularly risky in the case of YouTube clips from obscure Soviet archives).

In 1937, the following poem by Paul Valéry
was engraved on the facade of the Musée de
l'Homme, Paris.

*Il dépend de celui qui passe*
*Que je sois tombe ou trésor*
*Que je parle ou me taise*
*Ceci ne tient qu'a toi.*
*Ami, n'entre pas sans désir.*

It depends on those who pass
Whether I am a tomb or treasure
Whether I speak or am silent
The choice is yours alone.
Friend, do not enter without desire.

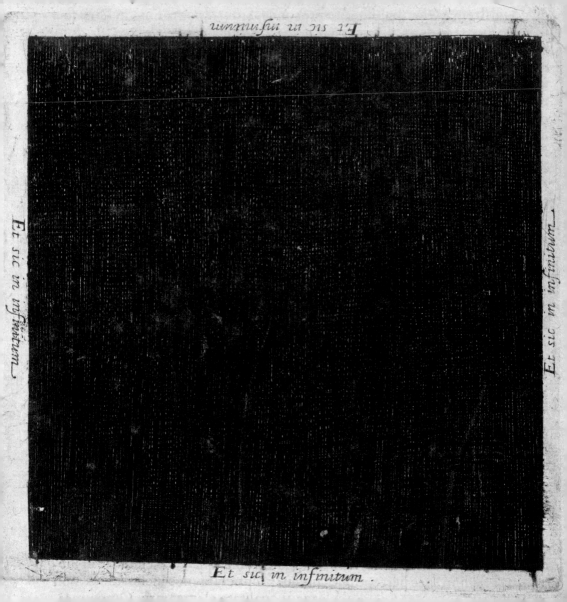

Et sic in infinitum

Et sic in infinitum

Et sic in infinitum

Et sic in infinitum .

# CREATION

←← 1 Black square representing the nothingness prior to the universe from *Utriusque Cosmi Maioris Scilicet Et Minoris Metaphysica* by Robert Fludd (English, 1574–1637), Oppenheim, Germany, 1617

→ 2 The end of the First Book of Macrocosmic Principles from *Utriusque Cosmi Maioris Scilicet Et Minoris Metaphysica* by Robert Fludd, Oppenheim, Germany, 1617

ACCORDING TO ANCIENT Chinese Daoist (or Taoist) tradition, the universe began as a formless, lifeless void. Over time, this void formed itself into a vast cosmic egg within which the opposing forces of Yin and Yang were hatched and the first living being, a furry, two-horned giant, known as Pangu, was conceived.

Oblivious to the primordial turmoil and chaos around him, Pangu slept for 18,000 years and grew, and grew. Eventually, the Yin and the Yang resolved themselves into a perfect, miraculous equilibrium, and Pangu awoke.

Unnerved to find himself surrounded by utter darkness and total silence, he fashioned a magical axe from the energies around him and, with an almighty swing, sundered the shell of the cosmic egg in two, splitting Yin and Yang.

The upper half of the shell became the sky (Yang) and the lower half, the earth (Yin).

Determined to keep the two halves of the egg apart, Pangu stood between them holding up the sky. With each day that passed, the sky rose ten feet above him and the layers of the earth increased by ten feet beneath him. In order to keep pace and the two worlds apart, Pangu himself was forced to grow by ten feet every single day.

Pangu laboured heroically for 18,000 years, until the realms were finally stabilised and then, exhausted by his efforts, he lay down and died, but death was not to be the end of him.

It is said that Pangu's breath became the wind and the clouds, and his voice the sound of thunder. His gleaming left eye became the sun and his twinkling right eye, the moon. His hair and beard found homes in the heavens as the constellations and the Milky Way, his limbs formed themselves into mountain ranges and his flesh became the fertile soil which feeds all living things. His flowing blood became the rivers of the world and his sweat, the rain. His bones turned to gemstones, minerals and the precious treasures hidden underground; his fur became trees, forests and flora. It is even claimed that the fleas which once tormented him were scattered by the winds to become the common ancestors of every bird, fish and animal.

Pangu created the world around us and the heavenly worlds above us but Daoists also believe that his spirit animates and lives within every creature and every person that has ever walked upon the earth.

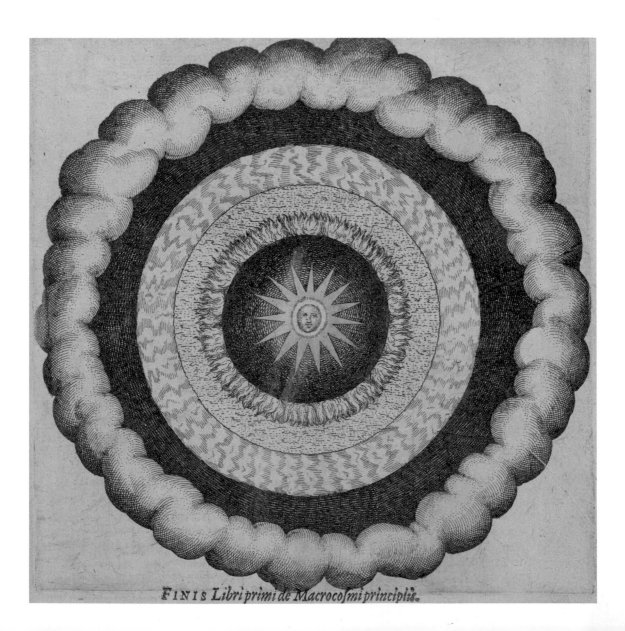

FINIS Libri primi de Macrocosmi principiis.

The Creation According to Genesis from *The Nuremberg Chronicles* (*Liber Chronicarum*), written by Hartmann Schedel and illustrated with woodcuts by Michael Wolgemut, 1493
Day four: the creation of the stars, the sun and the moon.

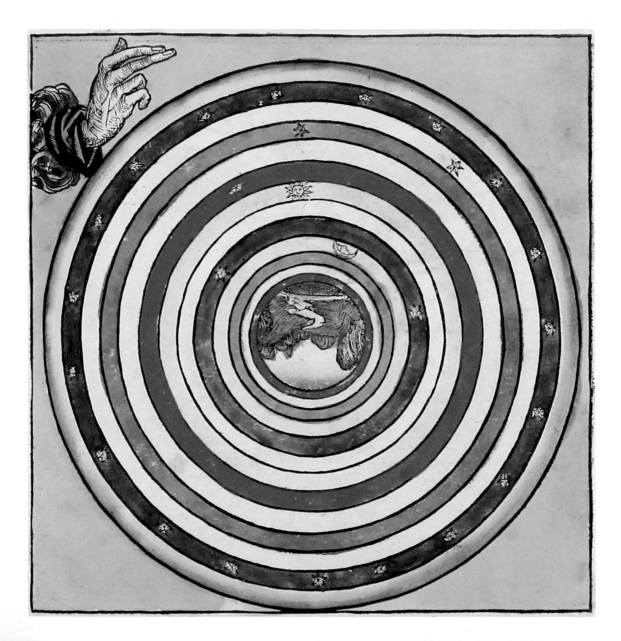

↓ 4  (a & b) Tantric paintings from Rajasthan, India, representing the Cosmic Egg (Brahmanda), artist(s) unknown, nineteenth or early twentieth century

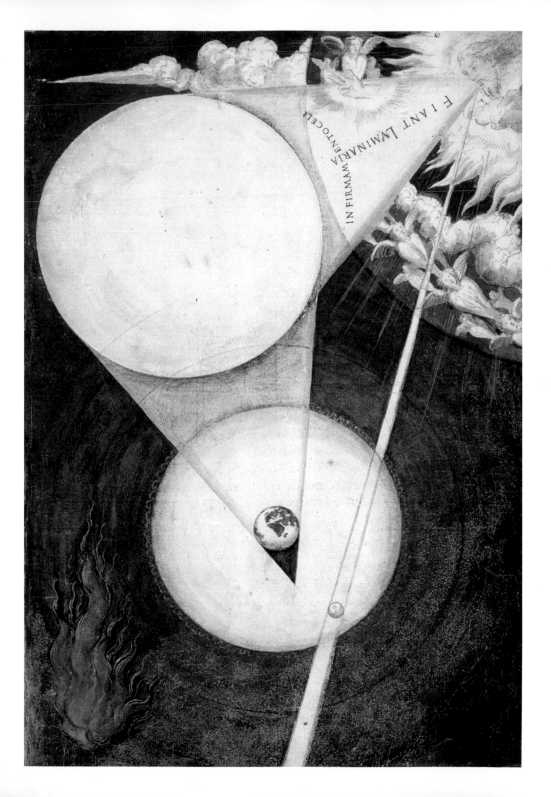

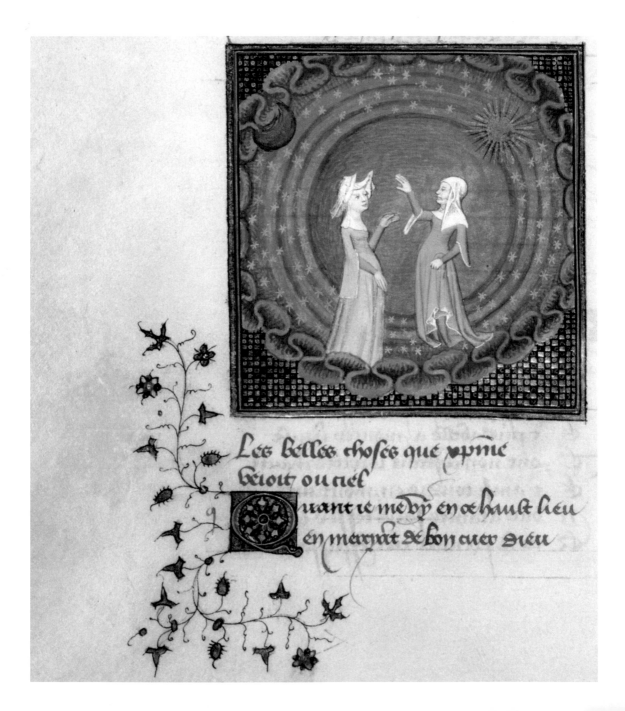

↓ **7** Creation of the Sun and the Moon from the *Bible
Historiale*, vol.1 by Master of Jean de Mandeville (active
1350–70), France, *c.* 1360–70

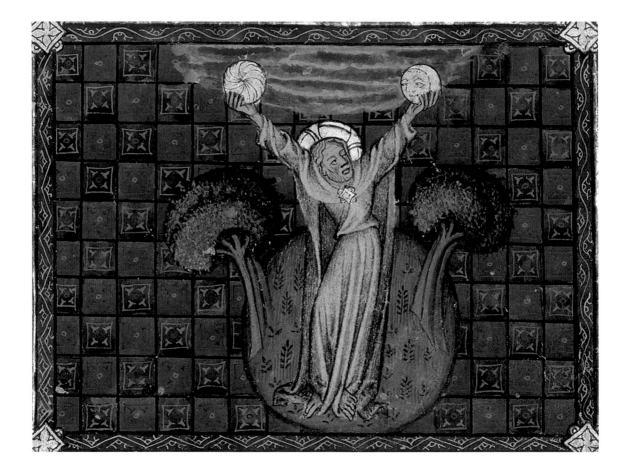

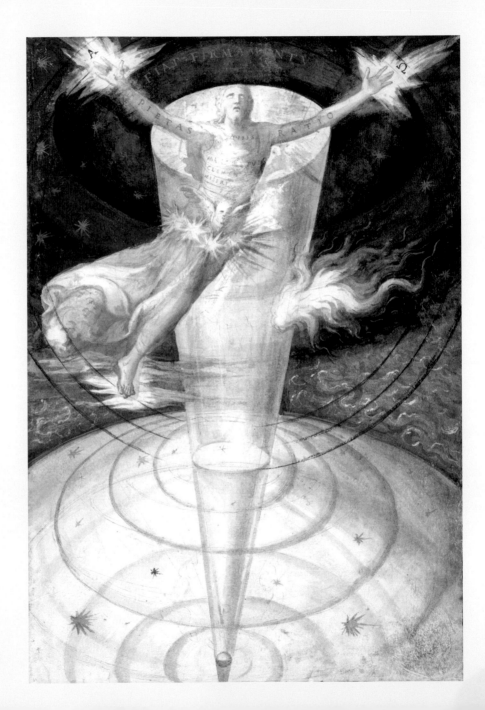

The creation of the world did
not occur at the beginning of time,
it occurs every day.

— Marcel Proust, *In Search of Lost Time*, vol. 3, *The Guermantes Way*, 1925

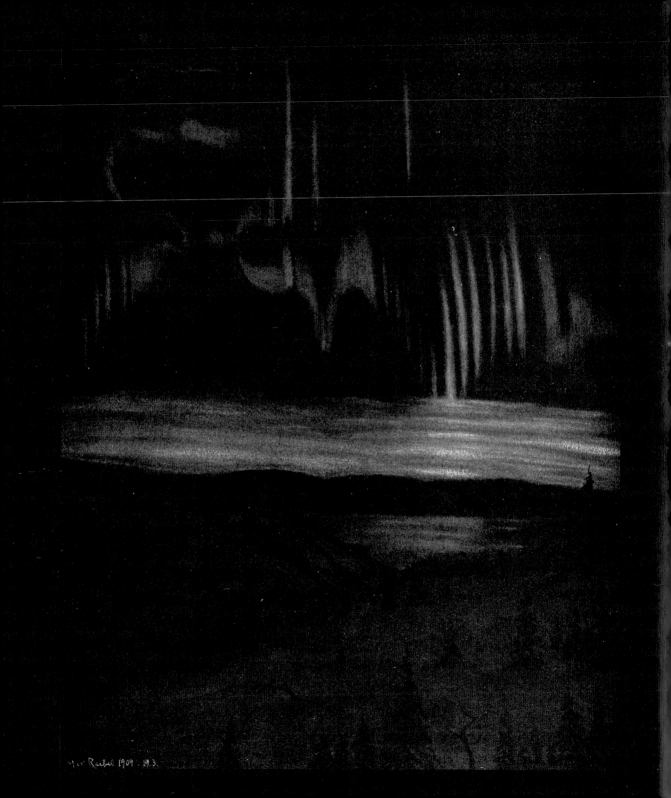

# THE
# FIRMAMENT

← ← 9 Astronomy: the Aurora Borealis, with Pine Trees in the Foreground by Max Raebel, colour process print, 1909

Raebel visited Norway for several years to make pastel studies of the aurora borealis.

IN THE TIME OF PRIMEVAL darkness and never-ending murk, before the miracle of Creation had occurred, the Maori god Rangi, the universal father and personification of the sky, fell in love with Papa, the goddess of the earth below. Utterly besotted, Rangi descended through the darkness to become one with Papa.

However, as is so often the case with *l'amour fou*, their loving embraces had unforeseen and catastrophic consequences. Rangi and Papa's passionate writhing crushed and trapped the host of lesser gods, to whom they had given birth, between them – condemning them to an existence of misery and unrelenting gloom.

Nothing could grow or flourish in this dense, all-consuming darkness. The lesser gods, imprisoned between the sky and the earth, employed all their powers, skills and cunning in a desperate attempt to free themselves and separate their infatuated parents, but all their plots and schemes came to nothing.

Their plight became increasingly hopeless and their methods more extreme until, at last, Tāne, the personification of the forests, devised an ingenious solution. He commanded his vast army of tall and noble trees to raise Father Rangi far above Mother Papa, to set him on high and support him there for ever more.

So it was that Tāne successfully wrenched his parents apart, uplifting his father far above his mother, creating the arch of the sky and flooding the earth with life-giving light. Ever since that day, Rangi has remained in his own realm, gazing down lovingly at Papa, and all living beings owe their existence to the gifts they both give us every day.

↓ **10** *Fireflies at Ochanomizu* by Kobayashi Kiyochika (1847–1915), colour woodblock print, Japan, *c.* 1880

→→ **11** Aurora Borealis: as observed 1 March, 1872, at 9.25 p.m. from *The Trouvelot Astronomical Drawings: Atlas* by Étienne Léopold Trouvelot, 1881–82

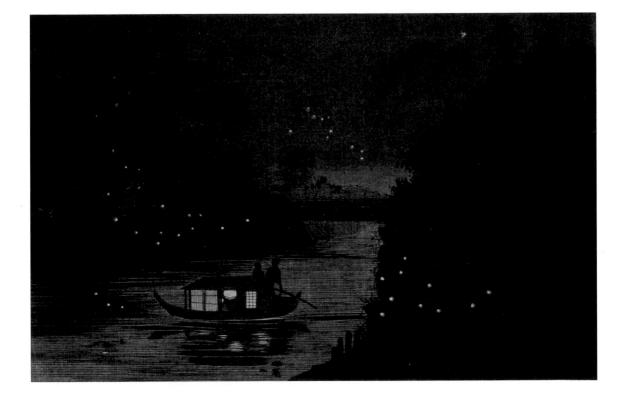

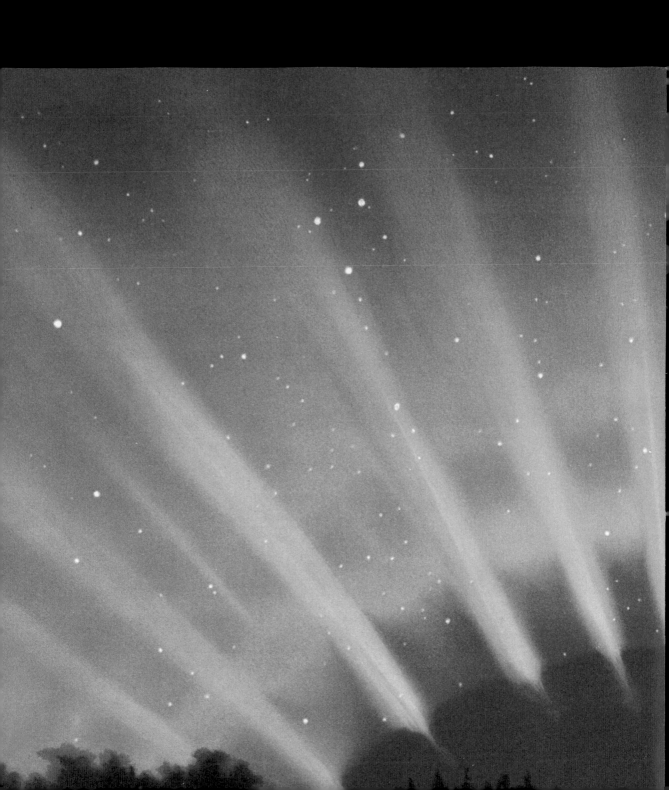

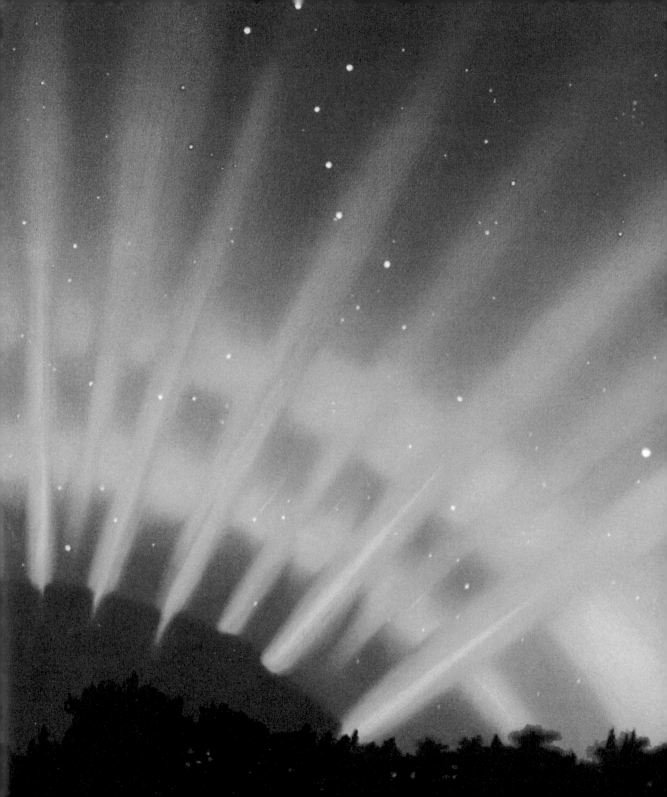

↓ 12 Three Crows Against the Rising Sun, from the series
Three Sheets (Mihira no uchi) by Totoya Hokkei (1780–
1850), part of an album of woodblock prints (surimono),
ink and colour on paper, Japan, mid 1810s

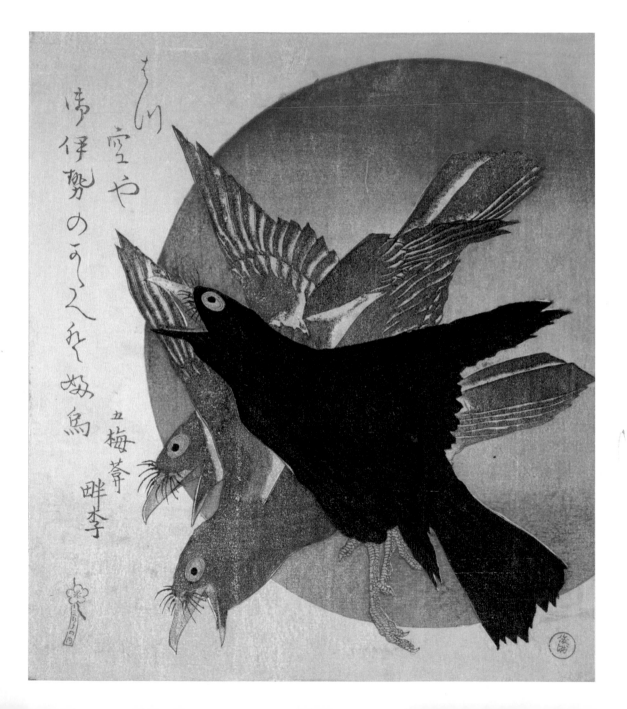

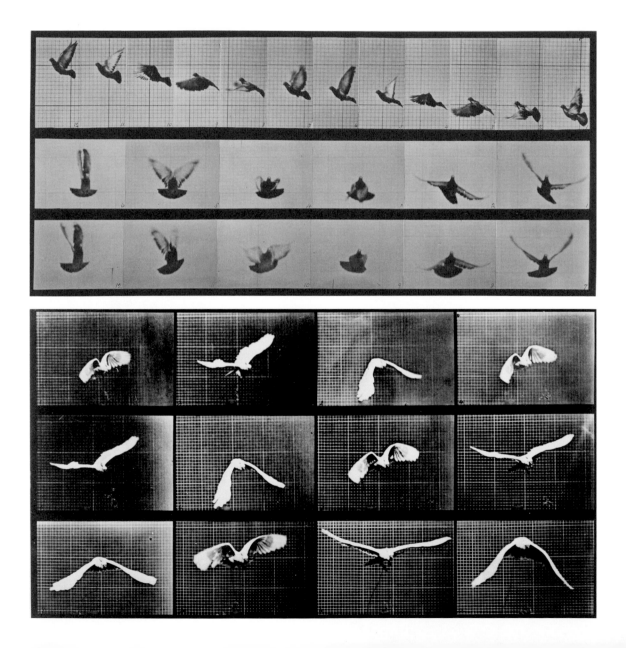

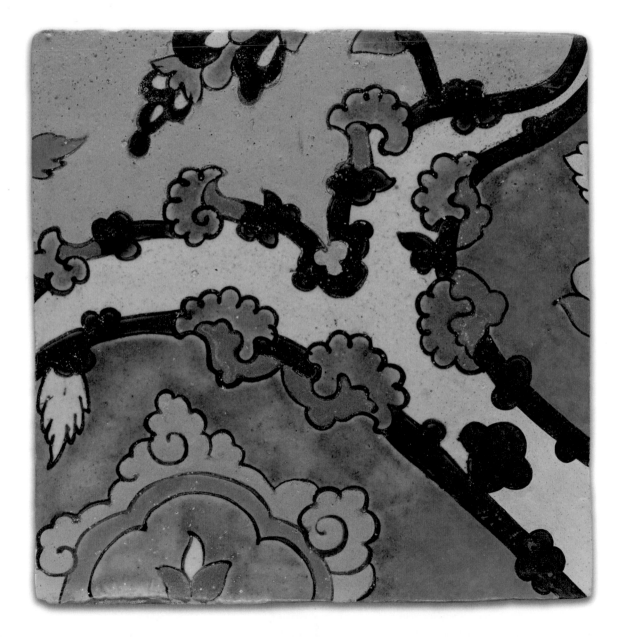

← 14 Square Tile Depicting Clouds, stonepaste, poly-
chrome glaze within black wax resist outlines (cuerda seca
technique), Iran (attributed), seventeenth century

↓ 15 *Buffalo Trail: The Impending Storm* by Albert
Bierstadt (American born in Germany, 1830–1902), oil on
canvas, 1869

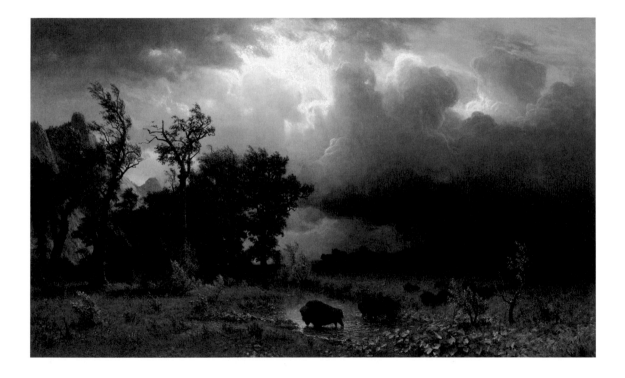

↓ **16** *Clouds* by Thomas Cole (born Bolton, Lancashire, England, 1801 – died Catskill, New York, USA, 1848), oil on paper laid down on canvas, *c.* 1838

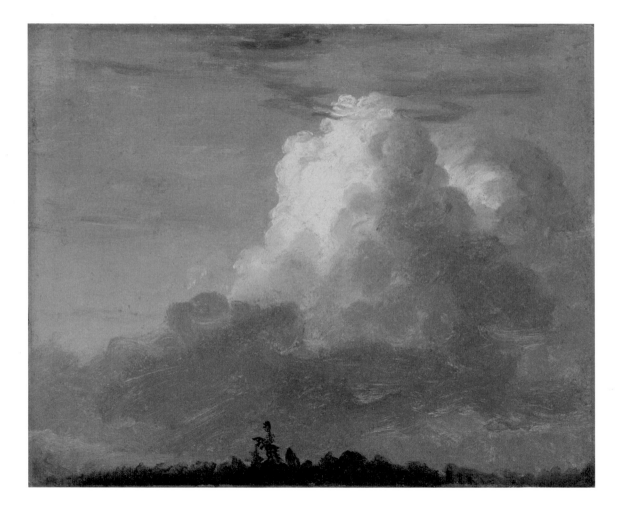

Only birds
sing the music of heaven
in this world.

— Issa (1763–1828)

In the midst of the plain
Sings the skylark,
Free of all things.

— Matsuo Bashō (1644–94)

Like shuttles fleet the clouds, and after
A drop of shade rolls over field and flock …
now the rain, A brittle sheen, runs upward like a cliff, Flying a bow …

How looks the night? There does not miss a star. The million sorts of unaccounted motes Now quicken, sheathed in the yellow galaxy. There is no parting or bare interstice Where the stint compass of a skylark's wings Would not put out some tiny golden centre.

The sun just risen Flares his wet brilliance in the dintless heaven …

— Gerard Manley Hopkins, *Sundry Fragments and Images*, 1967

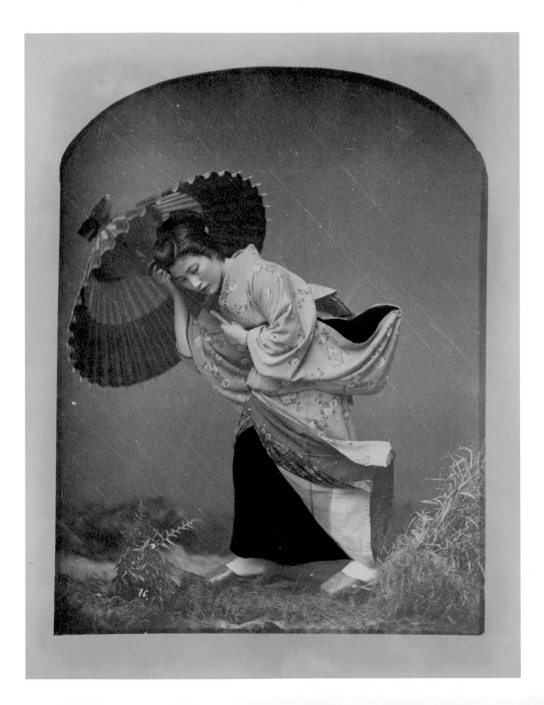

↓ **18** *A Paddle-steamer in a Storm* by J. M. W. Turner (1775–1851), watercolour, graphite and scratching out on medium, slightly textured, cream wove paper, *c.* 1841

→ **19** *Sky Study with Rainbow* by John Constable (1776–1837), watercolour on medium, smooth, blued white wove paper, 1827

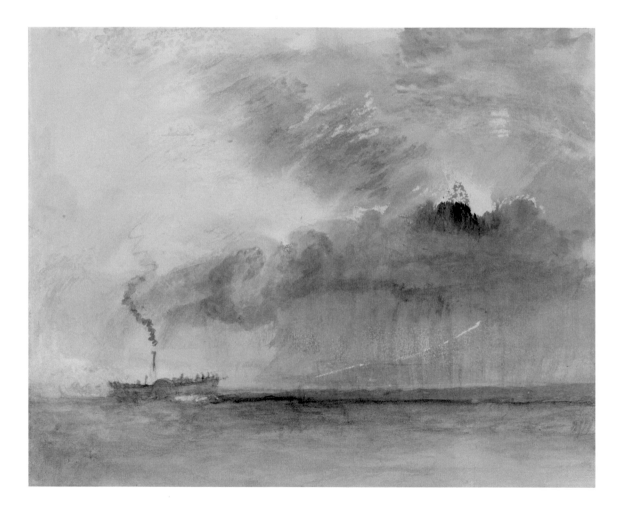

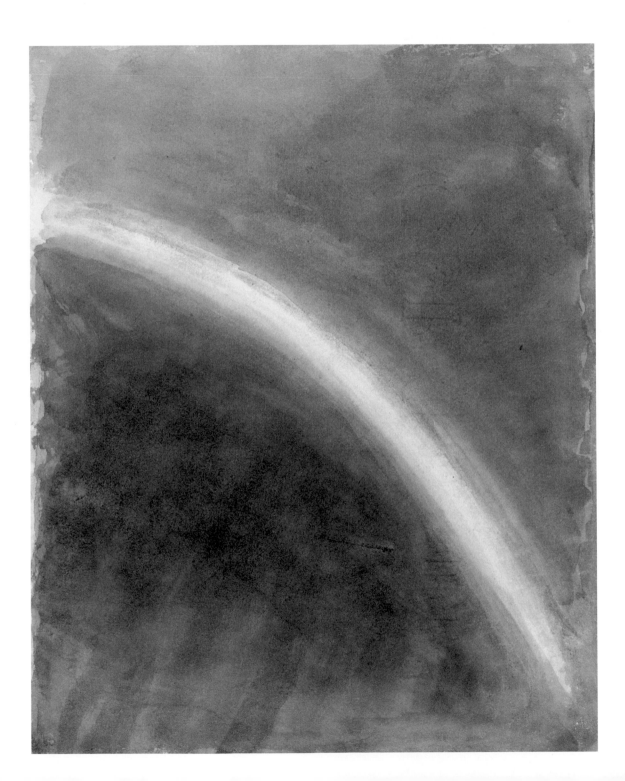

20 Sun, Moon and Lotus on a Lotus Throne, from a set of initiation cards (tsakali), ink and watercolour on paper, Tibetan, fourteenth or fifteenth century

21 *Frau vor untergehender Sonne* (*Woman Before the Setting Sun*) by Caspar David Friedrich (1774–1840), oil on canvas, *c.* 1818

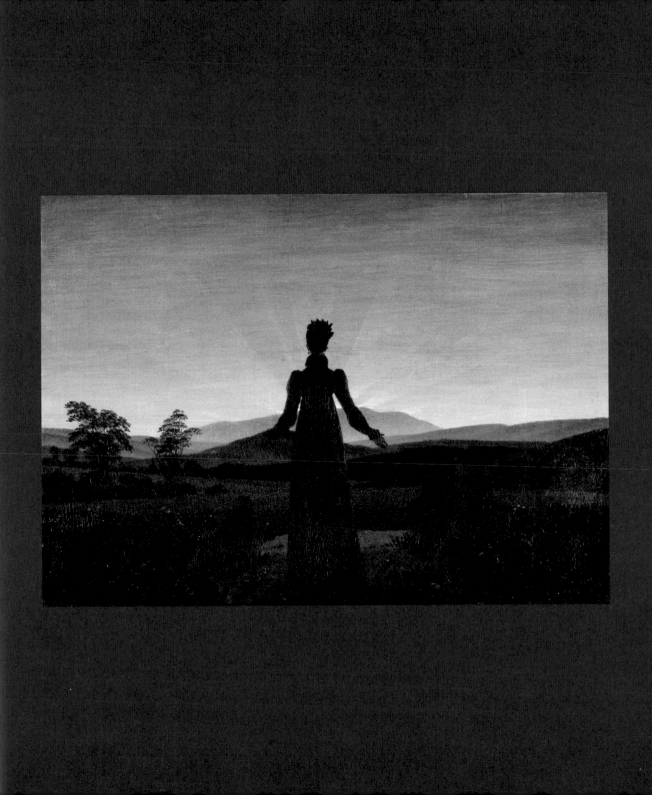

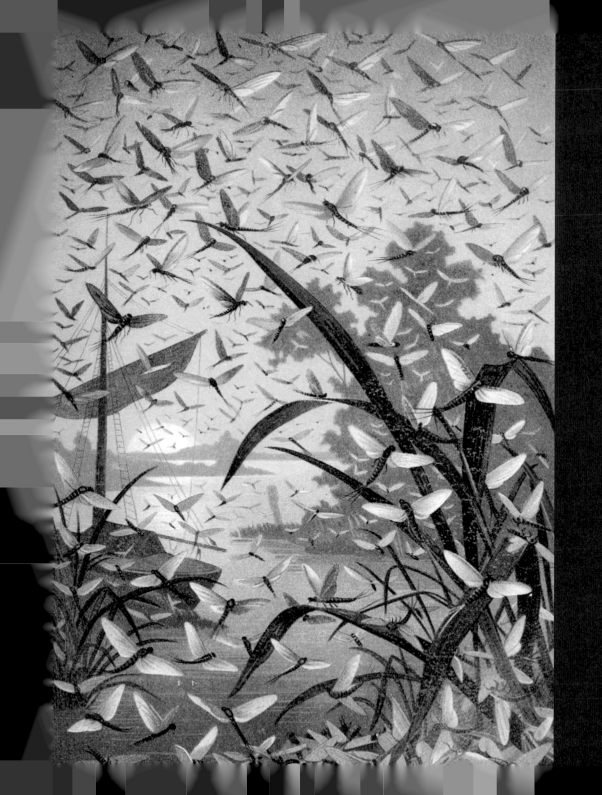

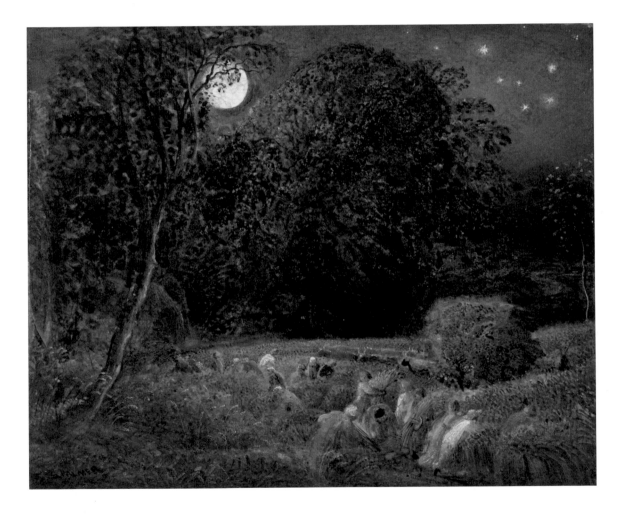

↓ 24 *The Tarō Inari Shrine in the Asakusa Ricefields* by Kobayashi Kiyochika, woodblock print, ink and colour on paper, Japan, 1877

→ 25 *Scops Owl in Moonlight* by Ohara Shōson (Japanese, 1877–1945), colour woodblock print, early 1920s

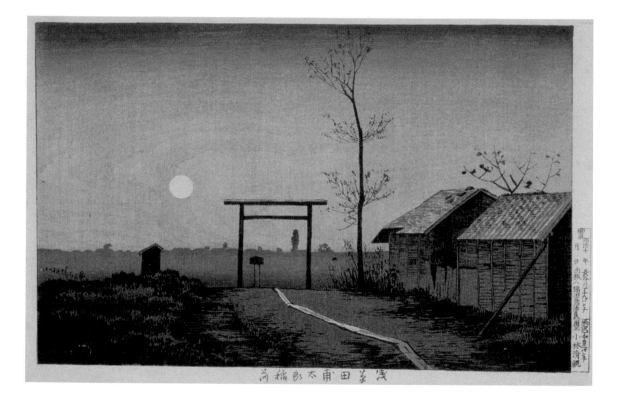

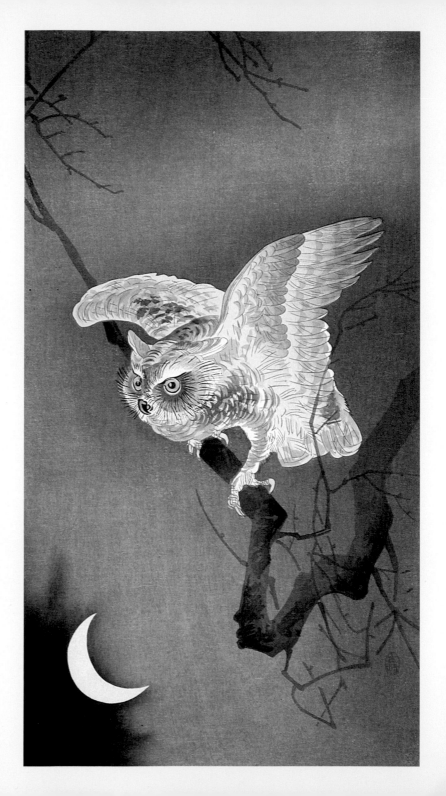

Slowly the west reaches for clothes of new colours
which it passes to a row of ancient trees.
You look, and soon these two worlds both leave you
one part climbs toward heaven, one sinks to earth […]

[…] one moment your life is a stone in you,
  and the next, a star.

— Rainer Maria Rilke (1875–1926), from 'Sunset'

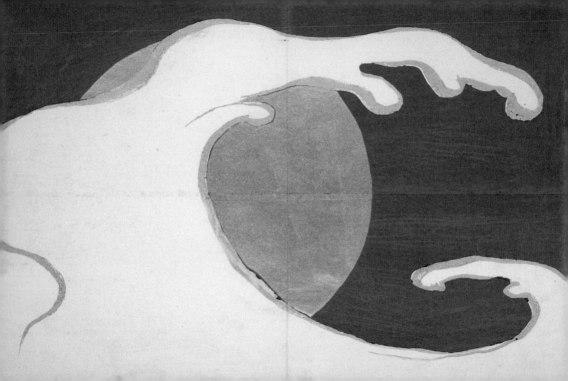

# THE FACE
# OF THE WATERS

THE ANCIENT GREEKS regarded the ocean as a vast circular river encompassing all the nations of the earth. This boundless river, named Oceanus, which had neither a source nor an outlet, also connected the known world to both the heavens and the realm of the dead.

Oceanus was the offspring of the union between the sky and the earth. He was the most ancient of the Titans, the twelve giant gods who ruled the world in the time before the gods and goddesses of Olympus. Oceanus fell in love with his own sister, Tethys, the goddess of fresh water, and their union proved remarkably fertile, producing no fewer than 3,000 children, including every sea, river, estuary, lake and stream on earth.

His daughter Metis was the goddess of prudence and deep thought, the first wife of Zeus and the mother of Athena, goddess of wisdom, civilisation, justice and the arts.

According to legend, every morning the sun would emerge from the ocean's far eastern shore and at the end of his long day's journey across the sky, sink back into the waters at the western limit of the earth. Every night, the sun would travel through the deep, dark ocean back to the east, where, refreshed and revived by the water's embrace, he would begin his journey anew. In this, as in so many other ways, the ocean has always sustained and nourished the whole world and everything upon it.

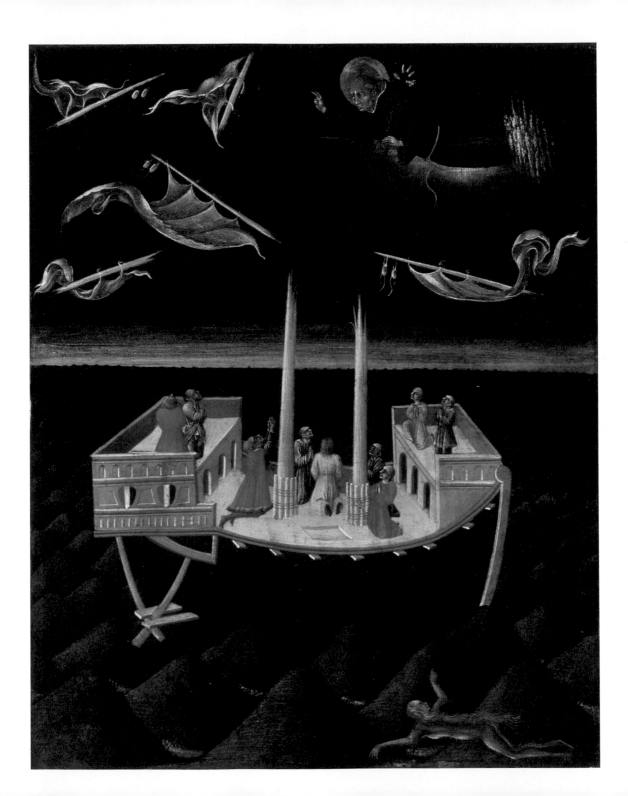

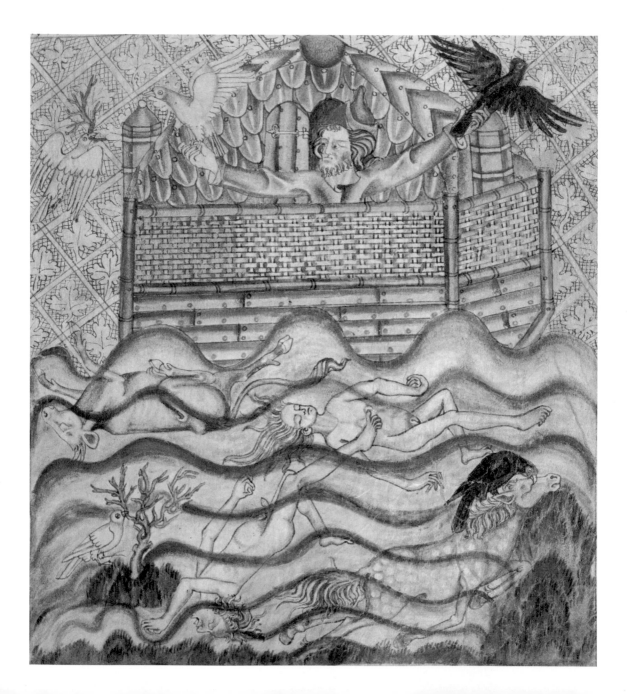

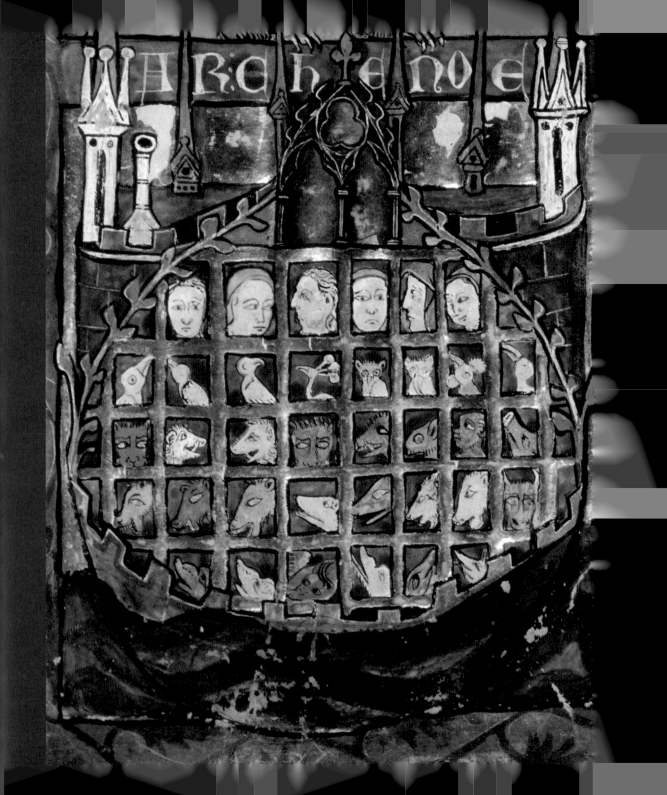

↓ **30**  Outer Right Wing of an Altarpiece with the St Elizabeth's Day Flood, 18–19 November 1421, by the artist known as the Master of the St Elizabeth Panels (Netherlands, active 1490–95)

→ **31**  Batrachia, plate 68 from *Kunstformen der Natur* (*Art Forms of Nature*) by Ernst Haeckel, published in Leipzig and Vienna, 1899–1904

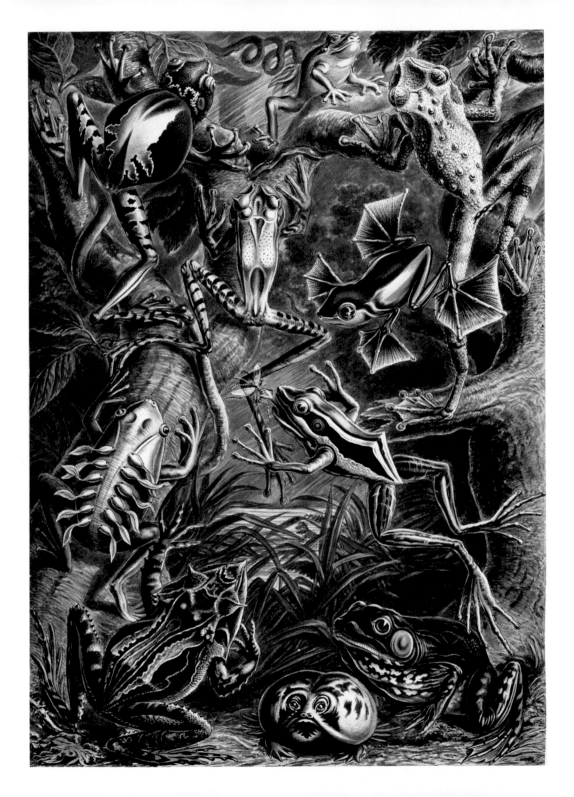

↓ 32 Ascidiae, plate 85 from *Kunstformen der Natur* (*Art Forms of Nature*) by Ernst Haeckel, published in Leipzig and Vienna, 1899–1904

→ 33 Great Barrier Alcyonaria from *The Great Barrier Reef of Australia; its products and potentialities* by William Saville-Kent, London, 1893

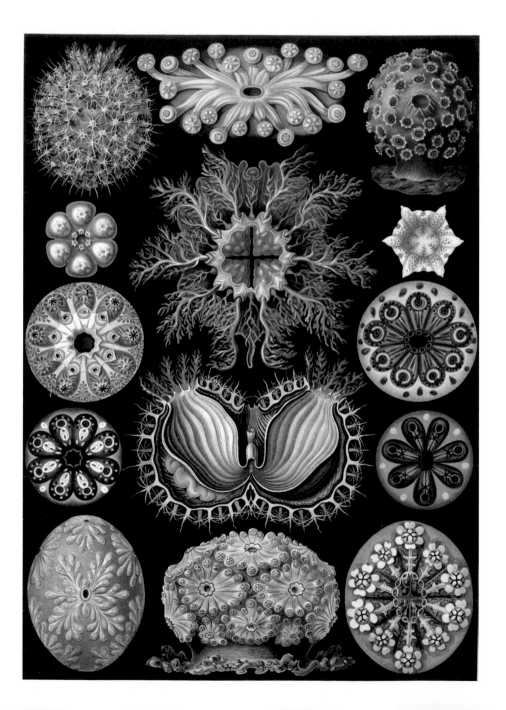

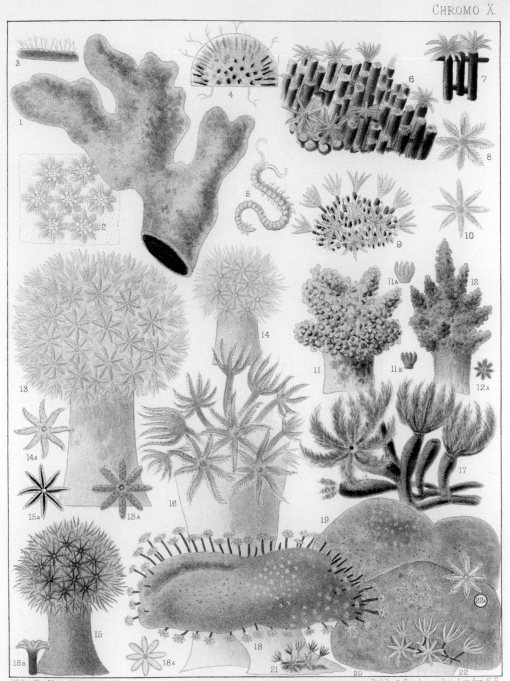

W. Saville-Kent, del. et pinx. ad nat.

Riddle & Couchman, Imp. London, S.E.

GREAT BARRIER REEF ALCYONARIA.

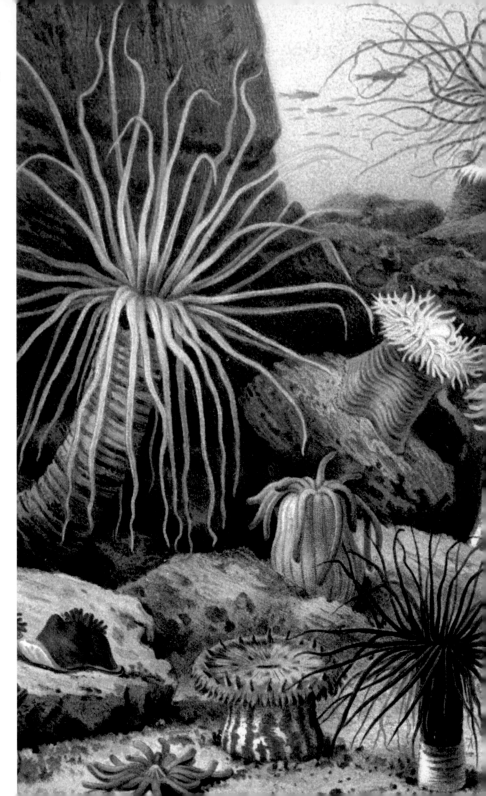

→ **34** Actiniaria by Giacomo Merculiano featured in *The Royal Natural History* by Richard Lydekker, published in London, 1893

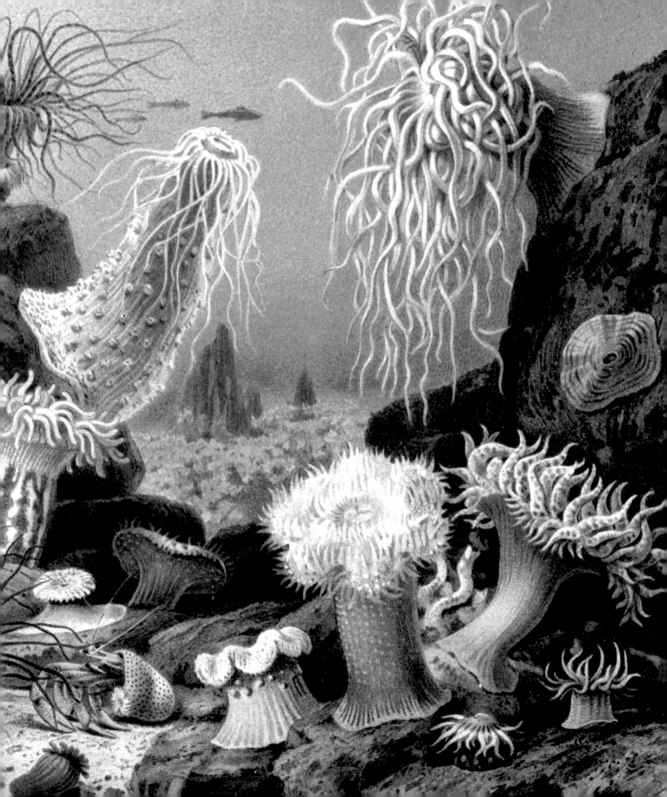

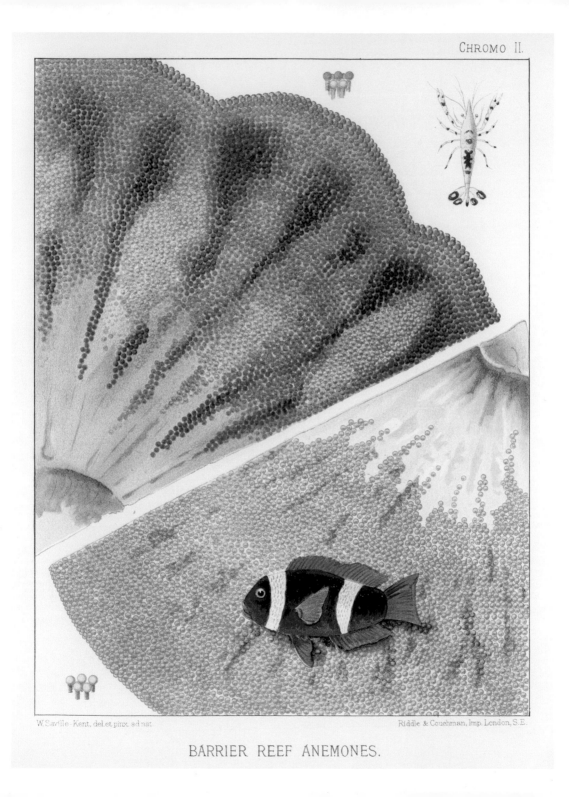

W.Saville-Kent, del.et pinx. ad nat.   Riddle & Couchman, Imp. London, S.E.

BARRIER REEF ANEMONES.

← 35 Barrier Reef Anemones from *The Great Barrier Reef of Australia; its products and its potentialities* by William Saville-Kent, London, 1893

↓ 36 Discomedusae, plate from *Kunstformen der Natur (Art Forms of Nature)* by Ernst Haeckel, published in Leipzig and Vienna, 1899–1904

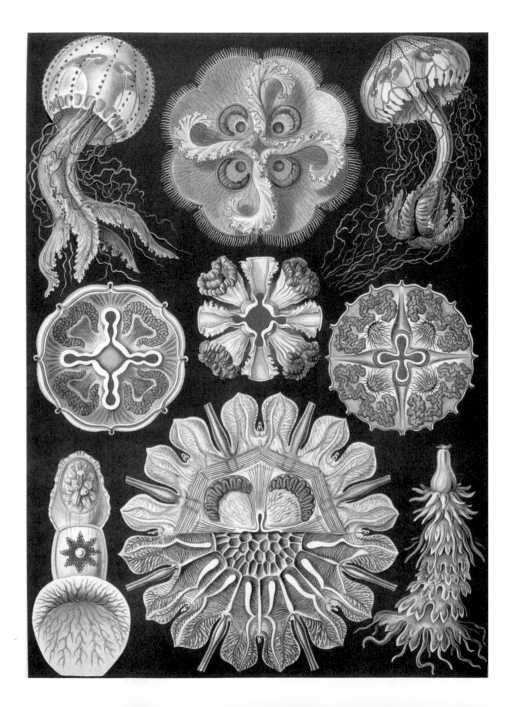

↓ 37 The Atlantic White-Spotted Octopus (*Octopus macropus*) by André Étienne d'Audebert de Férussac, from *Histoire naturelle generale et particuliere des cephalopodes acetabuliferes vivants et fossiles* by André Étienne d'Audebert de Férussac and Alcide Charles Victor Marie Dessalines d'Orbigny, Paris, 1848

→ 38 Paestan Red-Figure Fish Plate attributed to the Binningen Painter, terracotta, Paestum, Southern Italy, third quarter of fourth century BCE

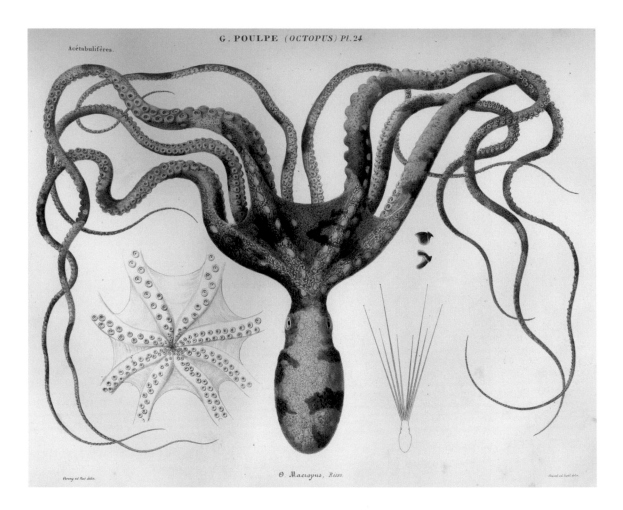

Acétabulifères.

G. POULPE *(OCTOPUS)* Pl. 24

O. *Macropus, Risso.*

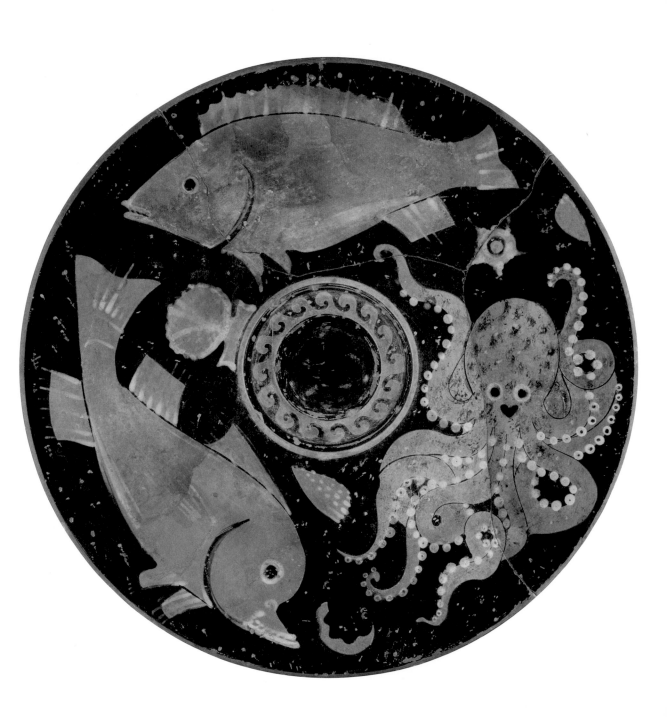

**39** Calligraphic Galleon by 'Abd al-Qadir Hisari, ink and gold on paper, Turkey, 1766–67

On the hull of the ship are the names of the Seven Sleepers and their dog. According to pre-Islamic Christian sources, the Seven Sleepers were a group of men who slept in a cave for centuries, where they were protected by God from religious persecution.

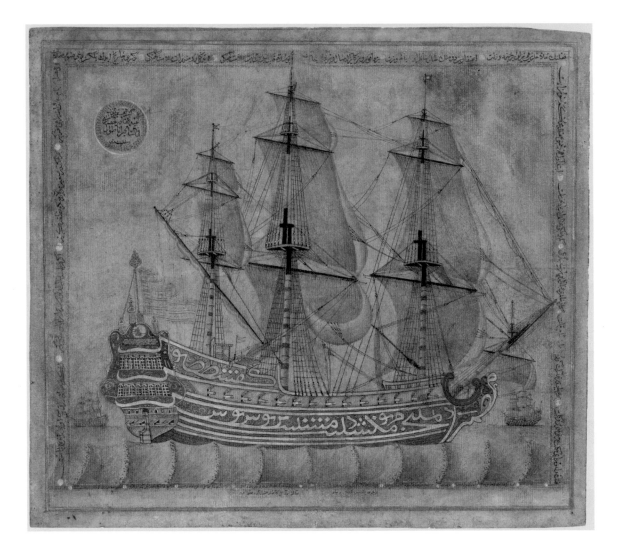

The true mystery
of the world is the visible,
not the invisible.

— Oscar Wilde, *The Picture of Dorian Gray*, 1890

The sea is a mirror, not only to
the clouds, the sun, the moon, and the stars,
but to all one's dreams, to all one's speculations […]
The sea tells us that everything is changing
and that nothing ever changes,
that tides go out and return,
that all existence is a rhythm;
neither calm nor storm breaks the rhythm,
only hastens or holds it back for a moment.

— Arthur Symons, 'In a Northern Bay', 1918

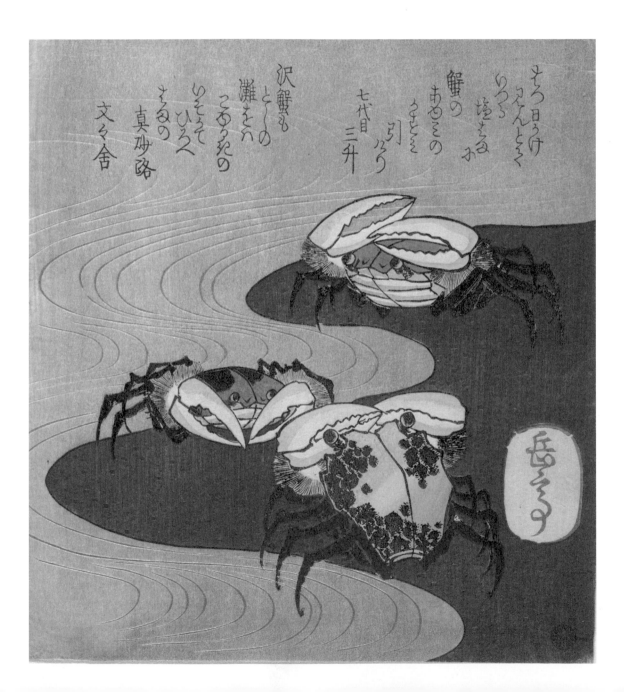

↓ **41** Fish, a painting from a thirteen-leaf album, by Ma Yuanyu, ink and colour on silk, China, Qing dynasty, 1690

→ **42** Wonders of the Seven Seas, from a seventeenth- or eighteenth-century manuscript copy of Persian polymath Abū-Yahyā Zakarīyā Ibn-Muhammad al-Qazwīnī's *Marvels of Things Created and Miraculous Aspects of Things Existing* (originally compiled in Iran or Turkey, *c.* 1203–83)

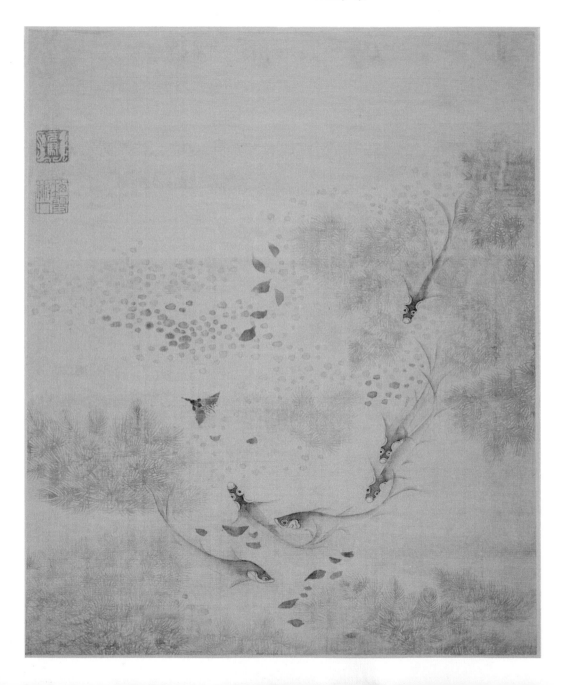

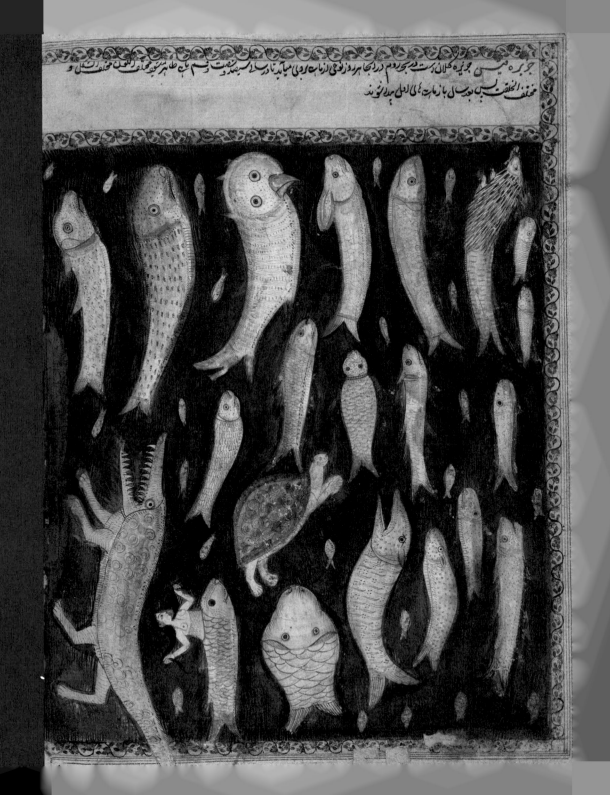

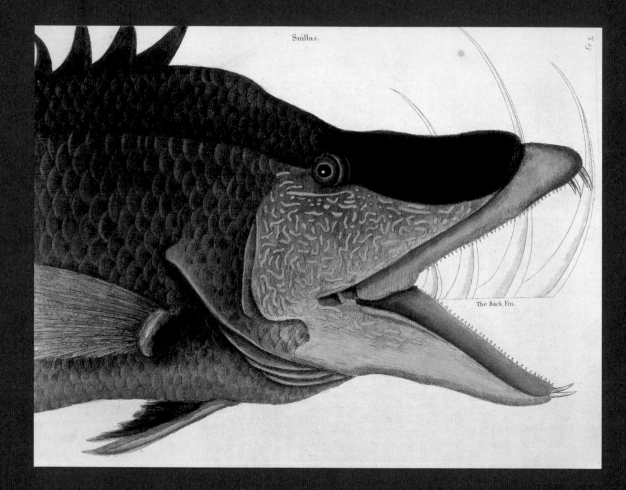

Suillus.

T.5

The Back Fin.

← 43 The Great Hog-Fish, from *Natural History of Carolina, Florida and the Bahama Islands*, volume 2, by Mark Catesby, published in London, 1734–47

↓ 44 Jonah and the Whale, folio from a *Jami al-Tavarikh* (*Compendium of Chronicles*), ink, opaque watercolour, gold and silver on paper, attributed to Iran, *c.* 1400

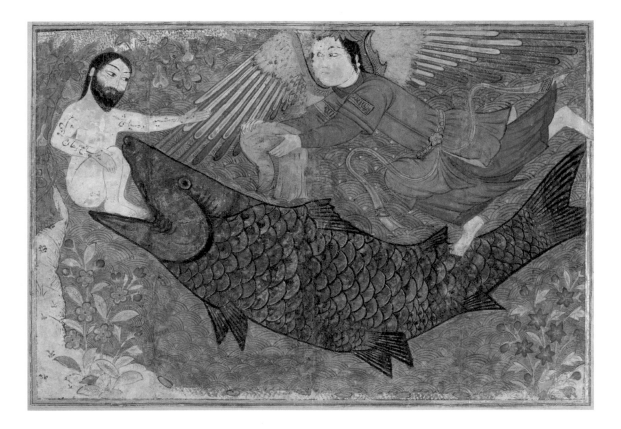

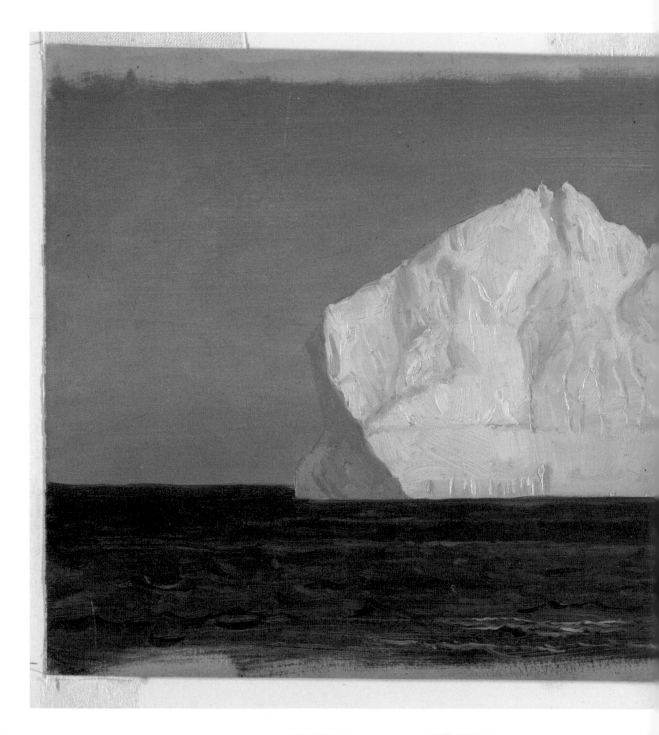

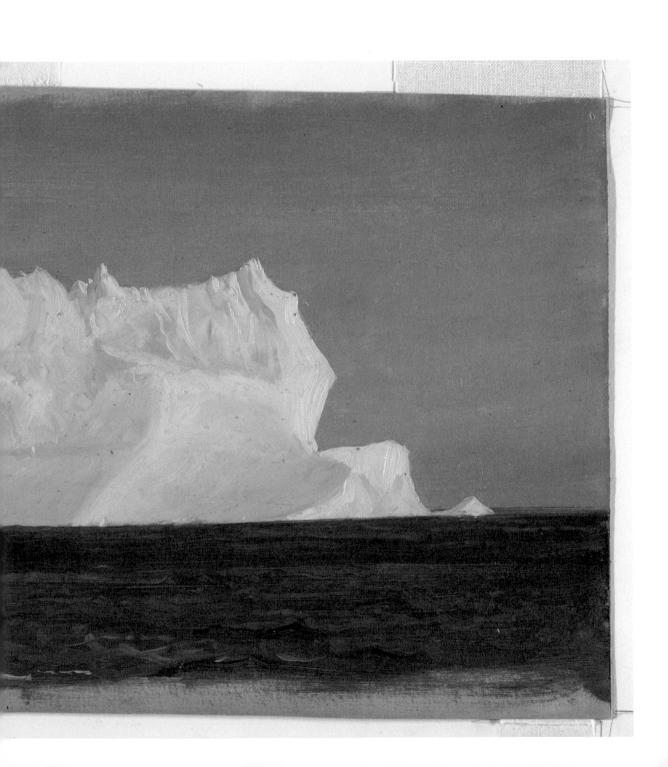

↓ **46** *Rough Waves* by Ogata Kōrin, two-panel folding
screen, ink, paint and gold leaf on paper, Japan, *c.* 1704–09

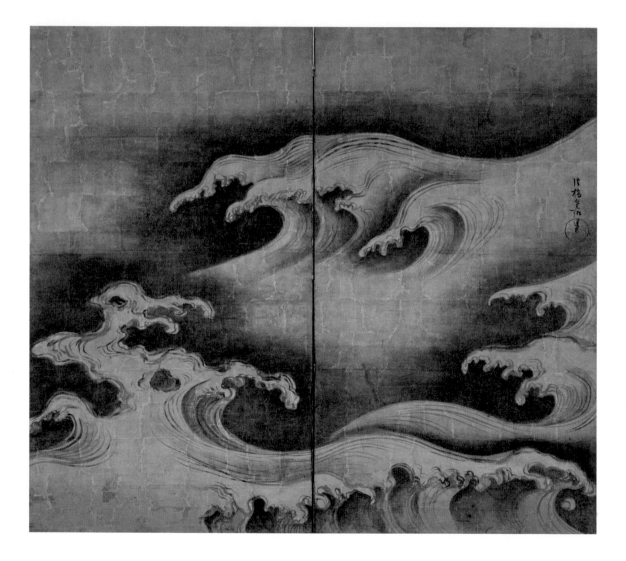

↓ 47 A coloured version of the drawing Big Wave, from the
album *100 Views of Mount Fuji* by Katsushika Hokusai,
Japan, Edo period, 1834

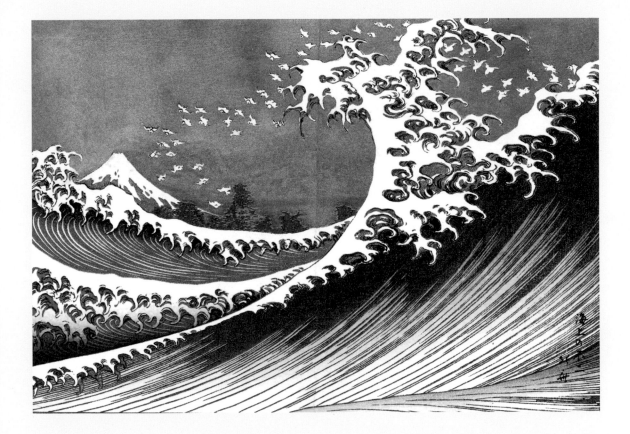

I will arise and go now, for always night and day
I hear the lake water lapping with low sounds by the shore;
While I stand on the roadway, or on the pavements grey,
I hear it in the deep heart's core.

— William Butler Yeats, from 'The Lake Isle of Innisfree', 1890

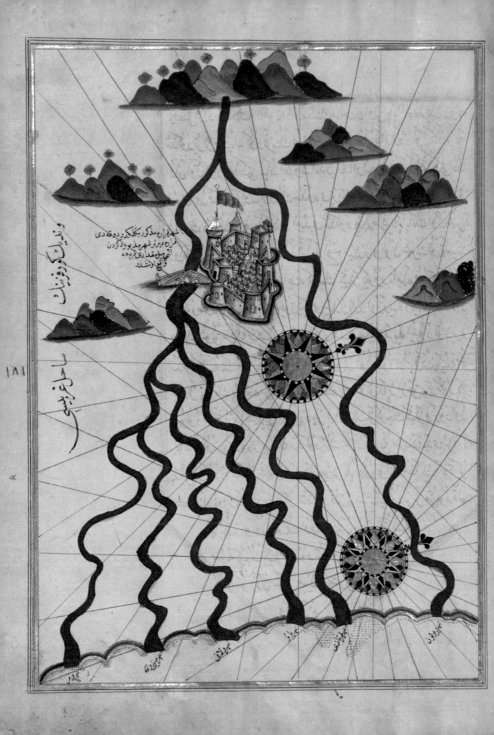

# THE FACE
# OF THE EARTH

ACCORDING TO THE FINNISH national epic, the Kalevala, at the beginning of time the face of the earth was covered by a single vast, boundless ocean, watched over by the sky and his daughter Ilmatar, the goddess of the air. She spent her days wandering the heavens sculpting clouds, dodging thunderbolts, sliding down rainbows and riding with the four winds.

Ilmatar eventually fell in love with the east wind and conceived a child. Ilmatar's pregnancy lasted for many centuries and she became increasingly weary and desperate to find respite from her endless wanderings. So, seeking a safe resting place, Ilmatar descended to the waters below but found nothing. Ilmatar swam and searched the oceans for 700 years, until one day she spotted another creature seeking a resting place, a magnificent golden eagle swooping and diving through the sky above, anxiously scanning the horizon. Ilmatar raised her knee above the water, offering the exhausted bird a safe landing place. Almost immediately the eagle laid seven golden eggs, placed herself on top of them and promptly fell asleep.

The bird spent several centuries incubating the eggs and Ilmatar remained as still and silent as possible, anxious lest she disturb them. Eventually, the heat of the eggs began to burn Ilmatar's leg, and to ease the constant pain and discomfort, she moved. This dislodged the eggs, which fell and shattered in the waves, creating a foaming and roiling primordial cosmic omelette which gradually spread across the ocean and the heavens. Ilmatar watched in amazement as one of the yolks shot into the sky to form the sun, while the white of the very same egg became the moon. The whites of the other eggs spattered across the firmament and became the stars and the Milky Way, and the egg shells joined together to become the earth.

Delighted with her new home, Ilmatar set about organising and shaping the newly formed land. She created mountain ranges with a sweep of her arms, her footprints became rivers, lakes and streams, she summoned forests with a click of her fingers. Once Ilmatar's work was complete, the new earth was ready to support life, and she at last gave birth to her son, Väinämöinen, the first human, god of magic, learning, poetry and father of agriculture.

Thanks to Ilmatar, the solid earth has provided a safe, fertile and fruitful resting place for every human and every creature since the time of the hatching of the golden eggs.

PLATE 22
SHEET 11

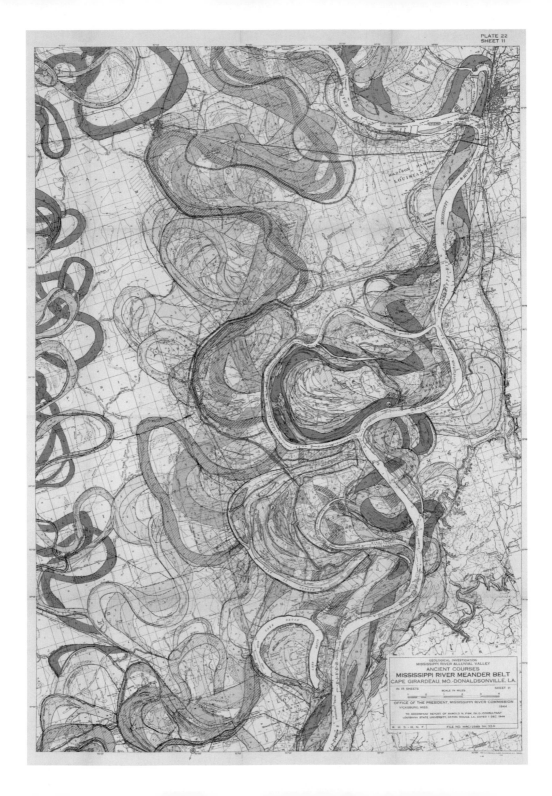

GEOLOGICAL INVESTIGATION
MISSISSIPPI RIVER ALLUVIAL VALLEY
ANCIENT COURSES
MISSISSIPPI RIVER MEANDER BELT
CAPE GIRARDEAU, MO.-DONALDSONVILLE, LA.

IN 15 SHEETS     SCALE IN MILES     SHEET 11

OFFICE OF THE PRESIDENT, MISSISSIPPI RIVER COMMISSION
VICKSBURG, MISS.
1944

TO ACCOMPANY REPORT OF HAROLD N. FISK, PH.D. CONSULTANT
LOUISIANA STATE UNIVERSITY, BATON ROUGE, LA. DATED 1 DEC 1944

FILE NO. MRC/2589 SH. 53-5

↓ 50 The Fool's Cap Map of the World, the artist, date
and place of publication are all unknown. A date of *c.* 1590
has been suggested because the geography of the map is
very similar to that of the world maps of Ortelius
published in the 1580s

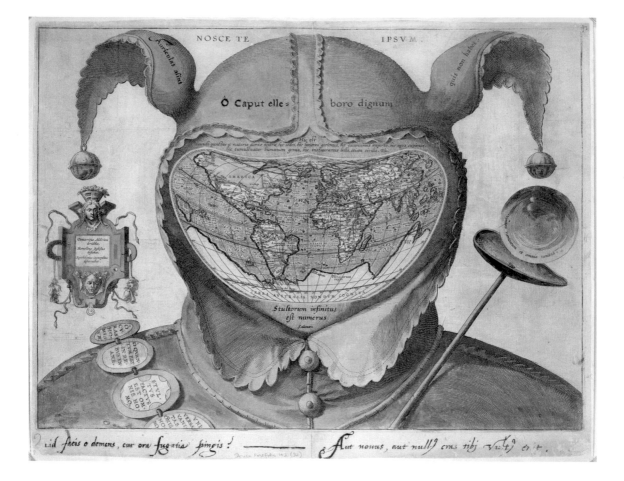

→ **52** Geological chart for use in the classroom from *Levi Walter Yaggy's Geographical Portfolio*, chromolithograph, Chicago, 1893

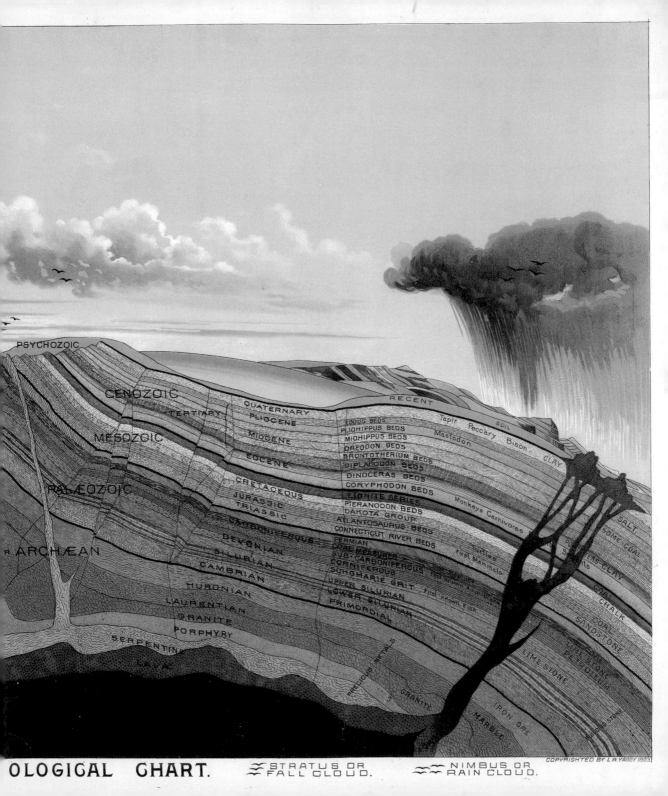

PSYCHOZOIC

CENOZOIC

TERTIARY

MESOZOIC

PALÆOZOIC

ARCHÆAN

QUATERNARY
PLIOCENE
MIOCENE
EOCENE
CRETACEOUS
JURASSIC
TRIASSIC
CARBONIFEROUS
DEVONIAN
SILURIAN
CAMBRIAN
HURONIAN
LAURENTIAN
GRANITE
PORPHYRY
SERPENTINE
LAVA

RECENT

EQUUS BEDS
PLIOHIPPUS BEDS
MIOHIPPUS BEDS
OREODON BEDS
BRONTOTHERIUM BEDS
DIPLACODON BEDS
DINOCERAS BEDS
CORYPHODON BEDS
LIGNITE SERIES
PTERANODON BEDS
DAKOTA GROUP
ATLANTOSAURUS BEDS
CONNECTICUT RIVER BEDS
PERMIAN
COAL MEASURES
SUB-CARBONIFEROUS
CORNIFEROUS
SCHOHARIE GRIT
UPPER SILURIAN
LOWER SILURIAN
PRIMORDIAL

PRECIOUS METALS

GRANITE

SOIL

Tapir  Peccary  Bison
Mastodon

CLAY

Monkeys Carnivores

Turtles
First Mammals
First Reptiles
First Winged Amphibians
First Known Fish

SALT
SOME COAL
POTTER'S CLAY
Serpents
COAL
CHALK
SANDSTONE
LIMESTONE
PETROLEUM
LIME STONE
IRON ORE
MARBLE

OLOGICAL  CHART.    STRATUS OR FALL CLOUD.    NIMBUS OR RAIN CLOUD.

53 *Futami-ga-ura akebono-no kuni Futami-ga-ura (Rocks at Ise, Land of Dawn)*, Utagawa Kunisada (1786–1864), polychrome woodblock print; ink and colour on paper, Japan, c. 1835

54 *The Amida Falls in the Far Reaches of the Kisokaidō Road (Kisoji no oku Amida-ga-taki)* by Katsushika Hokusai, from *A Tour of Waterfalls in Various Provinces*, colour woodblock print, Japan, c. 1832

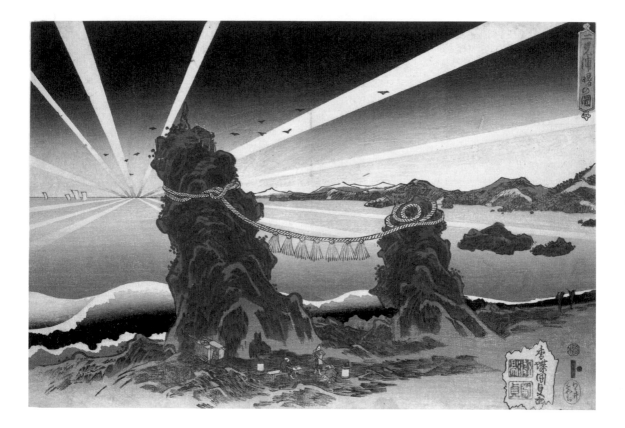

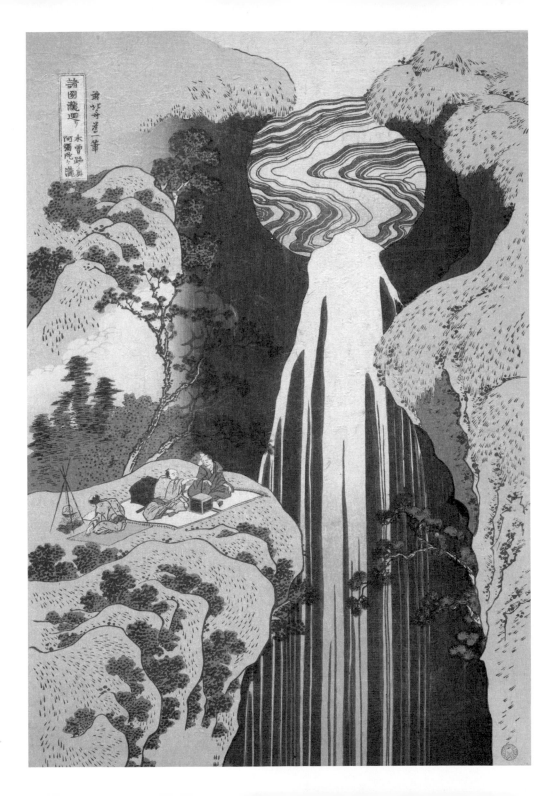

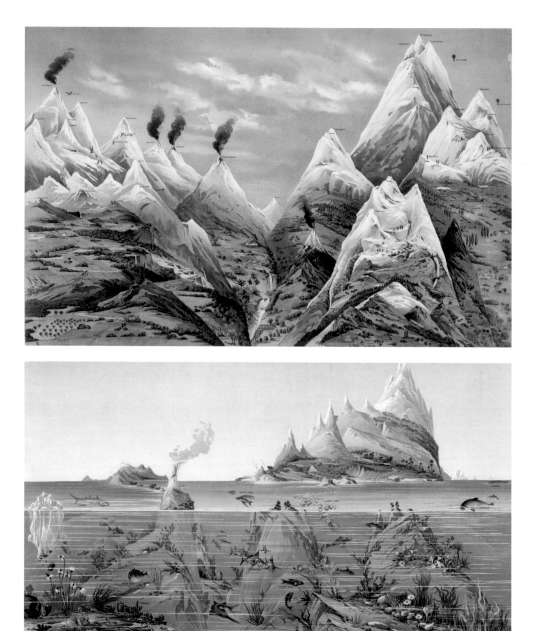

↓ 55 (a) *Nature in Ascending Regions* and (b) *Nature in Descending Regions*, educational charts for use in the classroom from *Levi Walter Yaggy's Geographical Portfolio*, chromolithographs, Chicago, 1893

→ 56 (a, b, c & d) A selection of plates from *British Mineralogy, or, Coloured Figures Intended to Elucidate the Mineralogy of Great Britain* by James Sowerby, 1802–1817

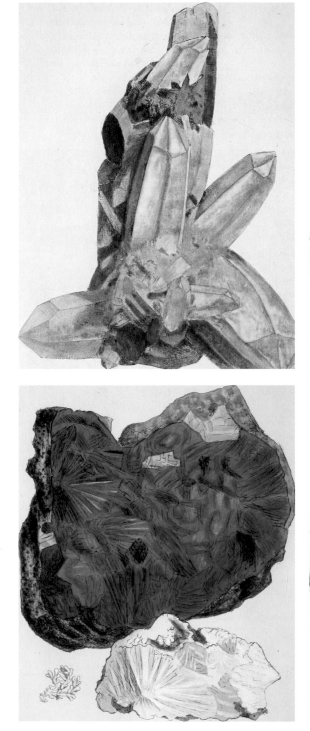

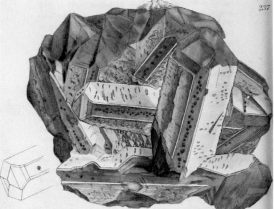

237

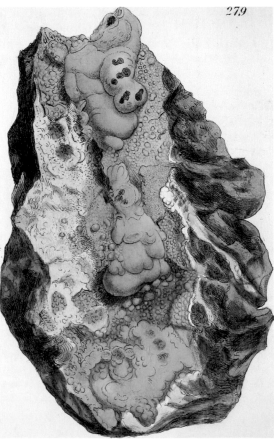

279

↓ **57** *Design for A Blue Grotto* by Thomas Grieve (British, 1799–1882), set design for an unknown theatrical production, watercolour, gouache, graphite and collage, undated

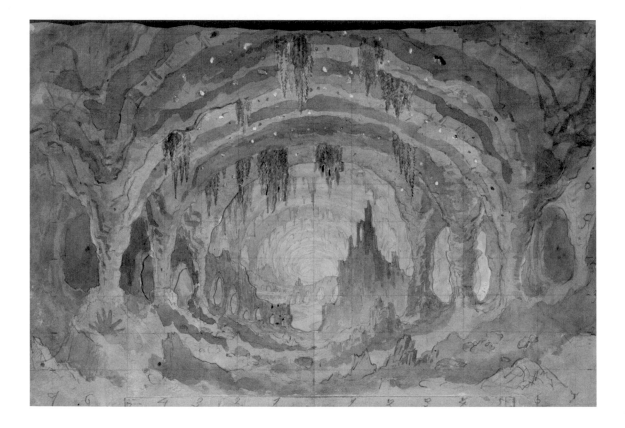

On the cellular surface of one of the blocks of it
[the volcano at Yewdale Crag], you may find more beauty,
and learn more precious things, than with telescope or
photograph from all the moons in the milky way, though
every drop of it were another solar system.

— John Ruskin (1819–1900)

There
are
plenty
of ruined
buildings
in the
world
but
no
ruined
stones.

— Hugh MacDiarmid (1892–1978), from 'On a Raised Beach'

The kind of place
   where the way a traveller's tracks
disappear in snow
   is something you get used to –
such a place is this world of ours.

— Princess Shikishi (1149–1201)

Kilimanjaro is a snow-covered mountain
19,710 feet high, and is said to be the
highest mountain in Africa. Its western
summit is called the Masai 'Ngaje Ngai',
the House of God. Close to the western
summit there is the dried and frozen carcass
of a leopard. No one has explained what
the leopard was seeking at that altitude.

— Ernest Hemingway, 'The Snows of Kilimanjaro', 1936

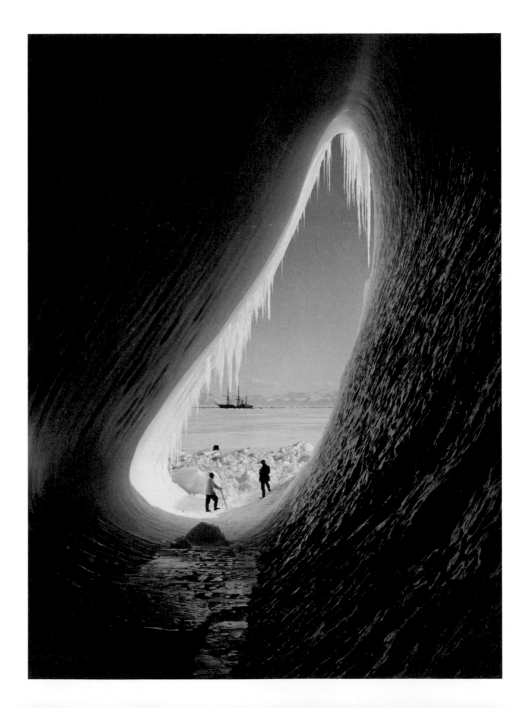

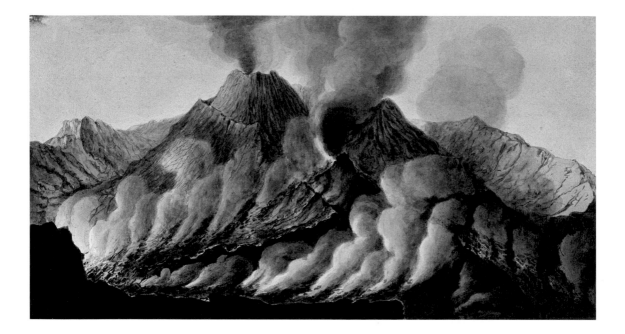

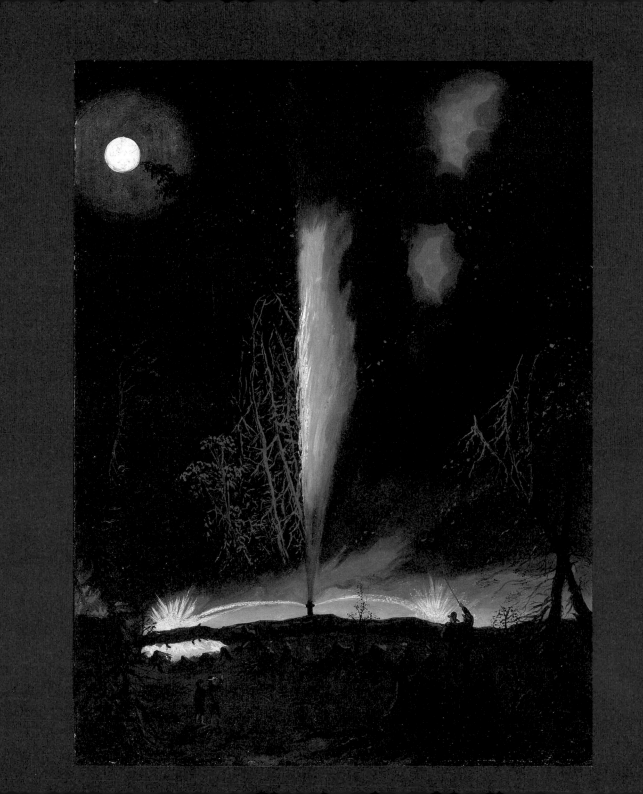

61 Chemistry: Various Crystalline Substances, unknown artist, coloured engraving, date unknown

62 Bladder and Kidney Stones by Max Brödel (1870–1941), watercolour illustration from *Diseases of the Kidneys, Ureters and Bladder* by Howard A. Kelly and Curtis F. Burnam, published in two volumes, 1914

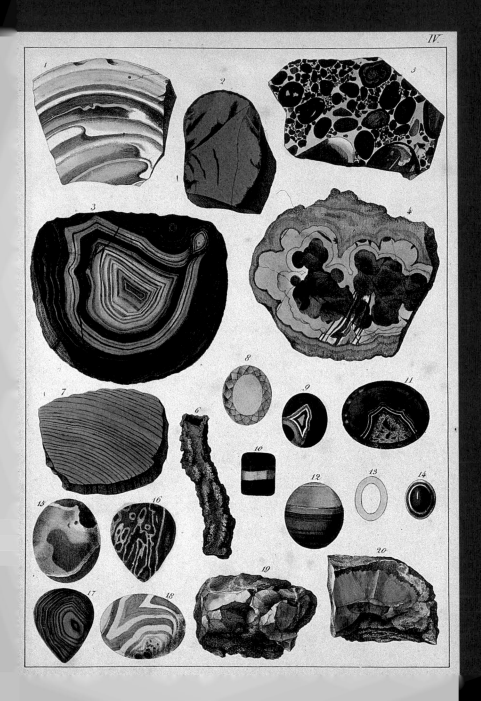

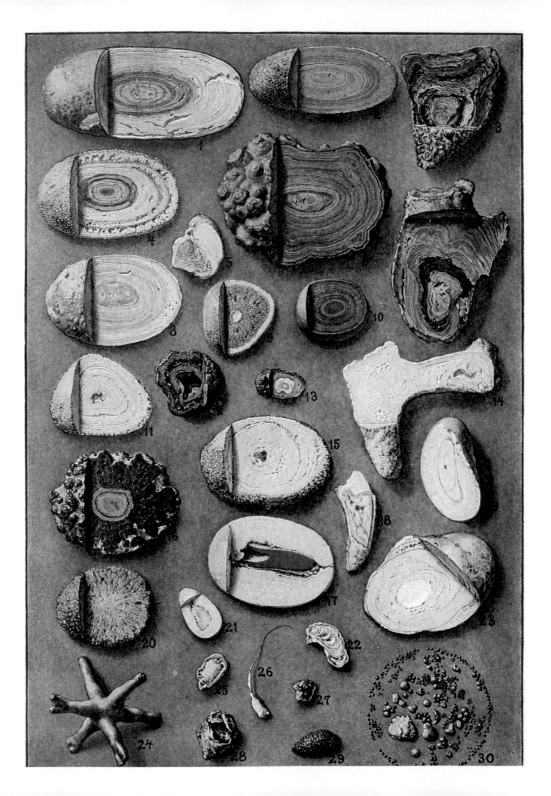

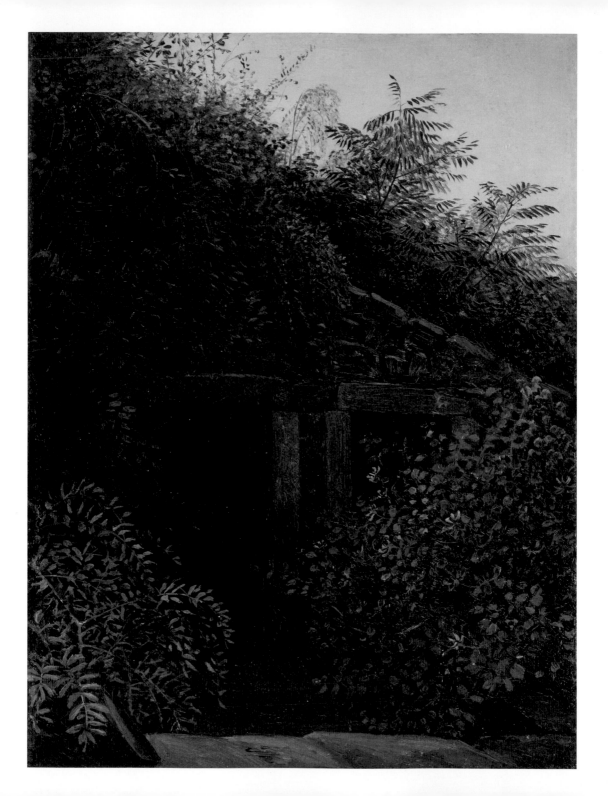

← **63** *An Overgrown Mineshaft* by Carl Gustav Carus (German, 1789–1869), oil on paper, laid down on cardboard, *c.* 1824

↓ **64** View of Toledo by El Greco (Doménikos Theotókopoulos, Greek, 1541–1614), oil on canvas, Spain, *c.* 1599–1600

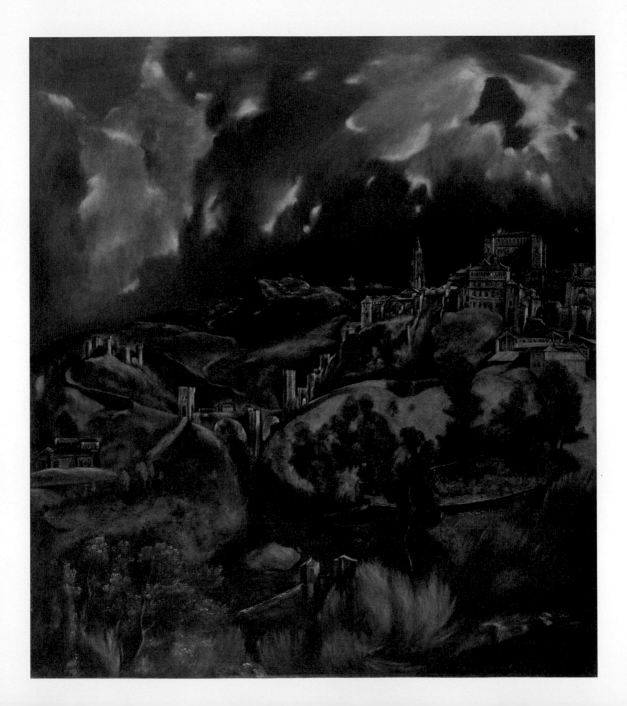

If there were as great a scarcity of soil as of jewels or precious metals, there would not be a prince who would not spend a bushel of diamonds and rubies and a cartload of gold just to have enough earth to plant a jasmine in a little pot, or to sow an orange seed and watch it sprout, grow, and produce its handsome leaves, its fragrant flowers, and fine fruit.

— Galileo Galilei, *Dialogue Concerning the Two Chief World Systems: Ptolemaic and Copernican*, 1632

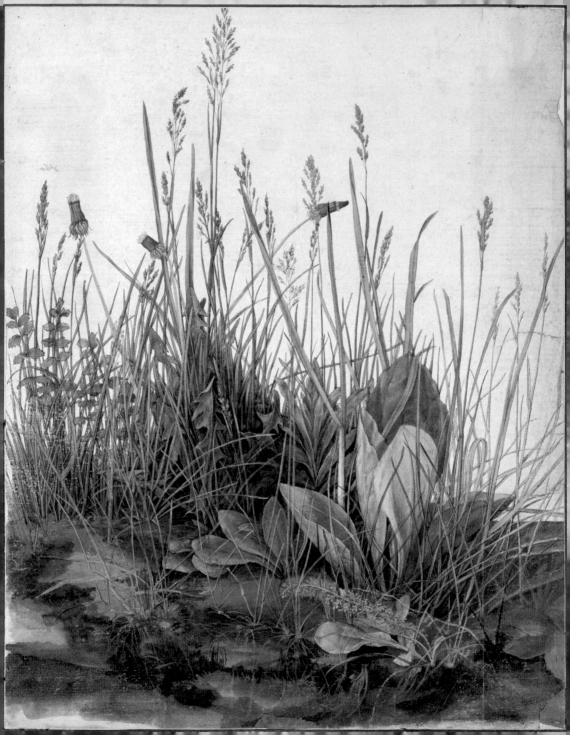

# THE VEGETABLE

# KINGDOM

TREES PLAY A CENTRAL role in Jewish mystical tradition and folklore – it is said that God planted the Tree of Life at the central point of paradise, protected by the most powerful of all guardian angels and nourished by the four winds. Every soul that has ever existed was once a blossom on the Tree of Life. Newborn souls bloom and ripen then fall from the tree into the treasury of souls where they are stored until angels summon them forth to assume their human form.

The late medieval mystic and scholar Rabbi Isaac Luria believed that trees were resting places for lost souls who had failed to repent during their lifetime and were thus unable to enter heaven. When the trees were in bloom during the early spring, the rabbi would perform certain rituals and seek to rescue the lost souls by guiding them towards the correct pathway to paradise.

Other distinguished scholars have reached the conclusion that trees themselves possessed souls. During his frequent travels, the eighteenth-century founder of the Breslov Hasidic movement, Rabbi Nachman, once spent the night in an inn in the remote Ukrainian countryside. In the middle of the night he was tormented by the most terrifying dreams and cried out in his sleep. When the innkeeper managed to wake the rabbi he immediately reached for the book he had placed on the nightstand, closed his eyes again and pointed to a passage which read: 'Cutting down a tree before its time is as grave a sin as killing a soul.'

Then, turning to the innkeeper, Rabbi Nachman asked if the inn had been built out of young trees cut down before their time. The bewildered innkeeper replied that, yes, this was indeed the case but what earthly reason could the rabbi possibly have for mentioning this now? He replied, 'All night I have been tormented by dreams in which I was surrounded by piles of horribly mutilated bodies, the innocent victims of a brutal massacre. I now realise these dreams were the souls of the young trees crying out to me for justice.'

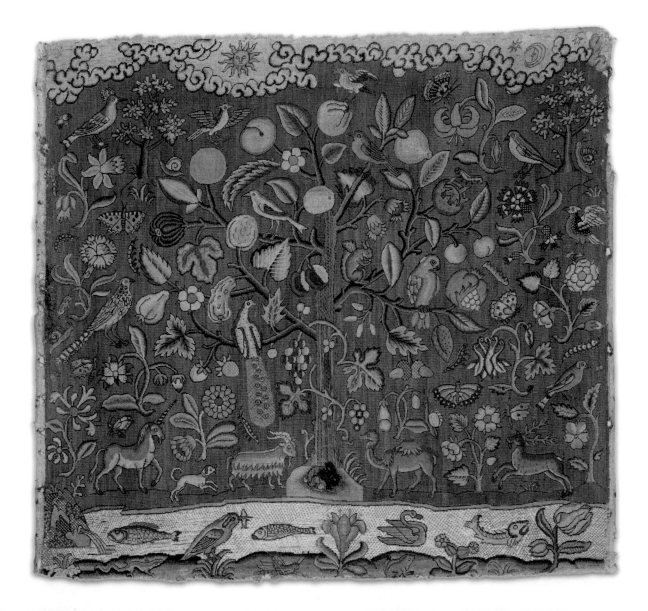

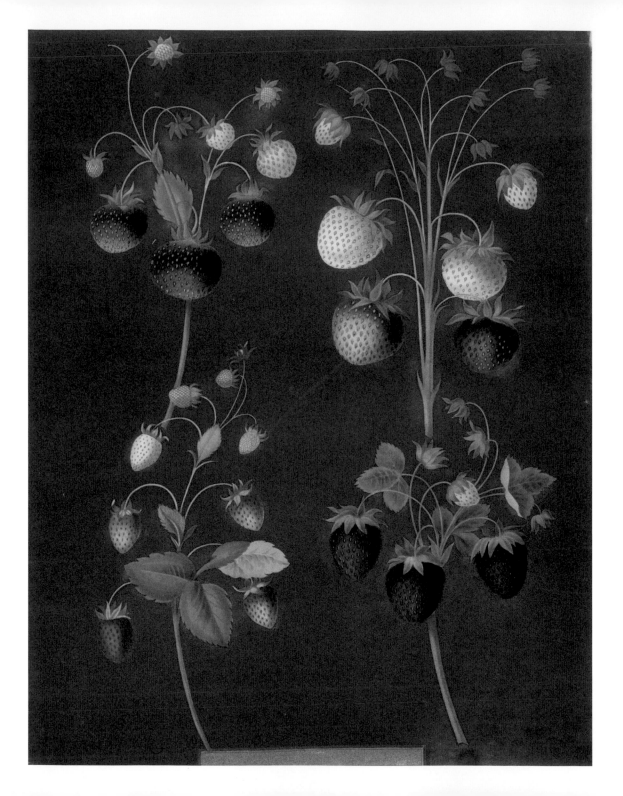

← **67** Strawberry Varieties: Hoboy – Chili strawberry – Scarlet-Alpine – Scarlet-flesh Pine from *Pomona Britannica* by George Brookshaw, hand-coloured aquatint engraving, London, 1812

↓ **68** Plate from *Lifelike Illustrations and Descriptions of Edible Mushrooms* by J. V. Krombholz (Northern Bohemia, today Czech Republic, 1782–1843), 1831

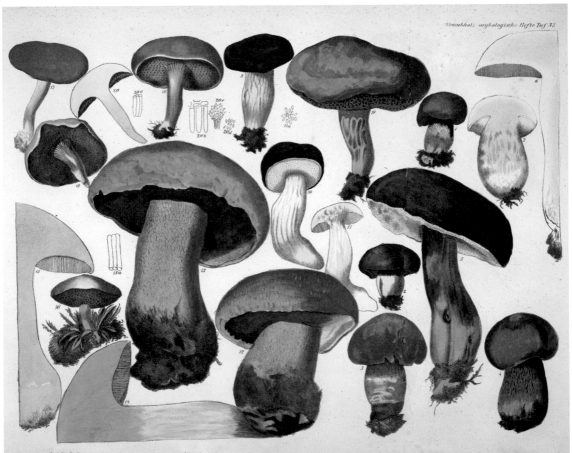

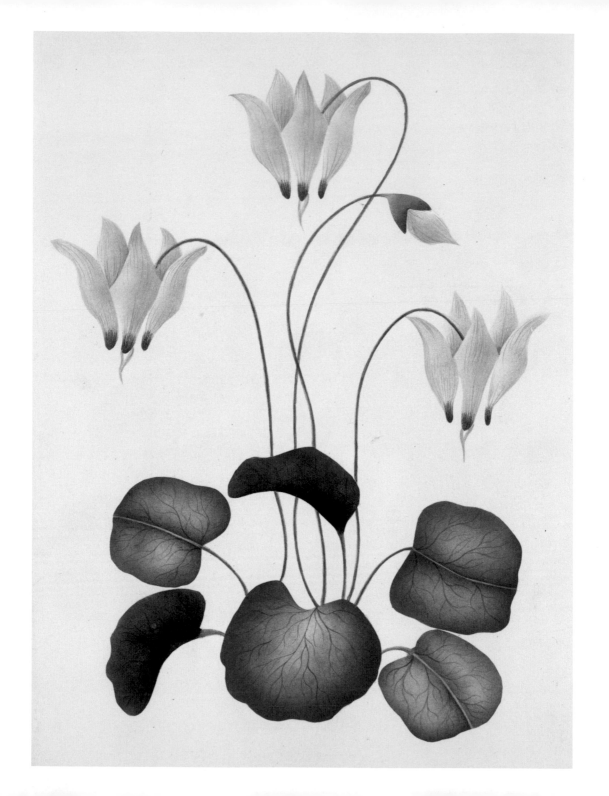

69 Flower with Three Blossoms, unknown British artist,
watercolour and gouache, between 1826–66

70 Plate from *The Anatomy of Plants* by Nehemiah
Grew, 1682
In the 82 illustrated plates included in this ground-breaking
work, English botanist Nehemiah Grew was the first to
depict the intricate inner structure and function of plants.

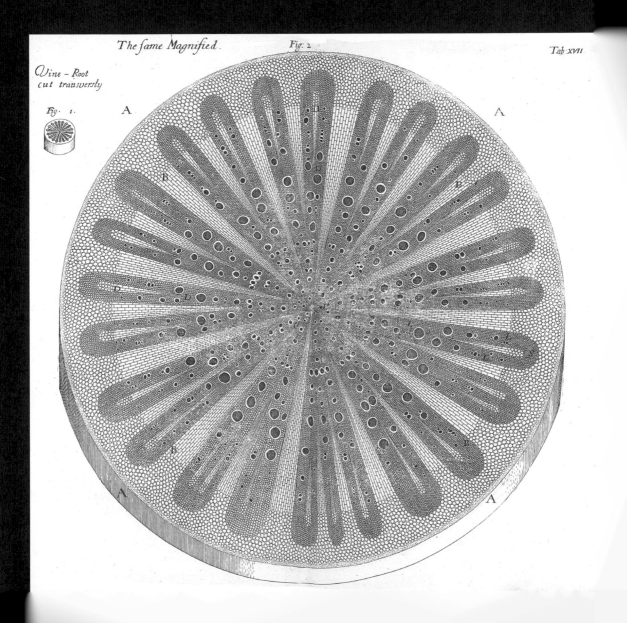

*The same Magnified.*      *Fig. 2.*      *Tab. XVII*

*Vine – Root*
*cut transversly*

*Fig. 1.*

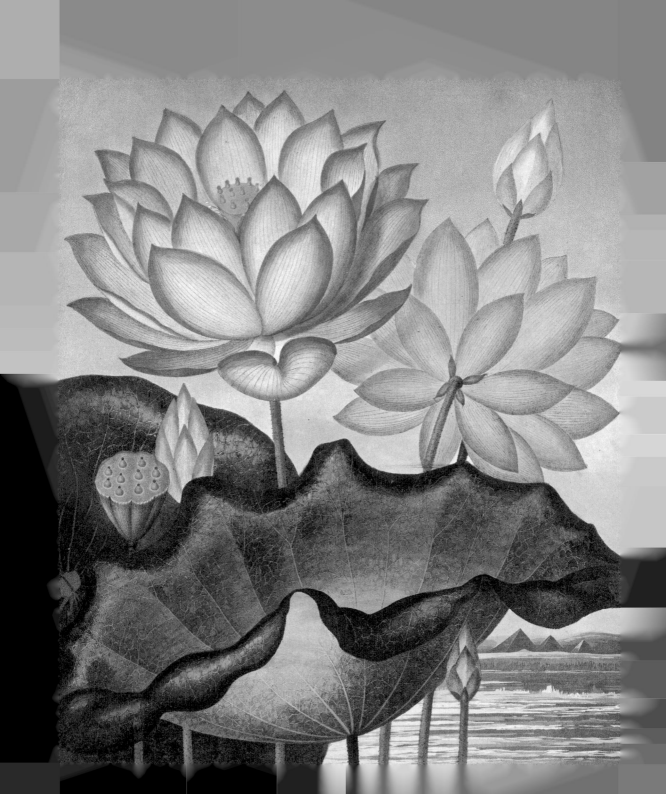

← **71** The Sacred Egyptian Bean engraved by Thomas Burke and Frederick Christian Lewis, after the painting by Peter Charles Henderson. Plate 30 from *Temple of Flora, or The Garden of The Botanist, Poet, Painter & Philosopher* by Robert John Thornton (*c.* 1768–1837), aquatint, mezzotint and stipple engraving with hand-colouring, England, 1812

↓ **72** Stigma and Pollen Tubes of *Lilium martagon*, (Martagon or Turk's cap lily) from the *The Dodel-Port Atlas* by Swiss-German botanist Dr Arnold Dodel-Port and his wife Carolina. The atlas consists of 42 botanical teaching charts published from 1878 to 1893

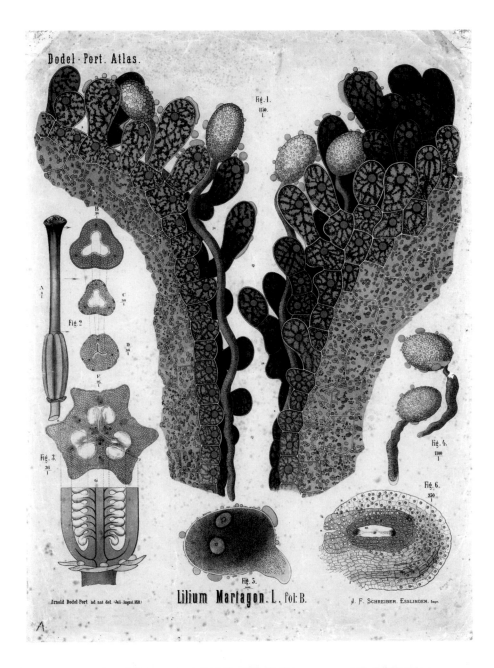

↓ **73** Phyllitis hemionitis from a sixteenth-century Italian edition of Pedanius Dioscorides's work on herbal medicine, *De Materia Medica* by Pietro Andrea Mattioli (1501–77), illustrations by Gherardo Cibo
Dioscorides (*c.* 40–90 CE), was a Greek physician and botanist, considered the founding father of pharmacology.

→ **74** *Cystoseira granulata* cyanotype from what is thought to be the first book of photographic illustrations, *Photographs of British Algae: Cyanotype Impressions* by Anna Atkins (English, 1799–1871), 1843

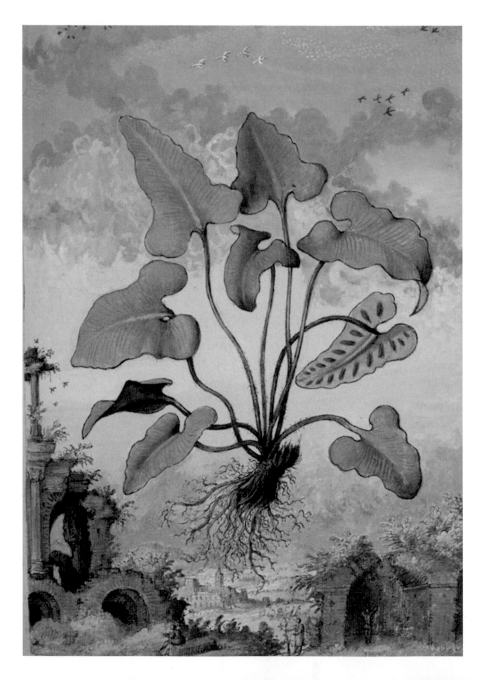

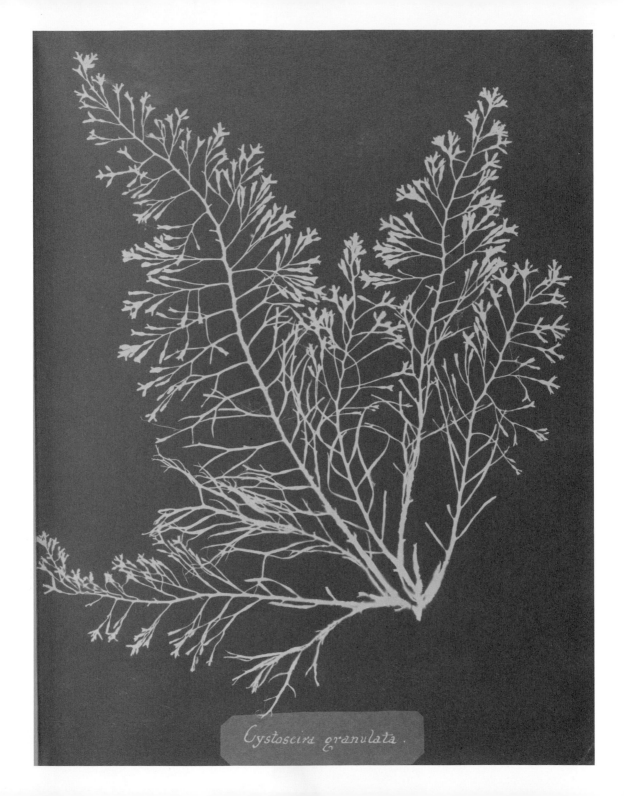

*Cystoseira granulata.*

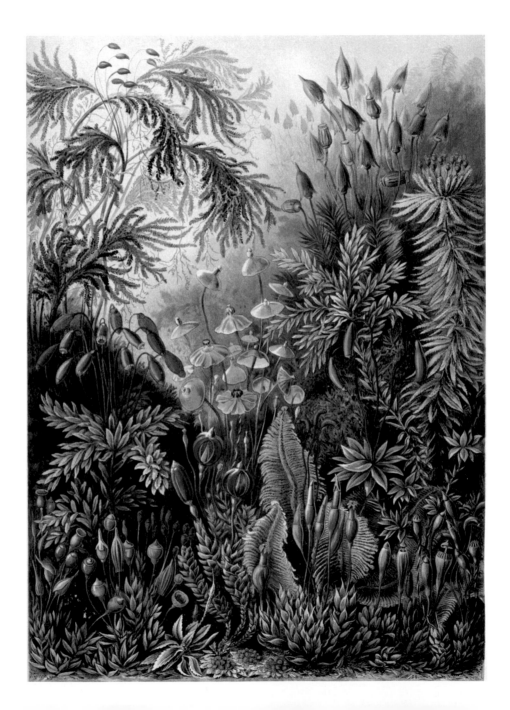

AD cœnam Agni prouidi et stolis albis Candidi: post transitum
maris rubri Christo canamus Principi. Cuius corpus
sanctissimum in Ara crucis torridum: cruore eius ro-
seo gustando niuimus deo. Protecti paschæ uespere ac deuastante
angelo: Erepti de durissimo Pharaonis Imperio. Iam pascha nostrū
Christus est, qui immolatus agnus est: sinceritatis azyma, caro eius
oblata est. O uere digna Hostia, per quam fracta sunt tartara: re
dempta plebs captiuata reddita uitæ præmia. Cum surgit Christus
tumulo, uictor redit de barathro: tyrannum trudens uinculo et re
serans paradisum. Quæsumus autor omnium in hoc paschali gau
dio: ab omni mortis impetu tuum defende populum. Gloria tibi reĉf.

← 77 Love-in-a-Mist, Sweet Cherry and Spanish Chestnut, a plate from *Mira Calligraphiae Monumenta* by Joris Hoefnagel (illustrator, Flemish/Hungarian) and Georg Bocskay (calligrapher, Croatian), 1561–62

↓ 78 Islamic Tile, fritware, underglaze painted, İznik, Turkey, *c.* 1580–90

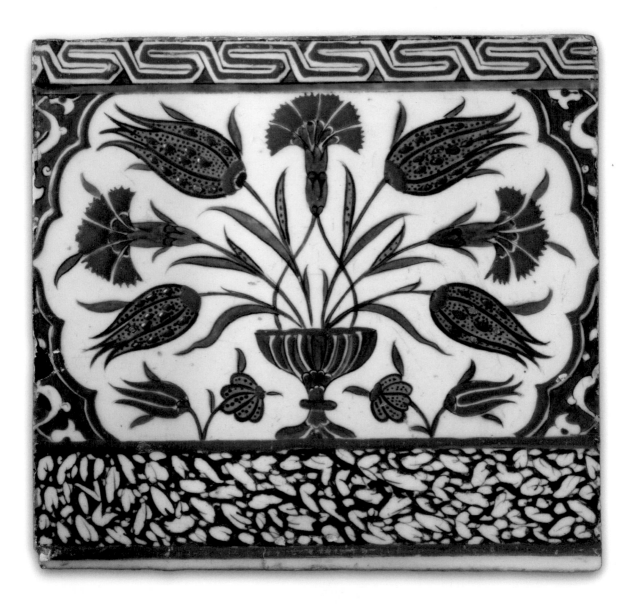

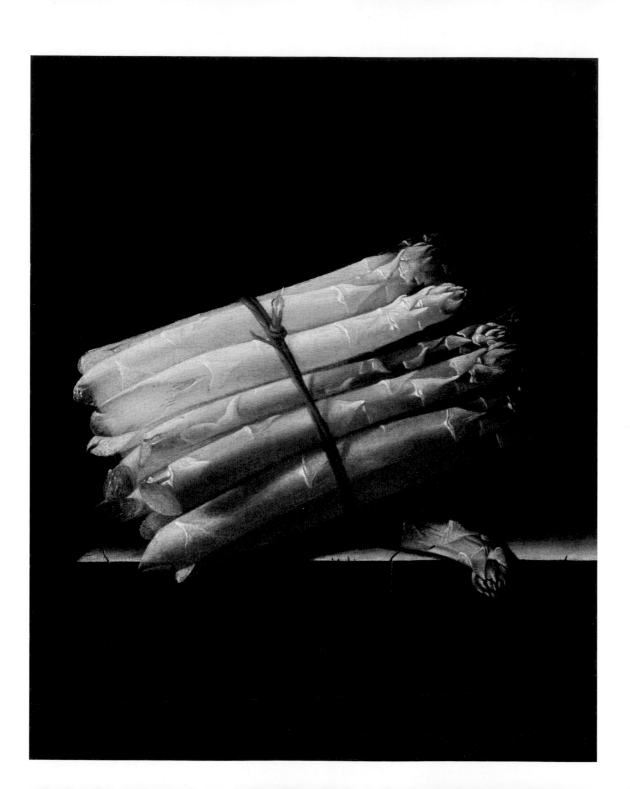

Beauteous the garden's umbrage mild,
Walk, water, meditated wild,
And all the bloomy beds.

— Christopher Smart, from 'A Song to David', 1763

You receive images and meanings which are arranged. I hope you will consider what I arrange, but be sceptical of it.

— John Berger, *Ways of Seeing*, 1972

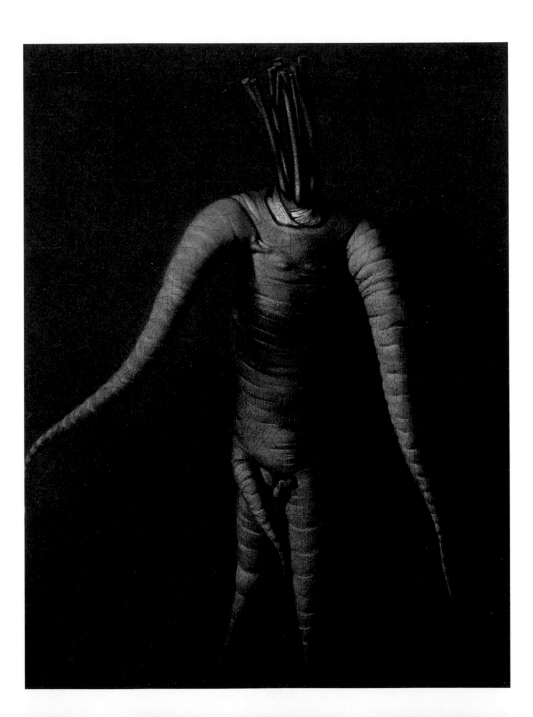

↓ **81** (a, b & c) Anthropomorphic herbs, plates from *Erbario*, a fifteenth-century illustrated herbal from northern Italy, author(s) unknown

→ **82** Miniature of plants, including a mandrake plant with a naked male body as the root, from a fifteenth-century version of the *Tractatus de Herbis*, a comprehensive visual encyclopaedia of medicinal plants and herbs for apothecaries and physicians. This edition was created in northern Italy (probably Lombardy) around 1440

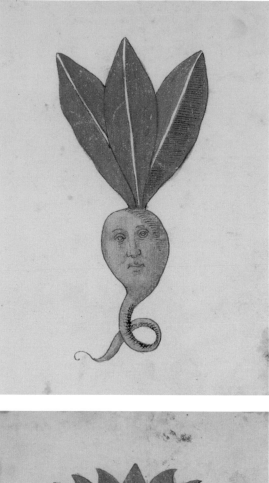

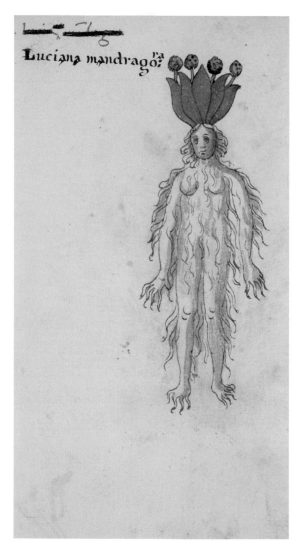

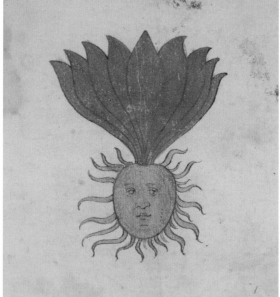

andragora . alio noie antini nõ noeit ei .
bolbaquinõ . a. carcemõ . a. abolorofa . a. andro
pomorcos . a. apolea . aut. die. tabrol . i. radic
mandragoie. filuestris ꝛ è ꝼmlis hõi. appꝛ hoc
noiaꞇ mandragora .

a Salua . alio noie
acopa. aut molo
chia . i. antonia uł
antoʒ. aut coluris.
aut diadema . a. laco rten.
a. uramoie. aut mal
ua rustica .

ZEA JAPONICA VARIEGATA.
XVIII

↓ 84 *Branches and Vines* quilt made by Ernestine
Eberhardt Zaumseil (1828–1904) in Pekin, Illinois, cotton,
silk and wool, *c.* 1875

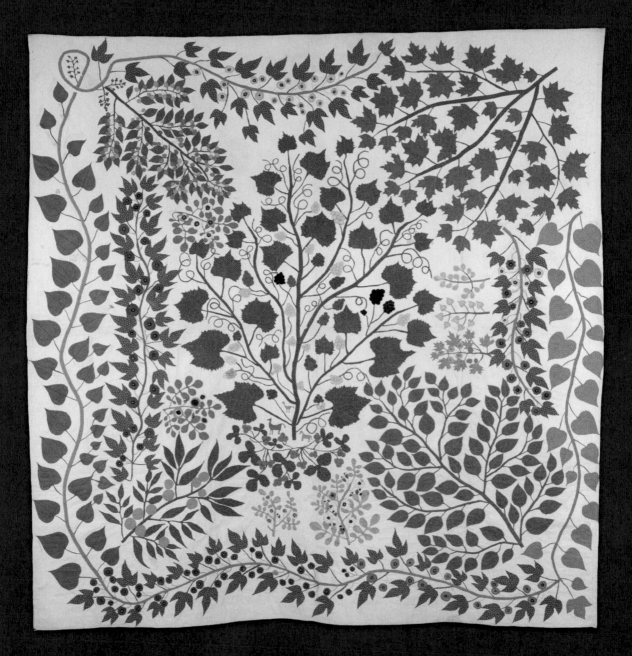

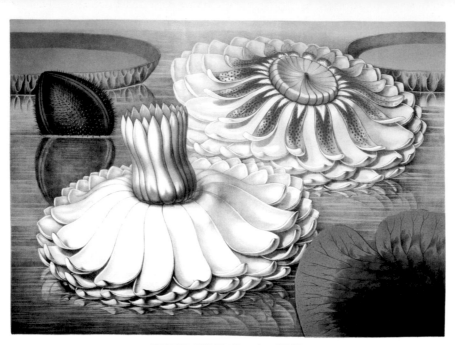

VICTORIA REGIA WATER LILY BY WILLIAM SHARP (1803–1875)

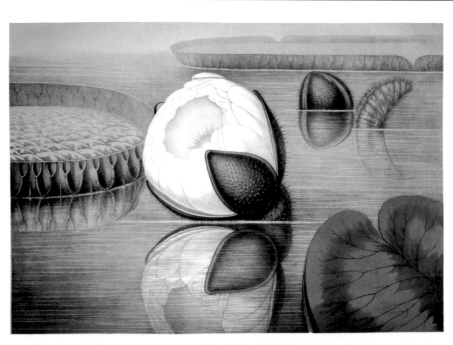

VICTORIA REGIA WATER LILY BY WILLIAM SHARP (1803–1875)

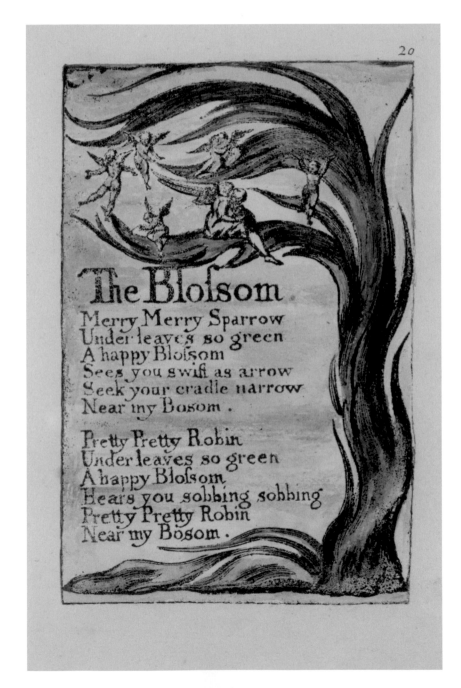

↓ **87** *Einzelne Tulpenblätter* (*Single Tulip Leaves*) by Maria Sibylla Merian (German, 1647–1717), watercolour and cover colours on parchment

→ **88** *Vase of Flowers* by Jan Davidsz de Heem (1606–84), oil on canvas, Netherlands, *c.* 1660

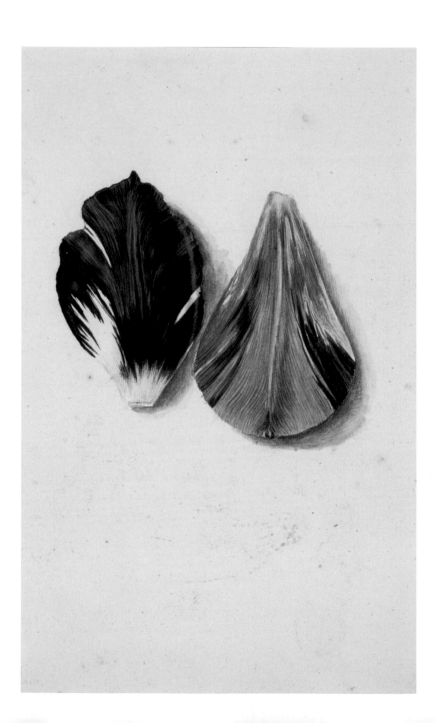

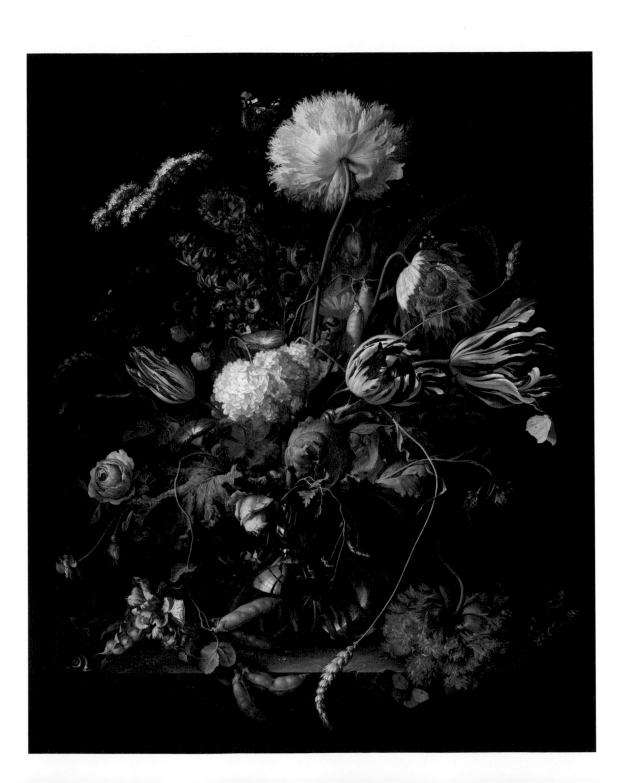

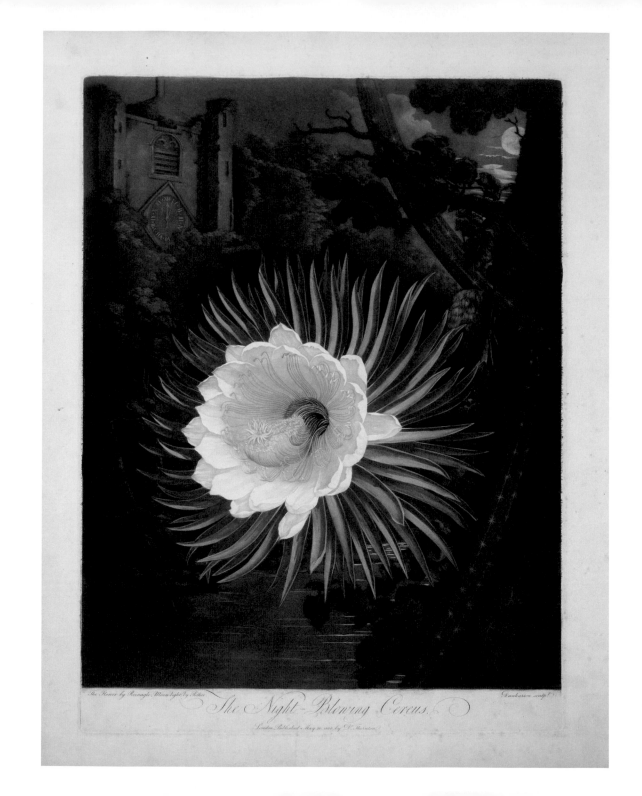

The Flower by Reinagle. Moonlight by Pether.

Dunkarton sculp.t

*The Night-Blowing Cereus.*

London Published May 10 1800 by Dr Thornton

← **89** The Night-Blooming Cereus, an engraving by Robert Dunkarton and Abraham Pether, after a painting by Philip Reinagle, from *Temple of Flora, or The Garden of The Botanist, Poet, Painter & Philosopher* by Robert John Thornton (*c.* 1768–1837), aquatint, mezzotint and stipple engraving with hand-colouring and touches of gum Arabic, England, 1812

↓ **90** *Untitled* (*Wild Fennel*) by William Henry Fox Talbot (English, 1800–77), salted paper print, 1841–42
A photographic trace of a botanical specimen laid on a sheet of chemically sensitised paper and set in the sun. The paper darkened wherever the light struck but the plant specimen blocked the sun's rays leaving a ghostly white image of where the plant lay.

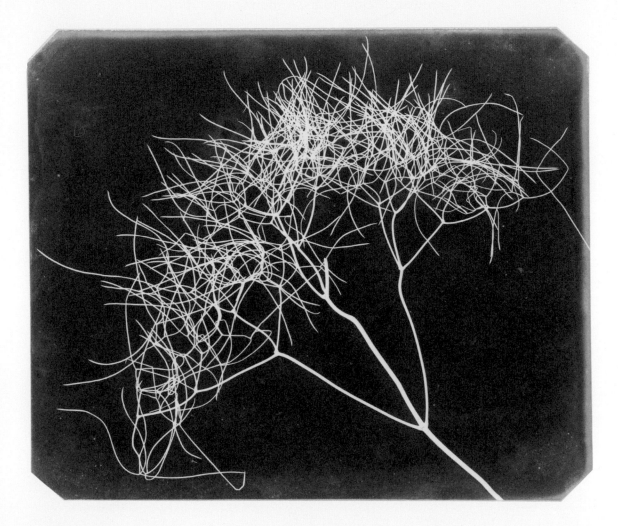

People from a planet without flowers
would think we must be mad with joy
the whole time to have such things about us.

— Iris Murdoch, *A Fairly Honourable Defeat*, 1970

O how I feel, just as I pluck the flower
And stick it to my breast – words can't reveal;
But there are souls that in this lovely hour
Know all I mean, and feel whate'er I feel.

— John Clare (1793–1864), from 'Nature'

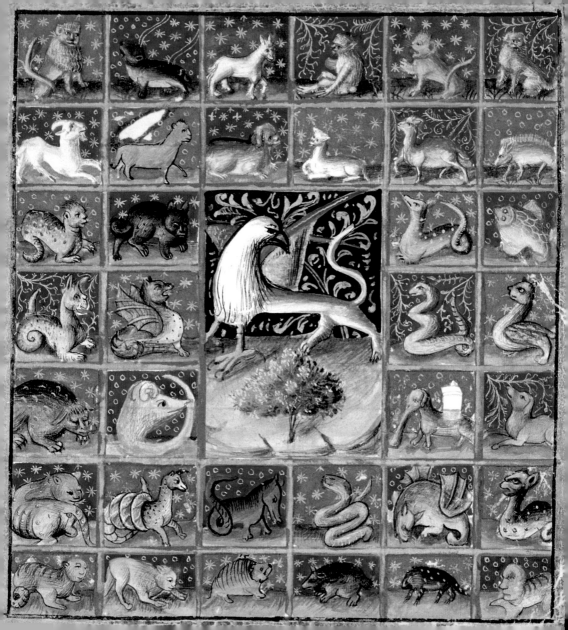

# THE ANIMAL

# KINGDOM

←← 91 The Properties of Beasts from fifteenth-century French edition of *Le livre des propriétés des choses de Barthélémy l'Anglais* (*On the Properties of Things by Bartholomew the Englishman*), an early attempt at creating an encyclopaedia of all known things, translated and edited by Jean Corbechon

→ 92 Noah's Ark, from *Commentaria in Apocalypsin* (*Commentary on the Apocalypse*) by Beatus of Liébana, created in Spain or France, twelfth century

THE SAN PEOPLE of southern Africa believe that they did not always live on the surface of the earth. Long ago, people and animals lived at peace beneath the ground alongside Kaang, the shape-shifting creator of the world. It was a subterranean paradise, where the people and animals spoke a common language and wanted for nothing.

However, Kaang decided to leave and explore the wider world above. Once he had arranged the moon, the sun and the stars in the sky, he set about sowing the barren land with plants, trees and vegetation. His creation complete, he called down to the underground kingdom for all the humans and animals to join him.

Kaang gathered all the people and animals together and told them this new world had been created for their benefit and its fruits were theirs to share, with one exception. He warned the people that they were to avoid fire at all costs and to never attempt to harness its power. If they disobeyed, the consequences would be catastrophic. The people made a solemn vow to never use the power of fire, and Kaang retreated to a secret vantage point high among the stars of heaven.

As the sun began to sink, the new world was gradually enveloped in darkness and the people began to panic. They could no longer see one another and their bodies grew cold. The animals, however, had been blessed with eyes that could see in the dark and bodies that were covered in fur, and so the darkness held no fear for them. As the night wore on, the people became increasingly desperate, shivering, stumbling and clinging together for warmth in the unfamiliar gloom. And so, forgetting their promise, the people set to work building a fire.

Once the fire was lit, the light returned, the people grew warm again and regained the power of sight. But terrified by the fire, the animals had fled, scattering across the earth, seeking refuge in the forests, among the mountains, in remote caves and up among the branches of the trees.

As soon as the people broke Kaang's commandment, the common language they shared with the animals vanished forever. The bond of trust between animals and people was broken, their friendship sacrificed, replaced by fear, suspicion and mutual incomprehension.

It is said that one day the common language will be heard again but whether it will be heard in this world, the old world below or in another world, as yet unknown, nobody knows.

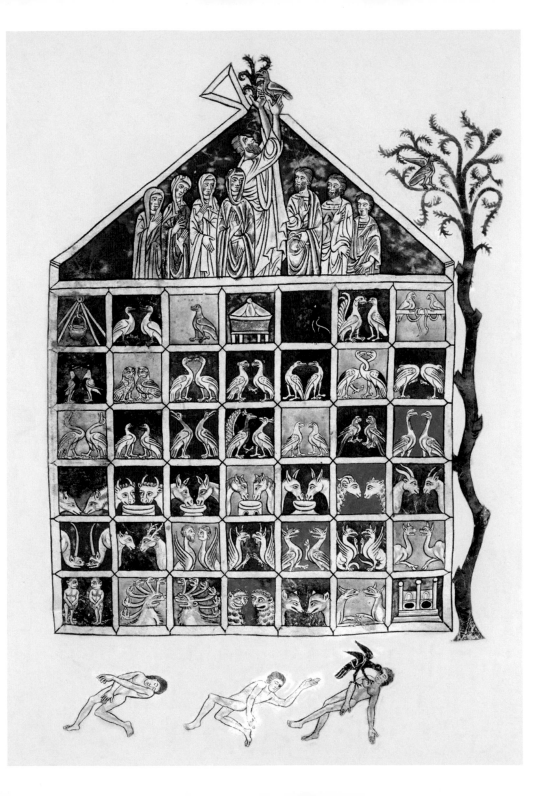

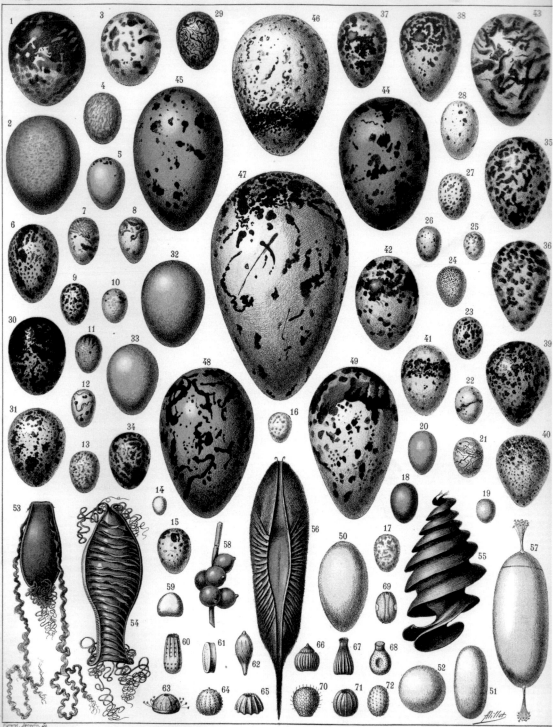

← 93 Oeufs (Eggs), illustration by Adolphe Millot (1857–1921) from *Nouveau Larousse Illustré*, published by Éditions Larousse, in seven volumes and a supplement, between 1897 and 1904

↓ 94 De Apibus (Of Bees), 'Bees make honey and skilful hives' from the *Aberdeen Bestiary* (*Liber de bestiarum natura*), created in England during the twelfth or early thirteenth century

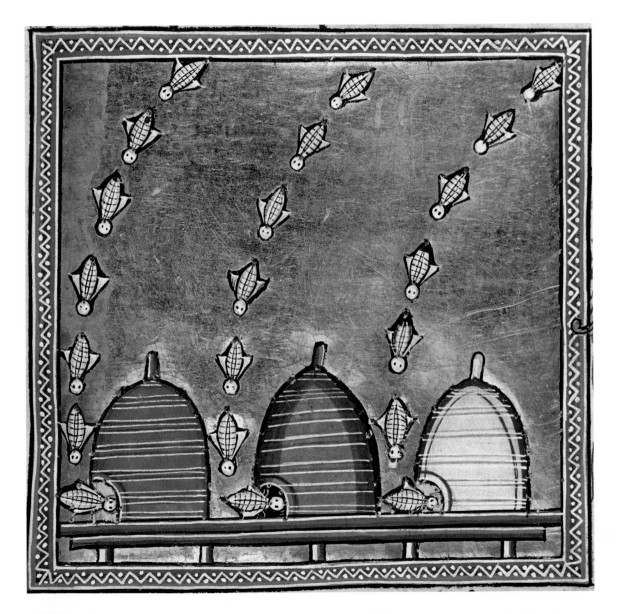

↓ 95 *Ono no Tōfū as a Frog* (*Kaeru ni kakete Ono no Tōfū*), silver, bronze and gilt disk, ivory bowl, kagamibuta (netsuke in the form of a mirrored lid), Japan, second half of the nineteenth century

→ 96 Stag Beetle by Albrecht Dürer, watercolour and gouache, 1505
The upper left corner of paper was added later, with the tip of the left antenna painted in by a different hand.

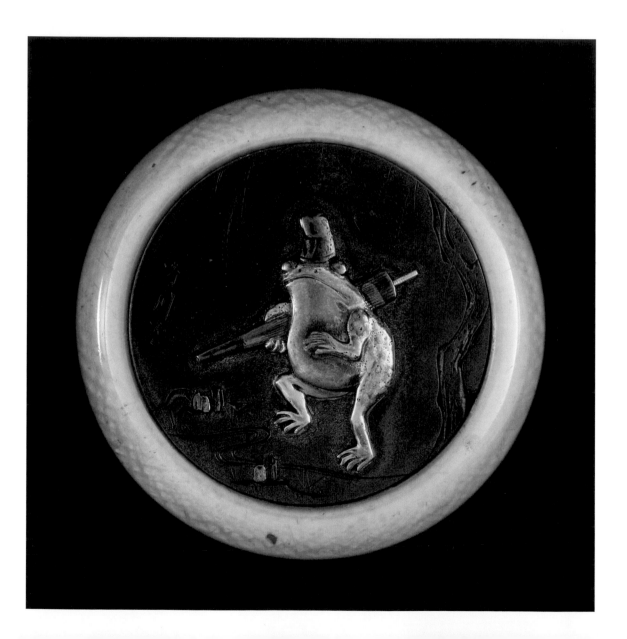

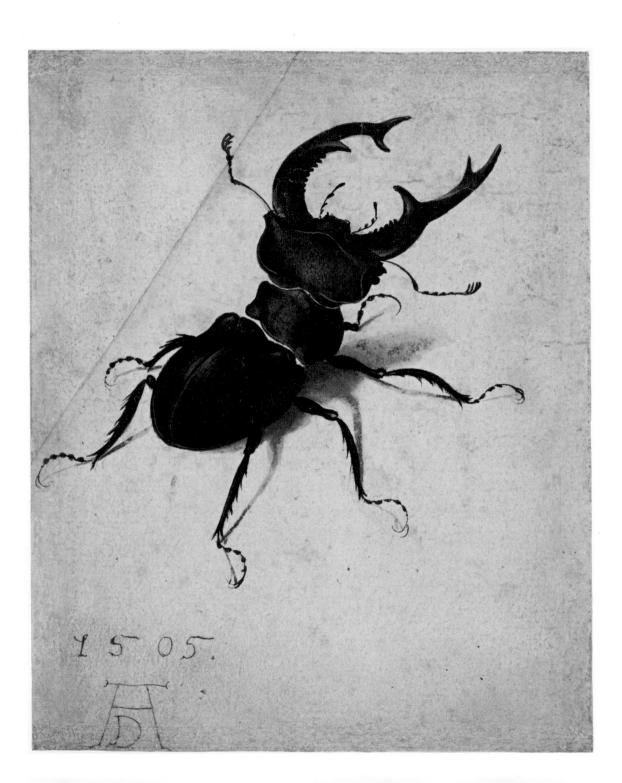

iudex districtus p perpetratis malis iram suam ad fe-
riendum pmouet. tunc omnis decor ille laudis
uelit fum euanescit.

S3 india nascitur bestia que manticora dicitur. tri-
plici dentium ordine coeunte vicib; alternis. facie
hominis. glaucas oculis. sanguineo colore. corpore
leonino. cauda velut scorpionis aculeo. spiculata
uoce tanquam sibila ut imittet modulos fistulax.
humanas carnes auidissime affectat. pedibus sic viget.
saltibus sic potest. ut mori eam nec extentissima spa-
cia possint cogere. nec obstacula latissima;

◂ 97 *Crocodile* from the *Rochester Bestiary*, probably
made at St Andrew's Priory, Rochester Cathedral, England,
c. 1230–40

↓ 98 *Chameleon* by Ustad Mansur (active c. 1600–20),
brush and ink with green body colour on discoloured
paper, Mughal India, 1612
As the leading animal painter at the court of Mughal
Emperor Jahangir, Ustad Mansur was given the honorific
title Nãdir-al-'Asr (Wonder of the Epoch).

↓ 99 Surinam Caiman Biting South American False Coral Snake, engraving from *Metamorphosis insectorum Surinamensium* (*Insects of Suriname*) by Maria Sibylla Merian (1647–1717), 1705

→ 100 Snake from *Thesaurus*, Vol. 2. by Dutch pharmacist, zoologist and collector Albertus Seba (1665–1736), 1735

TAB. LXXXI.

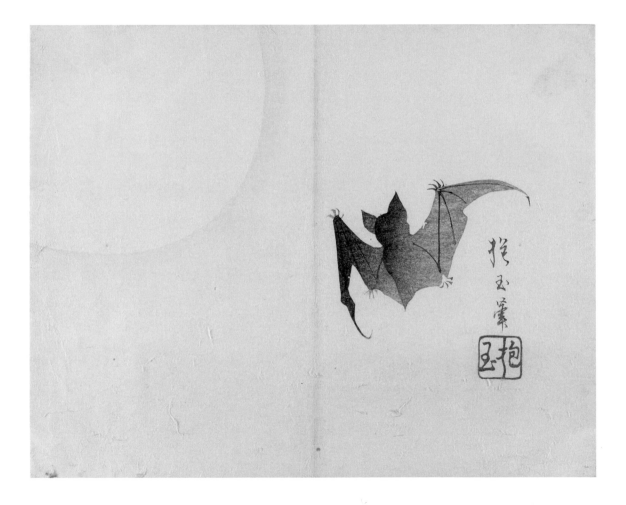

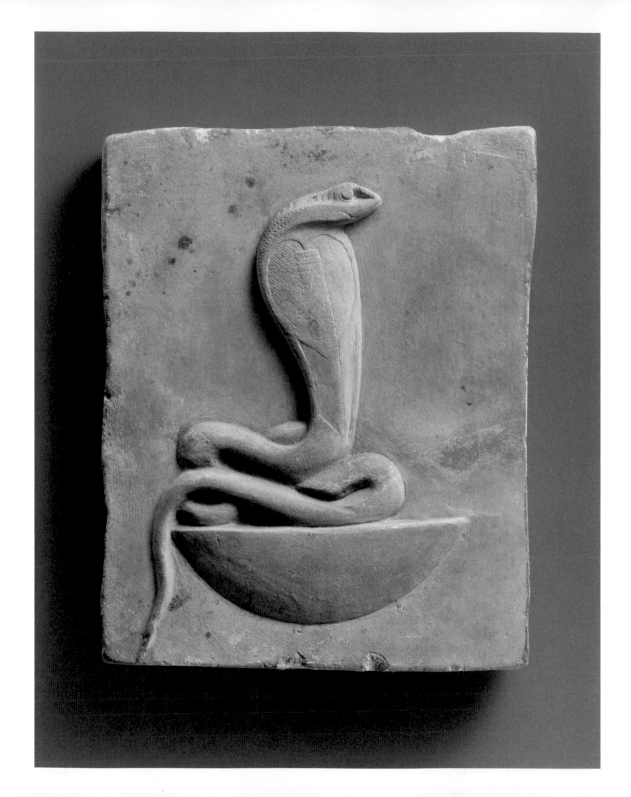

← 103 Relief Plaque of a Cobra on a Neb Basket,
unknown artist, Egypt, 400–30 BCE

↓ 104 Tile with two rabbits, two snakes and a tortoise,
illustration for thirteenth-century *Marvels of Things
Created and Miraculous Aspects of Things Existing* by
Zakariya al-Qazwini, earthenware, moulded and under-
glaze-painted decoration, Iran, nineteenth century

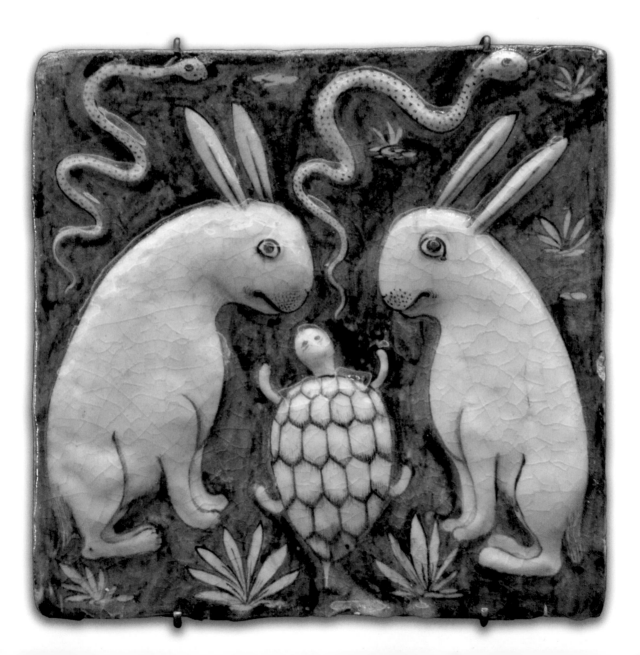

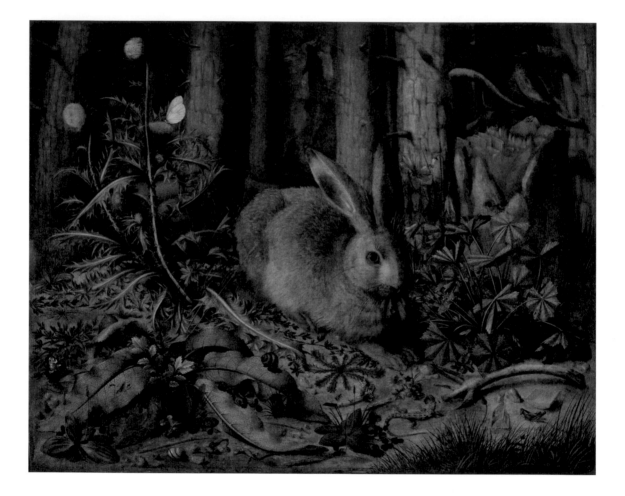

We
cannot fathom
the marvellous
complexity of an organic
being [...] Each living creature
must be looked at as a
microcosm – a little universe,
formed of a host of self-
propagating organisms,
inconceivably minute and
as numerous as the
stars in heaven.

— Charles Darwin, *The Variation in Animals and Plants under Domestication*, 1868

In nature nothing exists alone.

— Rachel Carson, *Silent Spring*, 1962

We need another and a wiser and perhaps a more mystical concept of animals. […] We patronise them for their incompleteness, for their tragic fate of having taken form so far below ourselves. And therein we err, and greatly err. For the animal shall not be measured by man. In a world older and more complete than ours, they move finished and complete, gifted with the extension of the senses we have lost or never attained, living by voices we shall never hear.

— Henry Beston, *The Outermost House: A Year of Life on the Great Beach of Cape Cod*, 1928

O friend, take care to do no harm to any living creature; to hurt his creation is to forget the Creator.

— Khwaja Abdullah Ansari (Persian Sufi Saint) (1006–88)

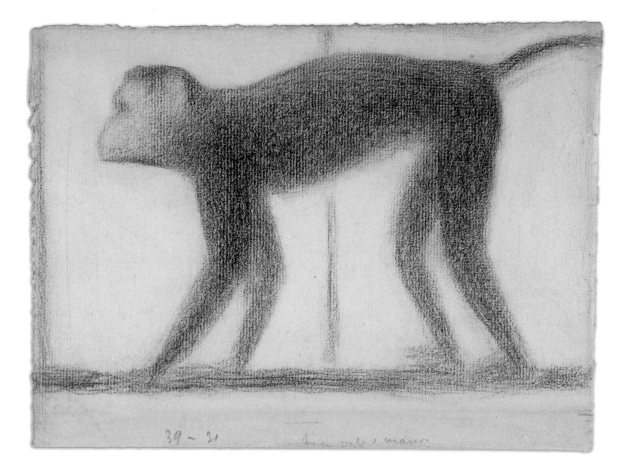

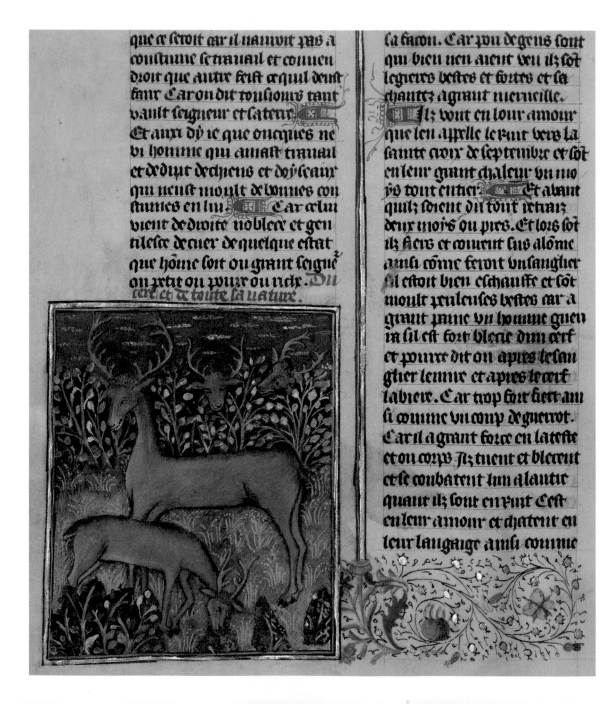

107 Deer, unknown artist, from *Livre de la chasse*, tempera colours, gold paint, silver paint and gold leaf on parchment, Brittany, France, *c.* 1430–40

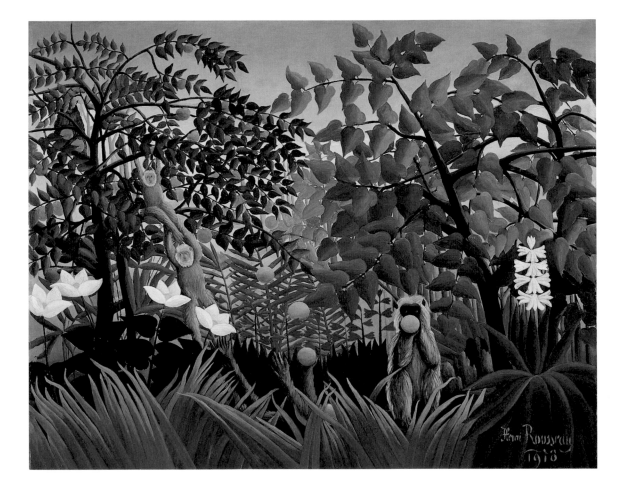

↓ **109** He-Goats, unknown artist, from *Livre de la chasse*, tempera colours, gold paint, silver paint and gold leaf on parchment, Brittany, France, *c.* 1430–40

→ **110** Composite camel with attendant, opaque watercolour and ink on paper, illustrated single sheet from a codex, attributed to Iran, Khurasan, third quarter sixteenth century

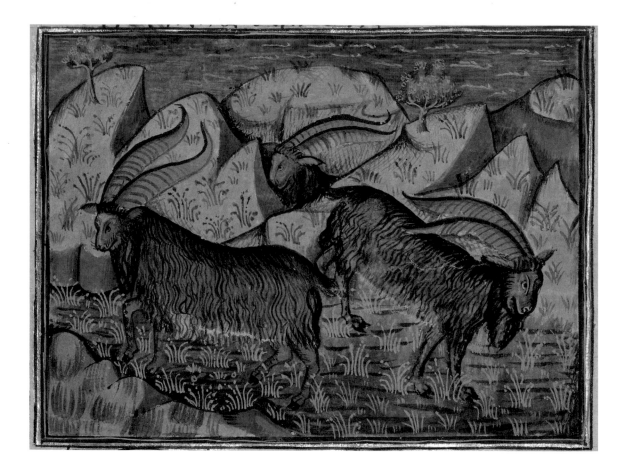

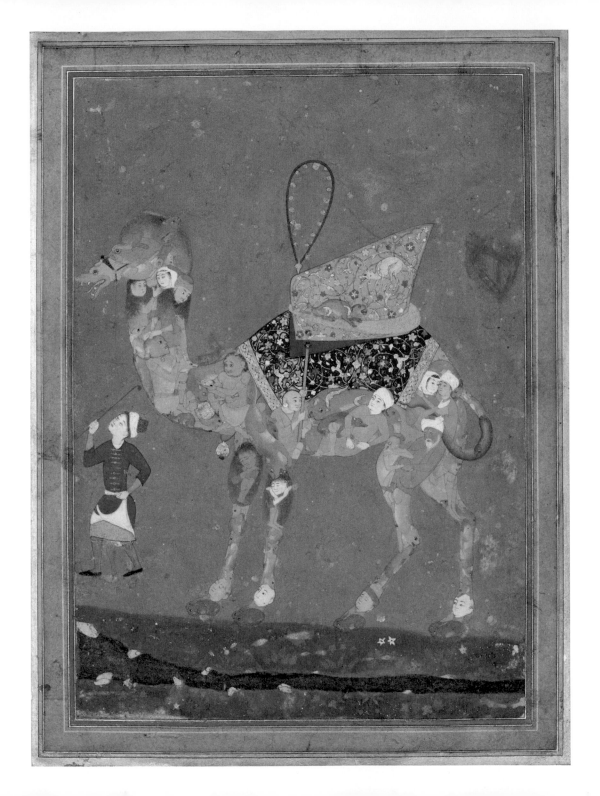

↓ III  Panel with striding lion, ceramic, Neo-Babylonian,
Mesopotamia, Babylon (Hillah, modern-day Iraq),
c. 604–562 BCE

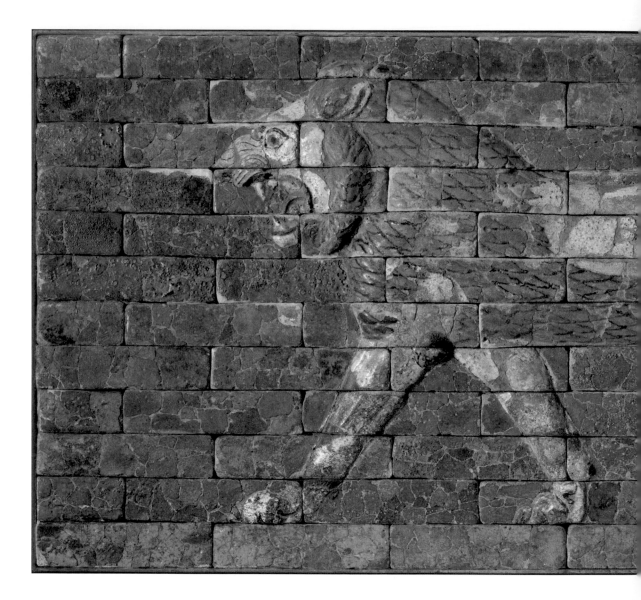

↓ **112** Three Horses, bronze plaque, Western Inner Mongolia or Northern China, fifth to fourth century BCE

→ **113** A circle of elephants depicting the attack on the city of Mecca by Abraha, the Abyssinian, Christian ruler of Yemen, who sought to capture the city and destroy the Ka'bah. According to tradition, this attack took place in 570 CE, the year of the Prophet Muhammad's birth. Leaf from a seventeenth- or eighteenth-century manuscript copy of *Marvels of Things Created and Miraculous Aspects of Things Existing* by Abu Yahya Zakariya' ibn Muhammad al-Qazwini, originally compiled in Iran or Turkey, *c.* 1203–83

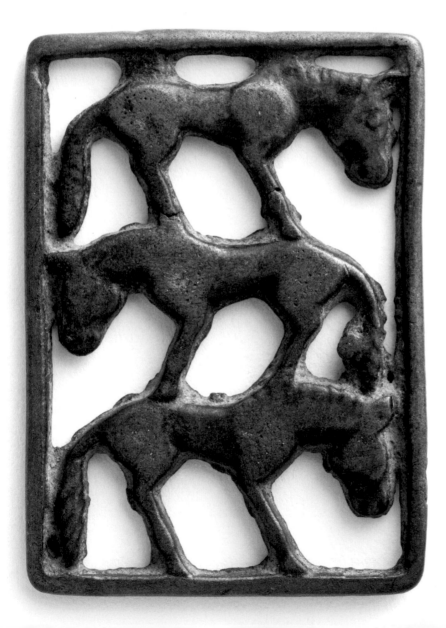

و الاول و ارباله ییمبه و اصدر امه جنع لابهالست و دن طایخورد نقدر لنعایک اذبحک ببرسفرد وخزاجنا بلایا صفا بهای بستاد

حرلک ببه برفین آنها اعذ اصفار از رزنگم دهلب کبا آبذ برسی فرشته همه هلالک نذدر قرآن خرداد برابرال علیه طرز ا بابهای
مبرهیم بحارسی سجال وفجیم کهف مالک دهورای کرده زبه زخ کبرست ددی دفشته ددبراحوال دخواص بغزا نجا مهامده لیکن ددباردت خذبه
ویمس مسح کومیل ادفت مقابله ددسردازی بیمر فو حرکا ابهای نسارهم نوبذسلک ادبنو

ربابل دانش حماره د فبهز بارسهاده حرفوماجه حرکوبذع بنترکالاق خوانذ ددحدیت سوی امدکوین لمری لصوف ذجبان مرکالاقسی
ذفتسه شبادبشیروی مذفی مبهول رابانفه بود ددکبردحوانی شذ خارت ددحاد کفته آبذبعمرکش ادروادلبذ بود درموزبعانی درکره حوبل

↓ 114 *Tiger and Lightning* by Kobayashi Kiyochika (1847–1915), colour woodblock print, Meiji period Japan, late nineteenth century

→ 115 *The Dog* (aka The Drowning Dog) by Francisco Goya (1746–1828), mixed method on mural transferred to canvas, 1820–23

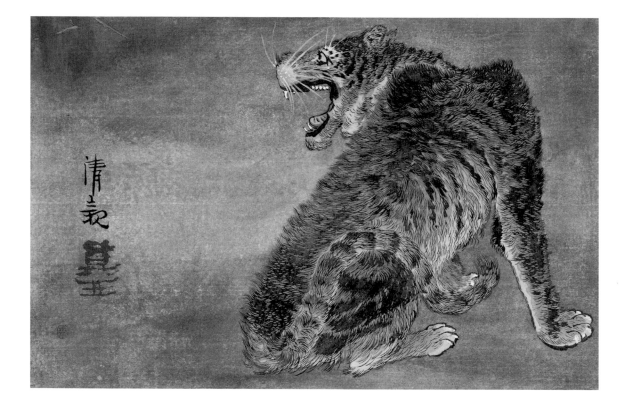

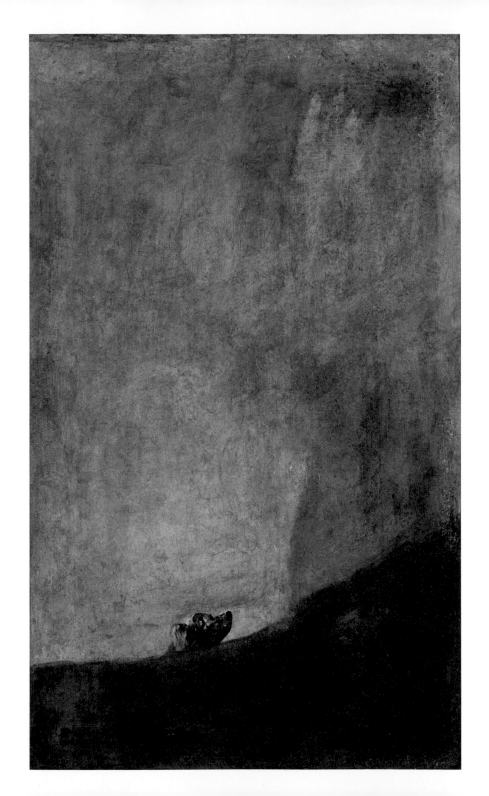

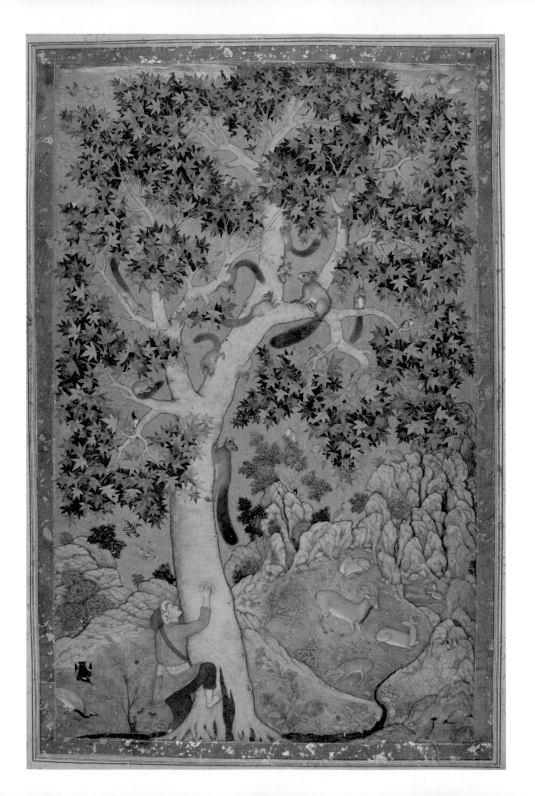

← 116 Squirrels in a Plane Tree with Hunter Attempting to Climb the Tree by Abu'l Hasan, Nadir al-Zaman (1588–*c.* 1635), gouache on paper, Delhi, Mughal India, 1605–08

↓ 117 Leopard Bearing Lion's Order to Fellow Judges, a plate from an eighteenth-century edition of *Kalila wa Dimna*, ink and opaque watercolour, Egypt or Syria

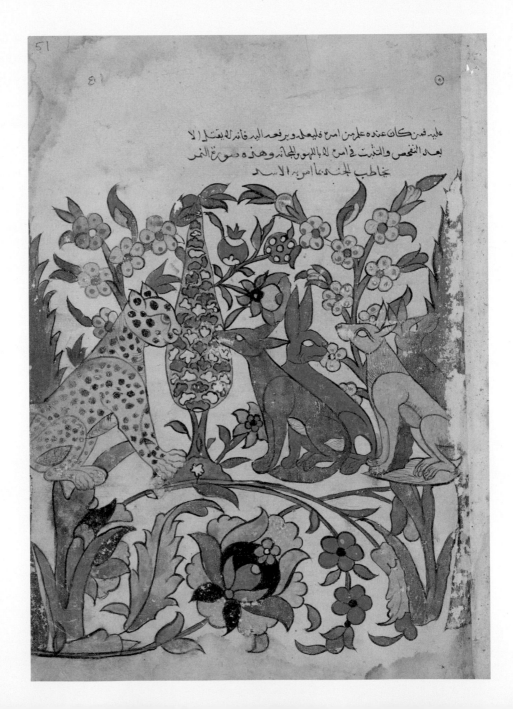

Love all God's creation, the whole and every grain of sand in it. Love every leaf, every ray of God's light. Love the animals, love the plants, love everything. If you love everything, you will perceive the divine mystery in things. Once you perceive it, you will begin to comprehend it better every day. And you will come at last to love the whole world with an all-embracing love.

— Fyodor Dostoevsky, *The Brothers Karamazov*, 1879–80

Continually
regard the World as
one living thing, composed
of one substance and one soul.
And reflect how all things have
relation to its one perception; how it
does all things by one impulse; how
all things are the joint causes of all
that come into being; and how
closely they are interwoven
and knit together.

— Marcus Aurelius Antoninus (121–180 CE), *Meditations, Book IV*

The "Anatomical Man" (or "Zodiacal Man") from the Très Riches Heures du Duc de Berry

# THE HUMAN

# REALM

←← 118 L'Homme anatomique, ou Homme zodiacal (Anatomical Man or Zodiacal Man) by the Limbourg Brothers, from *Les Très Riches Heures du duc de Berry*, tempera on vellum, 1411–16

→ 119 Rosette Bearing the Names and Titles of Shah Jahan, a folio from the *Shah Jahan Album*, ink, opaque watercolour and gold on paper, India, *c.* 1645

Muluku is the creator god of the Makua and Banayi people of Mozambique, but unlike many of his fellow all-powerful deities, Muluku had a definite sense of humour as shown in the tale of the first man and first woman.

In the beginning Muluku made two holes in the earth, the first man emerged from one hole, the first woman from the other. Muluku gave the man and woman land to cultivate, an axe, a pick, a pot, a plate and a handful of millet. He instructed them to work the ground and sow it with millet, and to construct a dwelling for themselves in which they could shelter, prepare and eat food.

However, instead of heeding Muluku's advice, the man and the woman decided that all this talk of 'cultivation' and 'construction' sounded far too exhausting and complicated and, besides, they were already incredibly hungry and who needs a plate anyway when you've got two hands complete with fully-functioning thumbs? As far as constructing a shelter was concerned, why bother going to all that effort when you are surrounded by trees which would surely provide ample protection from anything these so-called elements were likely to throw at you?

So it was that the man and the woman proceeded to scoff the millet raw, smashed the plate with the pick, relieved themselves in the pot and ran off into the forest feeling very pleased with themselves. Who, after all, needs the advice of self-appointed experts like Muluku?

Furious that he had been disobeyed, Muluku summoned a male monkey and a female monkey from the two holes in the earth and gave them identical tools and advice. The monkeys worked hard, dug the ground, planted millet, built a sturdy, spacious and well-appointed hut in which they cooked their food in the pot, serving it up on the plate.

Looking on from afar, Muluku was delighted. Speaking with the voice of thunder, he summoned the wretched man and woman from their hiding place among the trees. When they emerged Muluku grabbed the two monkeys, cut off their tails and fastened them to the backsides of the now terrified man and woman, saying to the monkeys: 'Be men!' And to the humans: 'Be monkeys!'

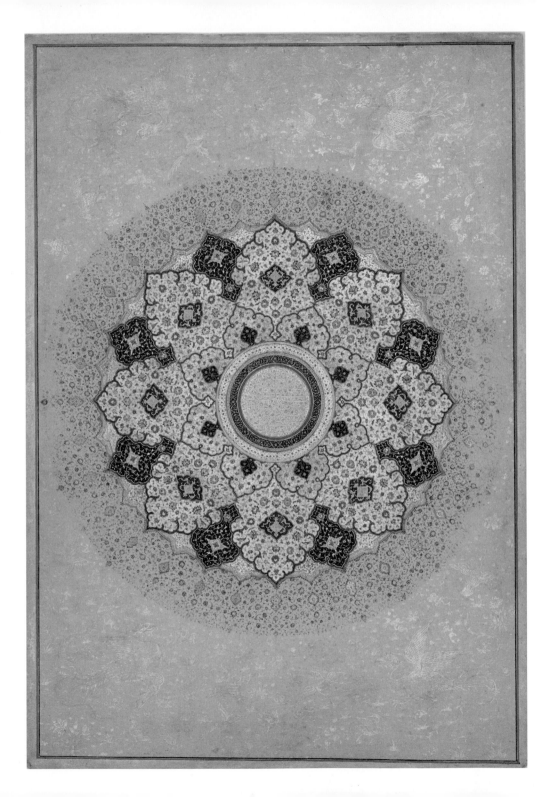

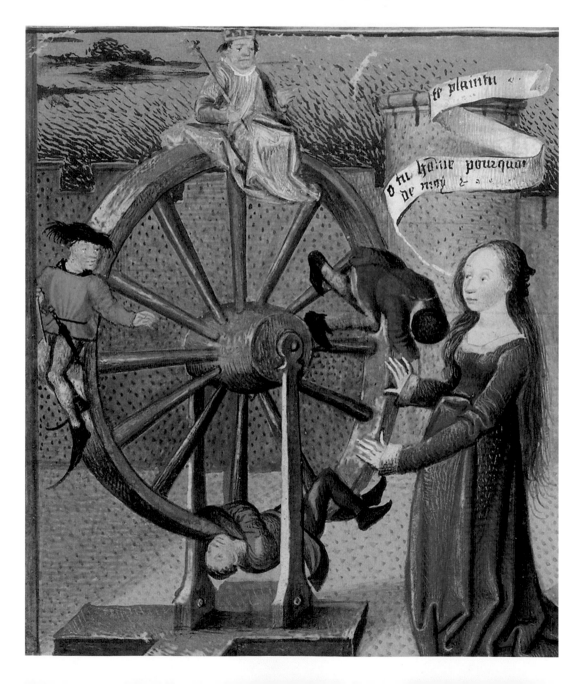

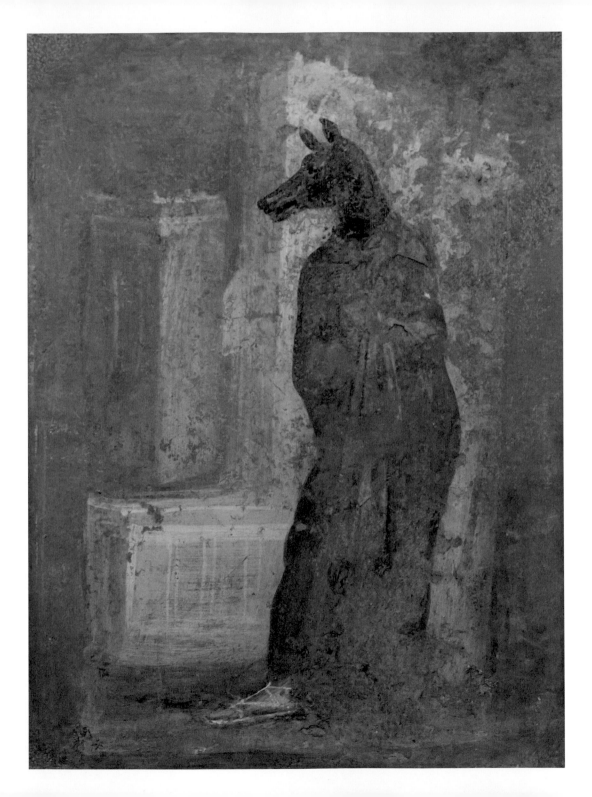

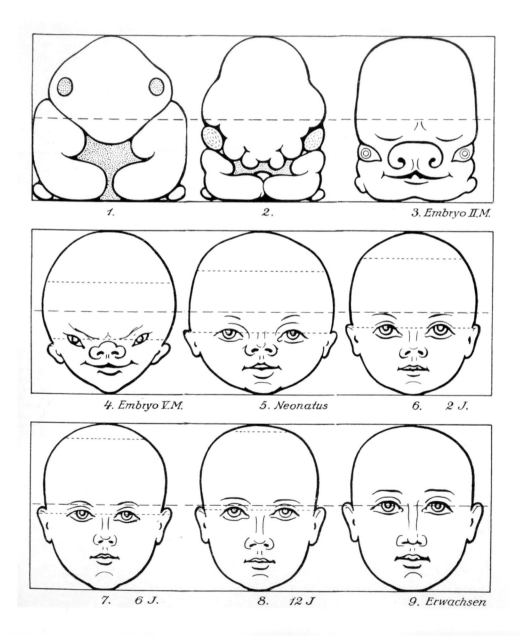

1.

2.

3. Embryo II.M.

4. Embryo V.M.

5. Neonatus

6. 2 J.

7. 6 J.

8. 12 J

9. Erwachsen

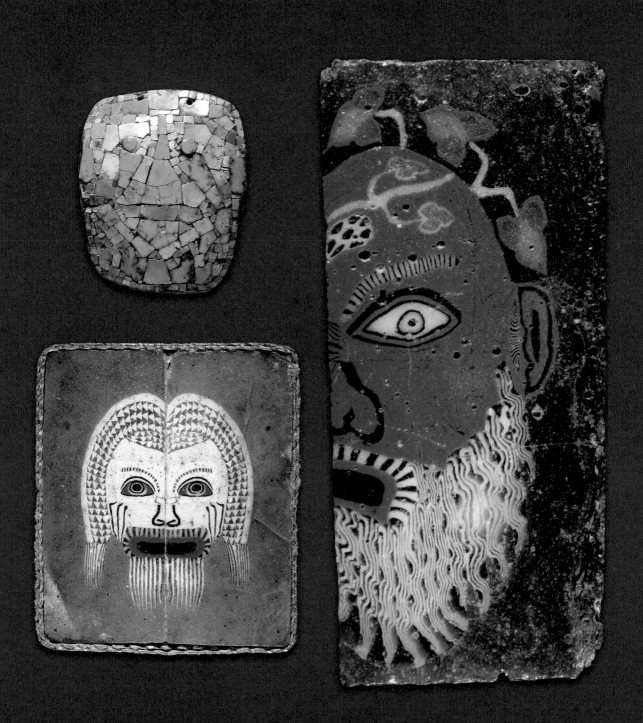

126 Snail Houses, illustration by Robinet Testard from *Secrets de l'histoire naturelle contenant les merveilles et choses mémorables du monde*, France, c. 1480–85

127 Universal Man and a portrait of Hildegard of Bingen, illumination from *The Lucca Codex*, vellum, c. 1410

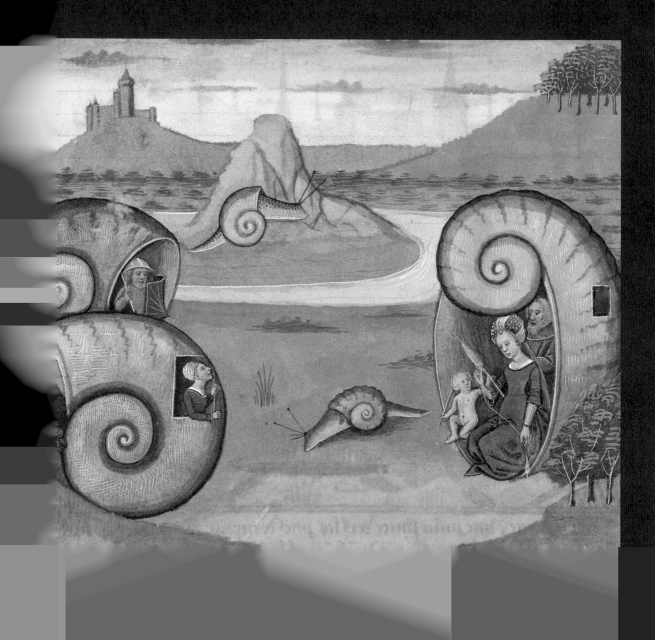

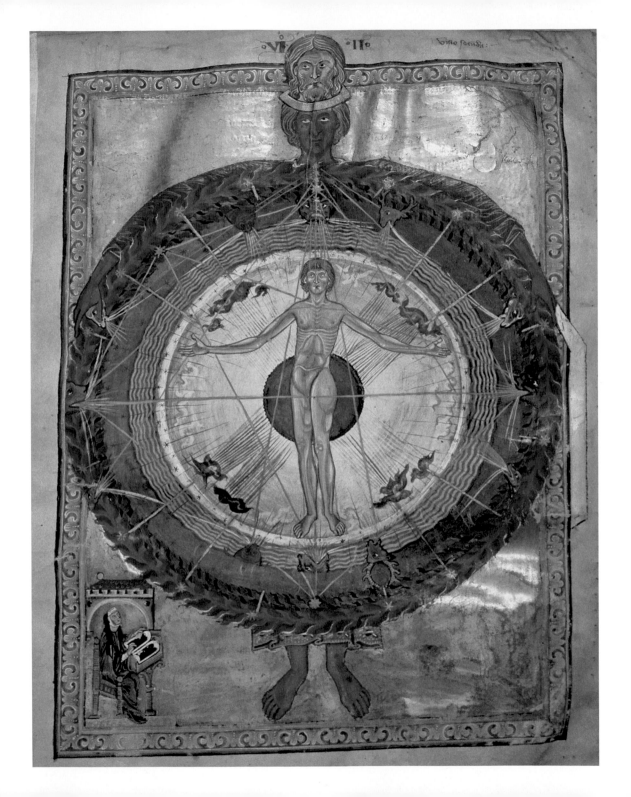

↓ **128** (a) Labours of the Month of September, facsimile of an illumination by the Limbourg Brothers from *Les Très Riches Heures du duc de Berry*, tempera on vellum, France, 1411–16

(b) Labours of the Month of February, facsimile of an illumination by the Limbourg Brothers from *Les Très Riches Heures du duc de Berry*, tempera on vellum, France, 1411–16

→ **129** *The Holy Kinship* from the workshop of Geertgen tot Sint Jans, oil on oak panel, Haarlem, Netherlands, *c.* 1495

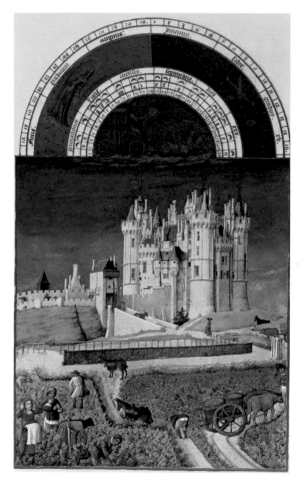

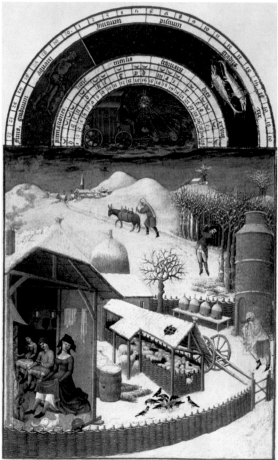

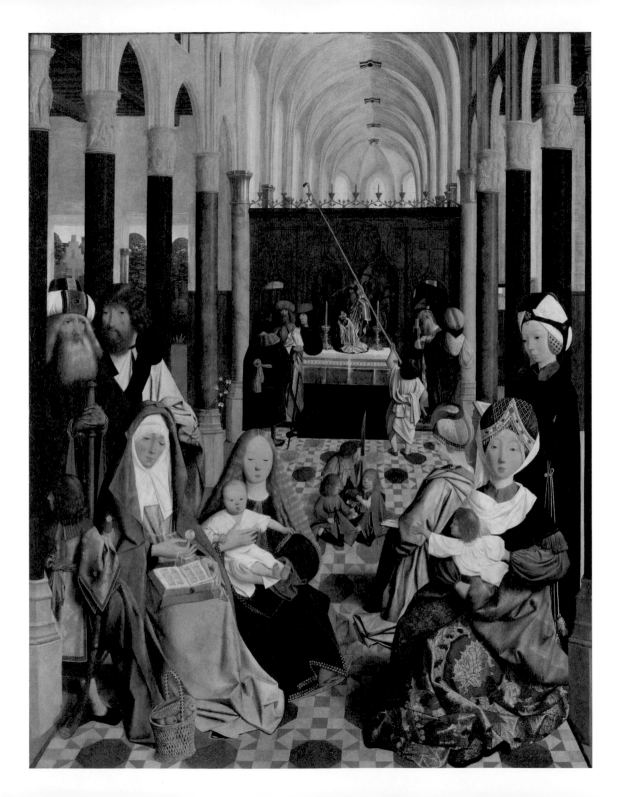

↓ 130 *A Young Daughter of the Picts* by Jacques Le Moyne de Morgues (French, *c.* 1533–88), watercolour and gouache, touched with gold on parchment, *c.* 1585

→ 131 (a, b, c & d) Plates from *One Hundred Portraits of Peking Opera Characters*, an album of 50 leaves by an unidentified artist, China, ink, colour and gold on silk, late nineteenth to early twentieth century

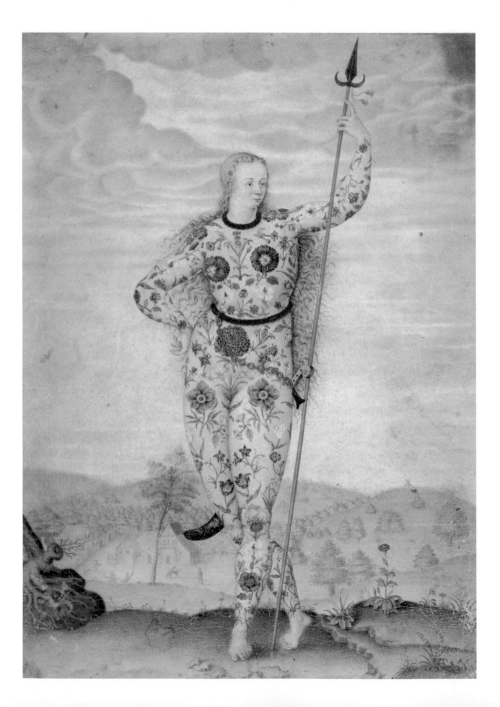

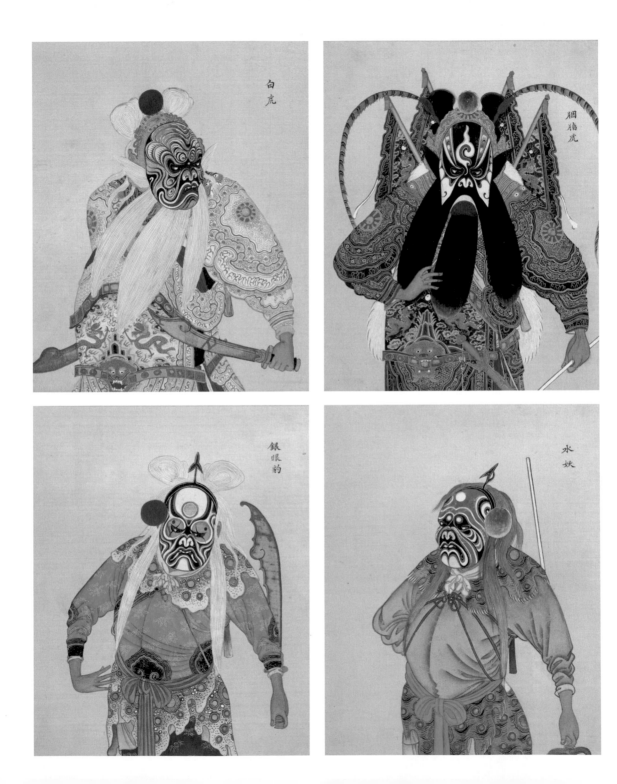

白虎

胭脂虎

銀眼豹

水妖

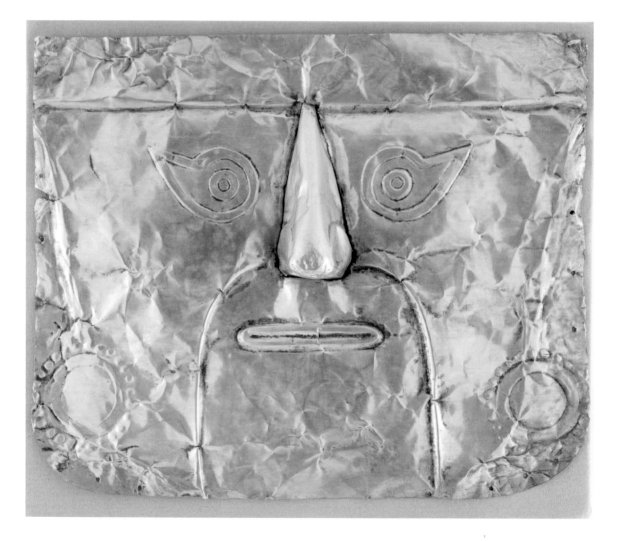

Man is only man at the surface. Remove his skin, dissect, and immediately you come to machinery.

— Paul Valéry, *Ouevres*, Tome 2, 1960

We carry within us the wonders
we seek without us.

— Sir Thomas Browne, *Religio Medici*, part 1, 1643

[I] wish for you only that the strange
thing may never fail you, whatever it is,
that gives us the strength to live on and
on with our wounds.

— Samuel Beckett, letter, 1963

↓ **133** Wound Man by Pseudo-Galen, from *Anathomia*, England, mid-fifteenth century

→→ **134** *The Man of Commerce* is a map of North America overlaid with a cross-section of a human, linking the veins, arteries and organs with the American transportation system. Published by the Land & River Improvement Company of Superior, Wisconsin, engraved by Rand McNally, 1889

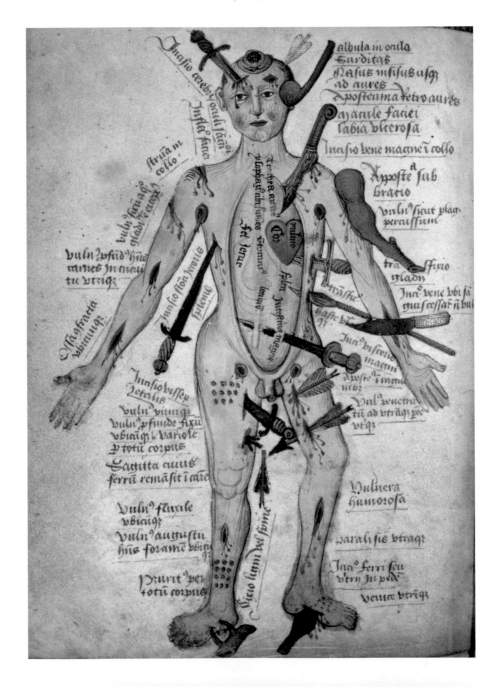

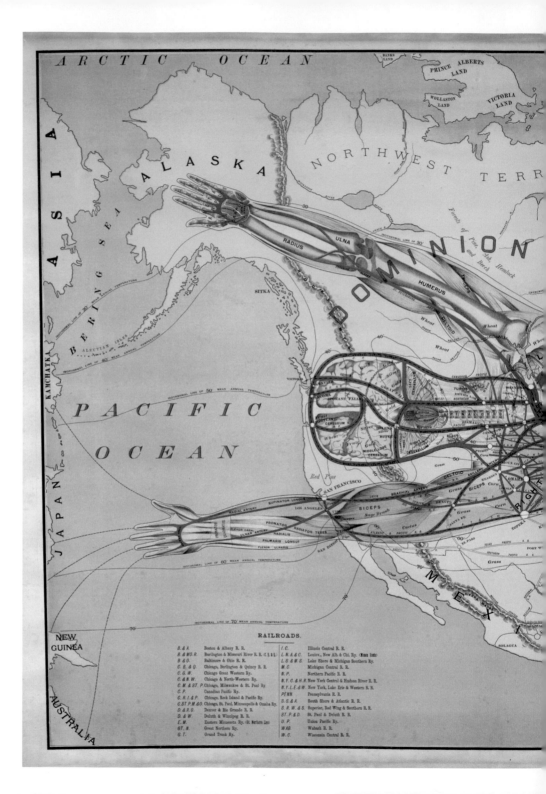

ARCTIC OCEAN

ASIA

ALASKA

NORTHWEST TERR

DOMINION

PACIFIC

OCEAN

JAPAN

KAMCHATKA

NEW GUINEA

AUSTRALIA

MEXI

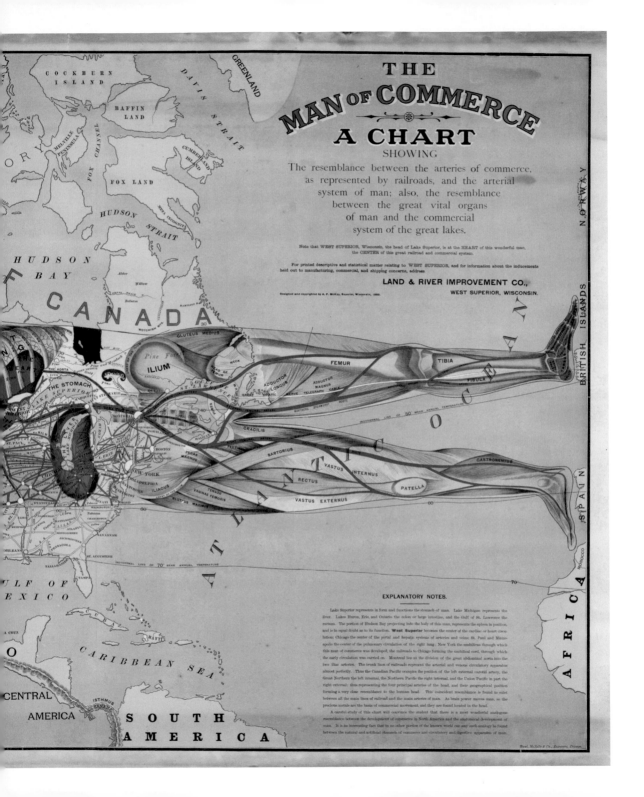

# THE
# MAN OF COMMERCE
## A CHART
### SHOWING

The resemblance between the arteries of commerce,
as represented by railroads, and the arterial
system of man; also, the resemblance
between the great vital organs
of man and the commercial
system of the great lakes.

Note that WEST SUPERIOR, Wisconsin, the head of Lake Superior, is at the HEART of this wonderful man,
the CENTER of this great railroad and commercial system.

For printed descriptive and statistical matter relating to WEST SUPERIOR, and for information about the inducements
held out to manufacturing, commercial, and shipping concerns, address

### LAND & RIVER IMPROVEMENT CO.,
#### WEST SUPERIOR, WISCONSIN.

Designed and copyrighted by A. F. McKay, Superior, Wisconsin, 1889.

## EXPLANATORY NOTES.

Lake Superior represents in form and functions the stomach of man. Lake Michigan represents the river. Lakes Huron, Erie, and Ontario the colon or large intestine, and the Gulf of St. Lawrence the rectum. The portion of Hudson Bay projecting into the body of this man, represents the spleen in position, and is in equal doubt as to its function. West Superior becomes the center of the cardiac or heart circulation; Chicago the center of the portal and hepatic systems of arteries and veins. St. Paul and Minneapolis the center of the pulmonary circulation of the right lung. New York the umbilicus through which this man of commerce was developed, the railroads to Chicago forming the umbilical cord, through which the early circulation was carried on. Montreal lies at the division of the great abdominal aorta into the two iliac arteries. The trunk lines of railroads represent the arterial and venous circulatory apparatus almost perfectly. Thus the Canadian Pacific occupies the position of the left external carotid artery, the Great Northern the left internal, the Northern Pacific the right internal, and the Union Pacific in part the right external; thus representing the four principal arteries of the head, and their geographical position forming a very close resemblance to the human head. This consistent resemblance is found to exist between all the main lines of railroad and the main arteries of man. As brain power nerves man, so the precious metals are the basis of commercial movement, and they are found located in the head.

A careful study of this chart will convince the student that there is a most wonderful analogous resemblance between the development of commerce in North America and the anatomical development of man. It is an interesting fact that in no other portion of the known world can any such analogy be found between the natural and artificial channels of commerce and circulatory and digestive apparatus of man.

Rand, McNally & Co., Engravers, Chicago.

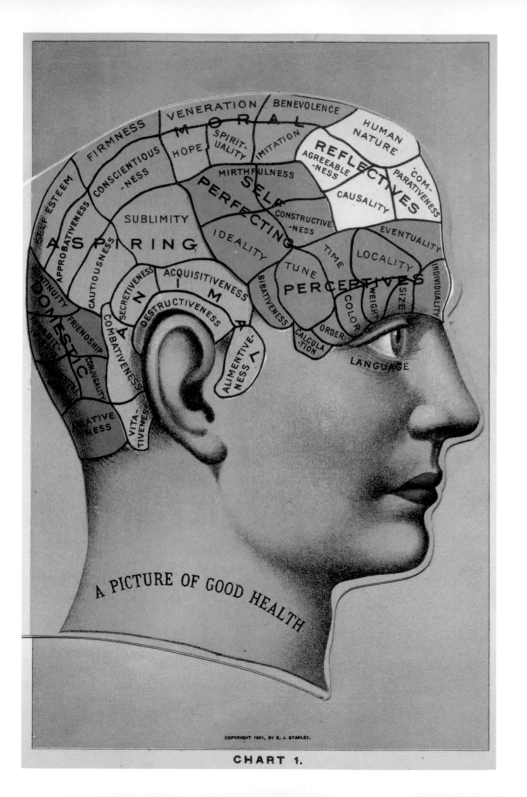

A PICTURE OF GOOD HEALTH

CHART 1.

← **135** *A Picture of Good Health*, phrenology chart, chromolithograph plate, published by E. J. Stanley, 1901

↓ **136** Muscles of the Head, colour mezzotint from *Suite de l'Essai d'anatomie en tableaux imprimés* by Jacques Fabien Gautier d'Agoty (1716–85), 1748

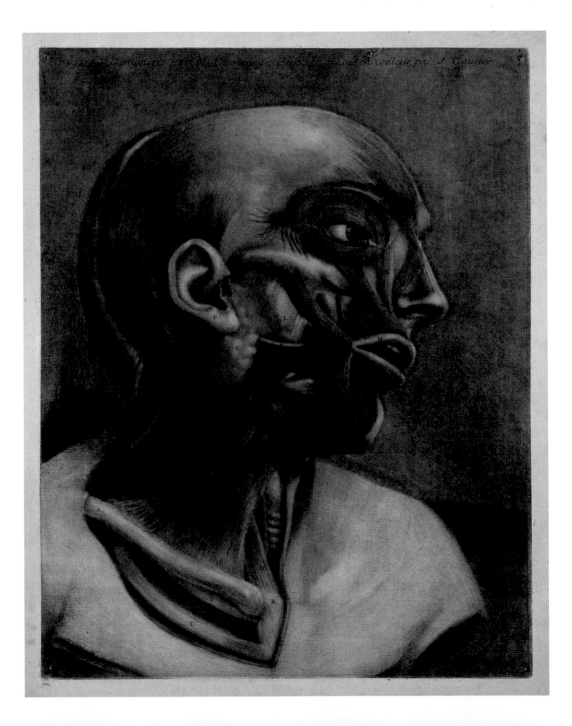

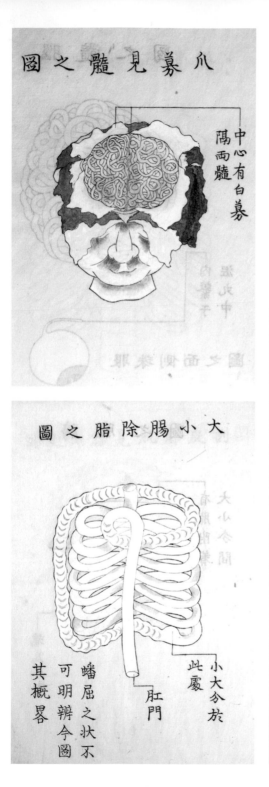

圖之髓見募爪

中心有白募
隔兩髓

圖之脂除腸小大

蟠屈之狀不
可明辨今圖
其概畧

小大分於
此處

肛門

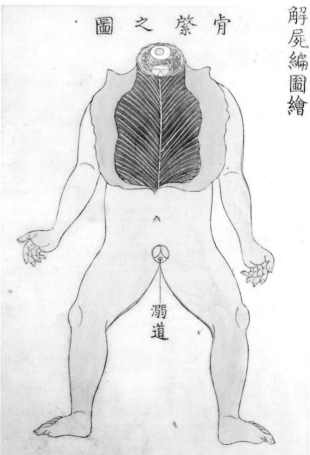

解屍編圖繪

膏繁之圖

溺道

←↙↓ 137 (a) *Shōbo ken sui no zu* by Aoki Shukuya, drawing of a human brain exposed by retracting the membranes and showing the two cerebral hemispheres separated by the median plane, plate 19a (b) *Daishōchō joshi no zu* by Aoki Shukuya, drawing of small and large intestines after removing fat, plate 21a (c) *Kōkei no zu* by Aoki Shukuya, drawing of a human torso with the chest cut open showing muscles, attachments, and the urinary tract, plate 14a
All three drawings from *Kaishi Hen* (*Analysis of Cadavers*) by Kawaguchi Shinnin, Japan, 1772

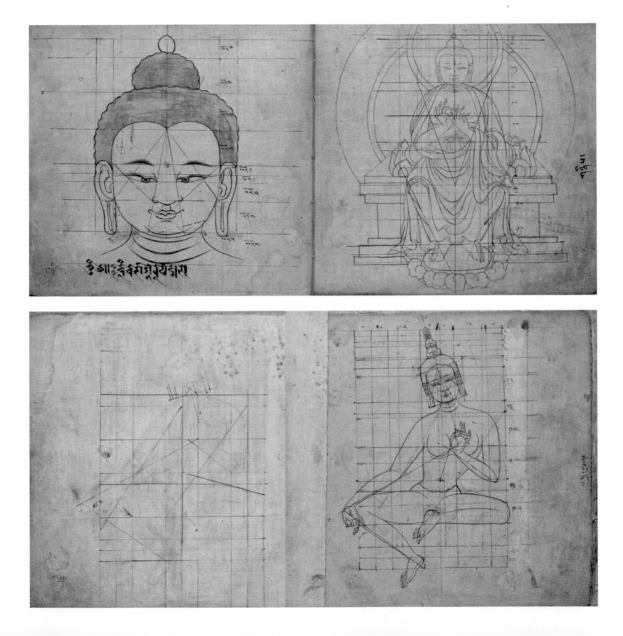

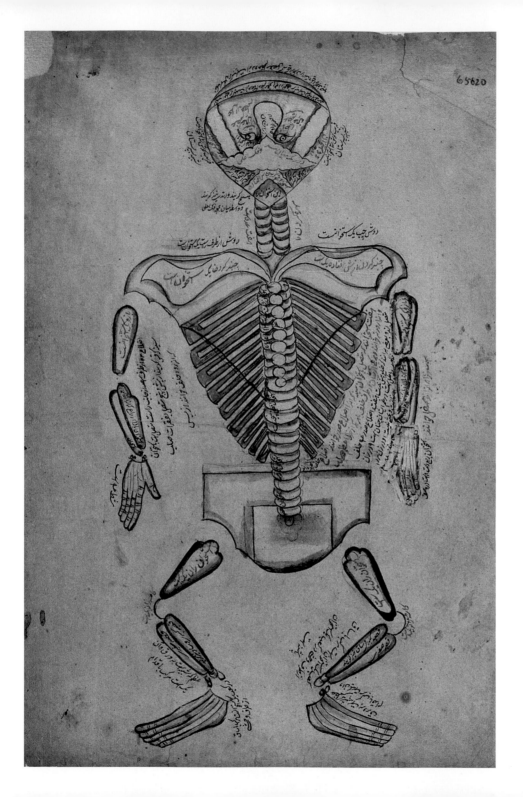

← **139** The Skeleton, illustration from a nineteenth-century edition of *Tashrih-i Mansuri* (*Mansur's Anatomy*) by Mansūr ibn Muhammad ibn Ahmad ibn Yūsuf Ibn Ilyās, a late fourteenth-century physician

Mansur was from a family of scholars and physicians active for several generations in the city of Shiraz. He dedicated his two major works, a general medical encyclopaedia and a study of anatomy, to the rulers of the province of Fars in modern Iran.

↓ **140** Muscle Man by Pseudo-Galen, showing the muscles and spine, front view, anatomical diagram from Anathomia, England, mid-fifteenth century

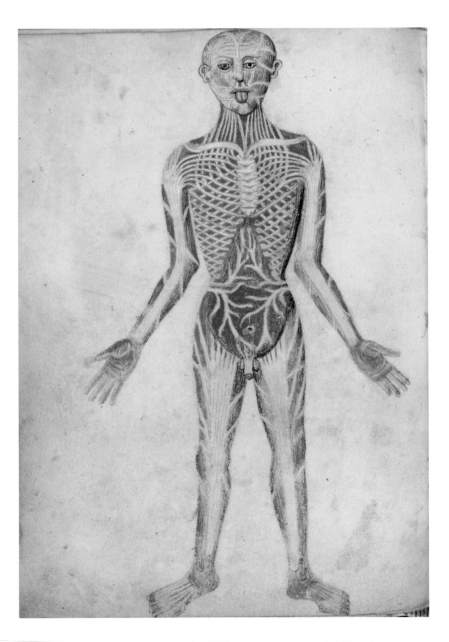

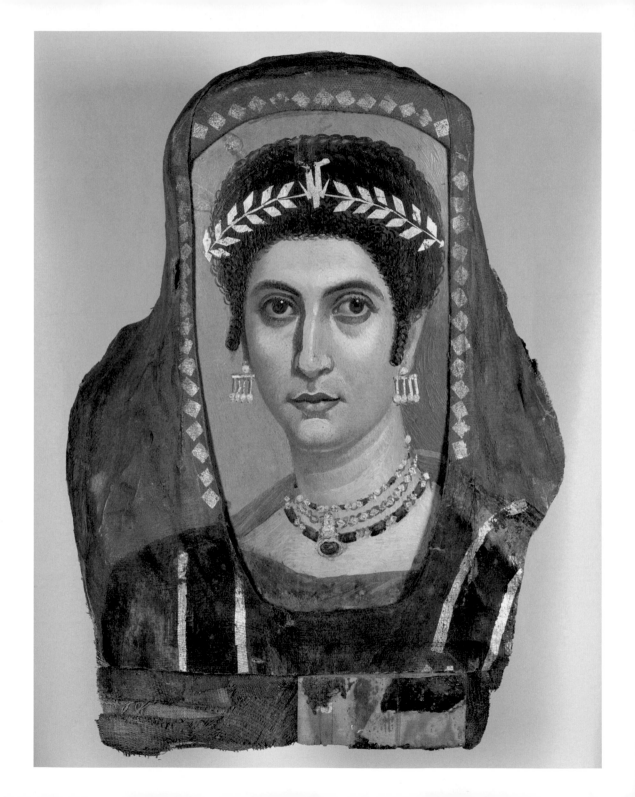

← 141 Mummy Portrait of a Woman attributed to the Isidora Master (Romano-Egyptian), encaustic on linden wood, gilt, linen, Egypt, *c.* 100 CE

↓ 142 Eye of glass paste and stone (marble, obsidian) set into bronze with an overhanging fringe of lashes. Made for insertion into a Greek statue, *c.* fifth to second century BCE

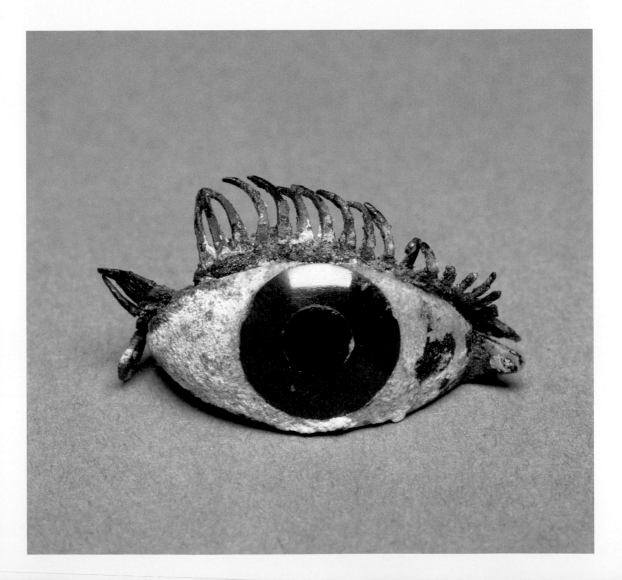

Hatred, which could destroy so much, never failed to destroy the man who hated, and this was an immutable law.

— James Baldwin, *The Fire Next Time*, 1963

Even broken in spirit as he is, no one can feel more deeply than he does the beauties of nature. The starry sky, the sea, and every sight afforded by these wonderful regions, seems still to have the power of elevating his soul from earth. Such a man has a double existence: he may suffer misery, and be overwhelmed by disappointments; yet, when he has retired into himself, he will be like a celestial spirit that has a halo around him, within whose circle no grief or folly ventures.

— Mary Shelley, *Frankenstein*, 1818

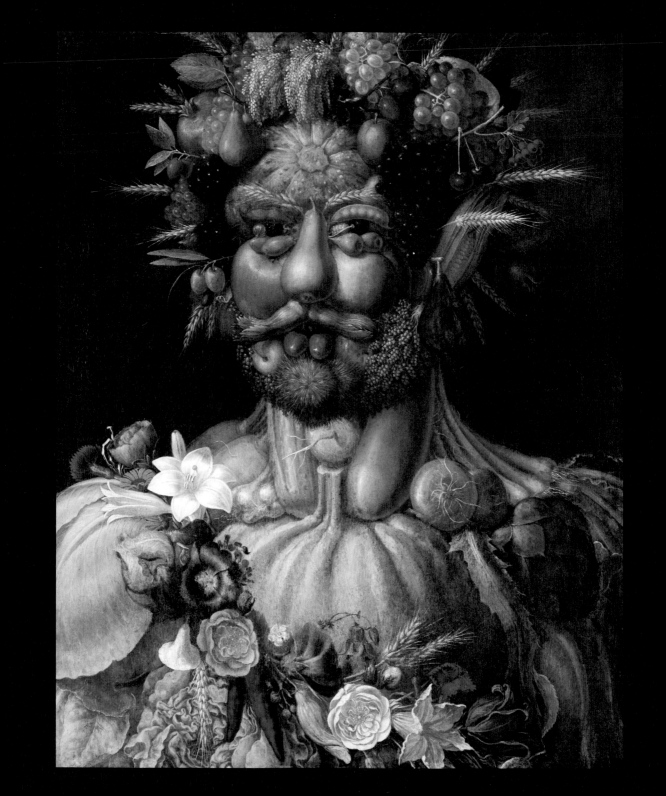

# THE REALM OF SCIENCE

# AND THE SENSES

←← 143 *Vertumnus*, a portrait depicting Rudolf II, Holy Roman Emperor, painted as Vertumnus, the Roman god of the seasons, by Giuseppe Arcimboldo, oil on panel, *c.* 1590–1

→ 144 Table 1, from *A New Elucidation of Colours, Original Prismatic and Material: Showing Their Concordance in the Three Primitives, Yellow, Red and Blue: and the Means of Producing, Measuring and Mixing Them: with some Observations on the Accuracy of Sir Isaac Newton* by James Sowerby, London, 1809

THOTH WAS THE ANCIENT Egyptian god of wisdom and knowledge; magic and science; of mathematics, art and astronomy; of medicine, music and poetry; of architecture and engineering; and the creator of written language. In short, Thoth was the father of human progress, and of all good things.

Thoth collected all the secrets of every god and goddess, and all the knowledge that is hidden in the stars into a single, sacred book. It is said that any person who deciphered and read the Book of Thoth would become the wisest of souls and the most powerful of magicians. However, this knowledge came at a terrible price, for the book was cursed, and any human who read it would be condemned to suffer pain and tragedy before they could use their newly acquired powers.

The early humans had been blessed with the senses, brute instinct and the basic means of survival, but lacked the intelligence to understand the world in which they found themselves. They looked but could not see, they heard but did not listen, they could grasp but they could neither build, nor create. Thoth's gifts of wisdom and language gave humans the self-awareness and intelligence to interpret the evidence of their senses, and the means and wherewithal to exploit the fruits of the earth and to build a society based upon communication and collective endeavour.

Thoth reigned on earth for 3,226 years, an era of unparalleled peace and progress. He was the wisest of the gods and, cursed books notwithstanding, humankind's greatest benefactor.

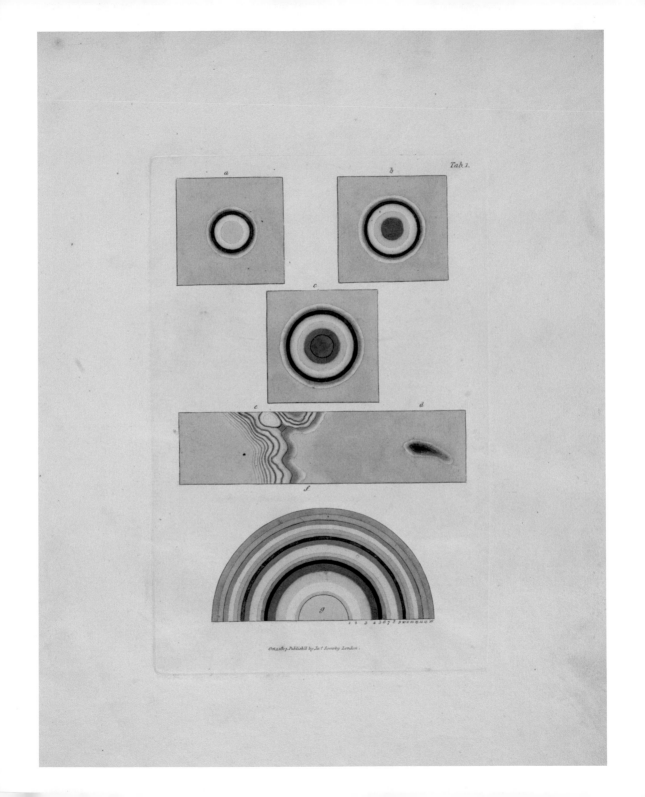

*Tab. 1.*

Onyx &c. Publish'd by Ja.ᵗ Sowerby London.

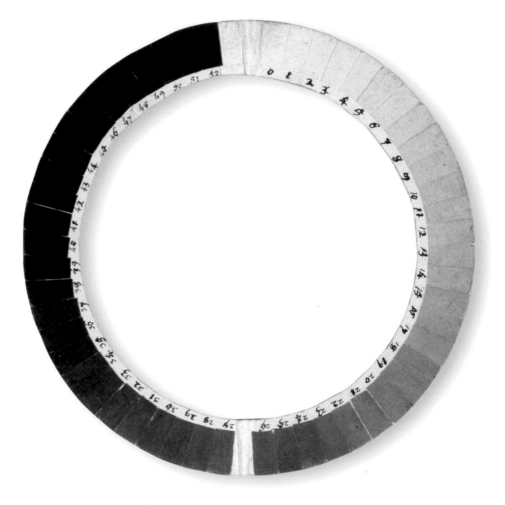

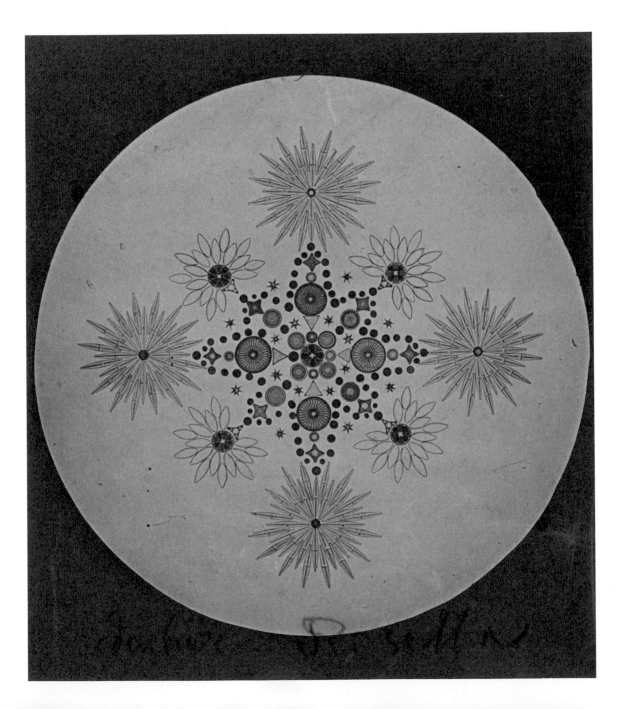

↓ **147** Painting of the Italian Renaissance geometer, Franciscan friar, associate of Leonardo da Vinci and pioneer of the art of accounting and bookkeeping, Fra Luca Pacioli, attributed to Jacopo de Barbari, *c.* 1495–1500

→ **148** (a & b) Plates from *Perspectiva Corporum Regularium* by Wenzel Jamnitzer, engravings by Jost Amman, Nuremburg, 1568

*Perspective of the Regular Bodies* is a compendium of extravagant geometrical drawings based upon the five Platonic Solids – the tetrahedron, cube, octahedron, dodecahedron and icosahedron – intended to showcase the remarkable graphic skills of the artist Wenzel Jamnitzer, who was at the time the most renowned goldsmith in Europe.

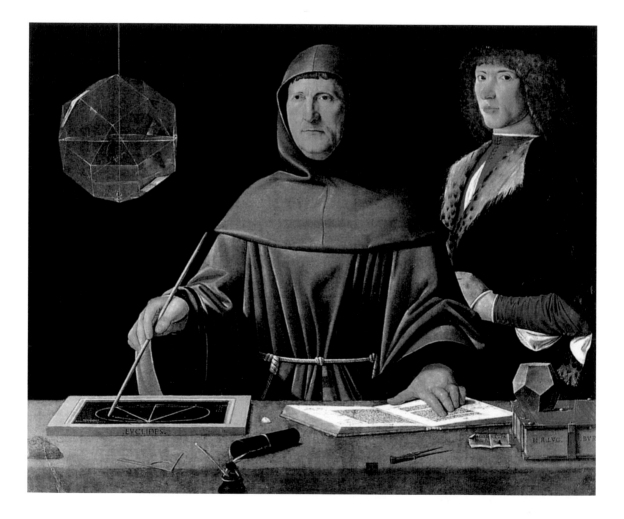

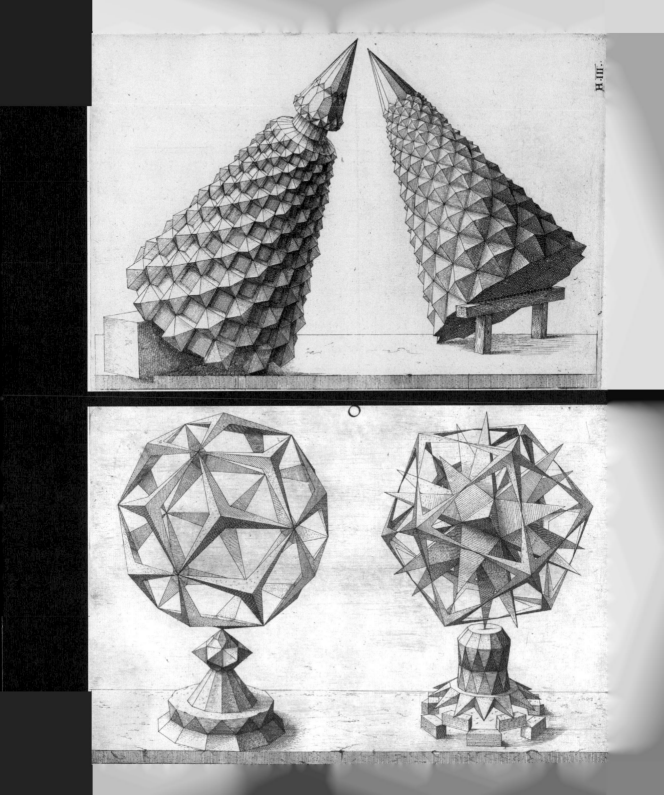

149 Optics: An Eye in a Star, the spokes of which divide
the spectrum of colours, the figures representing the
colours each bear a banner in their own colour and a sprig
of a particular plant. Engraving by J. Chapman after A.D.
M'Quin, London, 1820

150 Astronomer by Candlelight by Ge
1613–75), oil on panel, late 1650s

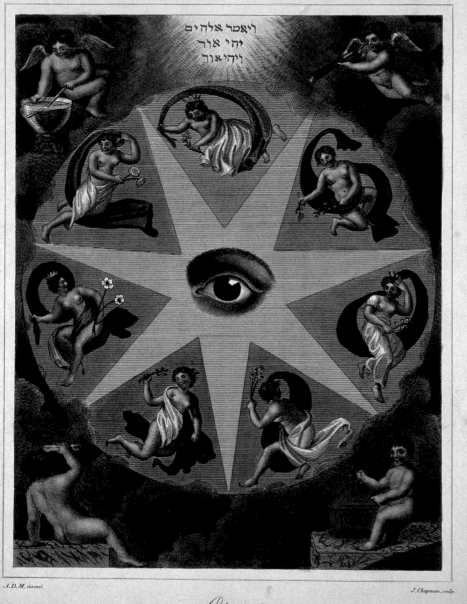

וַיֹּאמֶר אֱלֹהִים
יְהִי אוֹר
וַיְהִי־אוֹר

A.D.M. invenit.

J. Chapman, sculp.

*Optics.*

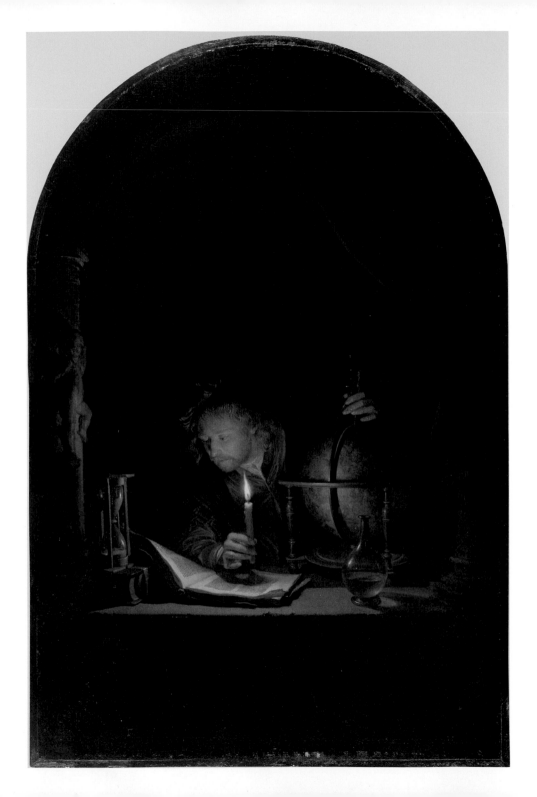

*Oct.1.1807. Publish'd by Ja.ˢ Sowerby London.*

Here forms, here colours, here the character of
every part of the universe are concentrated to a
point; and that point is so marvellous a thing …
Oh! marvellous, O stupendous Necessity —
by thy laws thou dost compel every effect to be
the direct result of its cause, by the shortest
path. These are miracles …

— Leonardo da Vinci (1452–1519)

I do not think there is any thrill that can go through the human heart like that felt by the inventor as he sees some creation of the brain unfolding to success … such emotions make a man forget food, sleep, friends, love, everything.

— Nikola Tesla, 1896

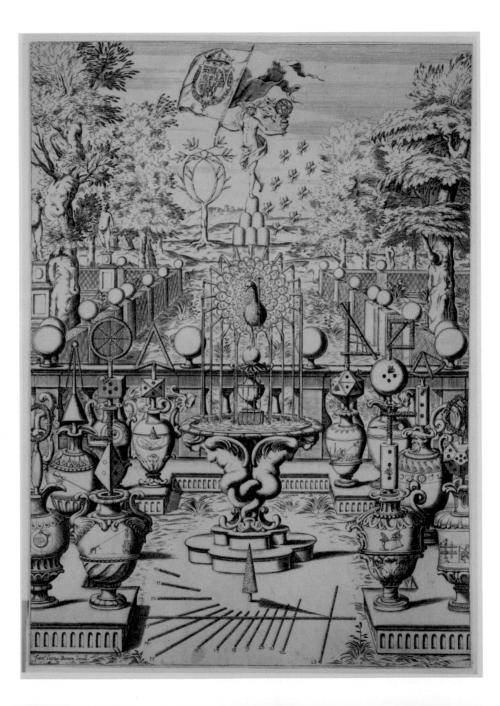

← ← **151** The Chromatic Scale, Table 5 from *A New Elucidation of Colour* by James Sowerby, etching, watercolour and gum arabic, London, 1809

↓ **152** Garden of Mathematical Sciences by Francesco Curti (Italian, 1603–70), engraving, seventeenth century

↓ **153** Six Views of Subarachnoid Injections of the Human Brain by Axel Key and Gustav Retzius, from *Studien in der Anatomie des Nervensystems und des Bindegewebes*, Stockholm, 1875

→ **154** Cell layers in the embryo from *Anthropogenie, oder, Entwicklungsgeschichte des Menschen* by Ernst Haeckel (1834–1919), Leipzig, 1874

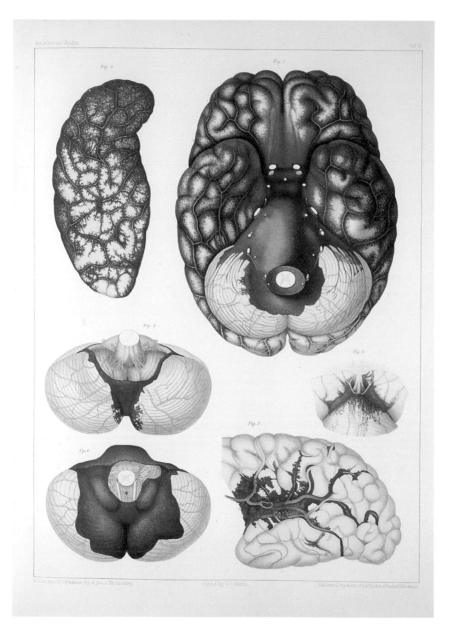

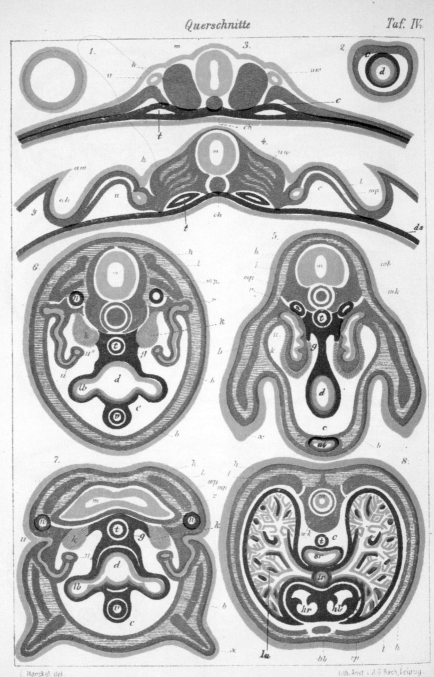

↓ 155 The Goddess Flora, or La Primavera (Spring), scattering flowers, fresco from Stabiae, Campania, Italy, *c.* first century CE

→ 156 Portrait of a Woman with a Flower, opaque watercolour and gold on paper, Mughal India, second half of the seventeenth century

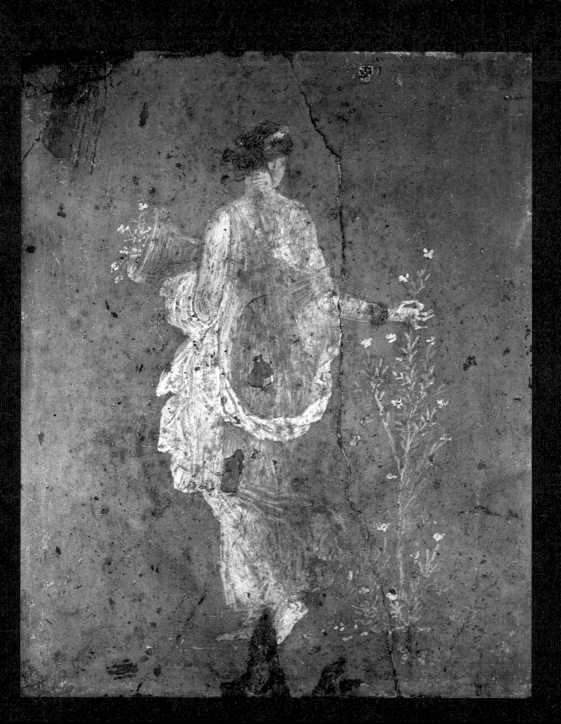

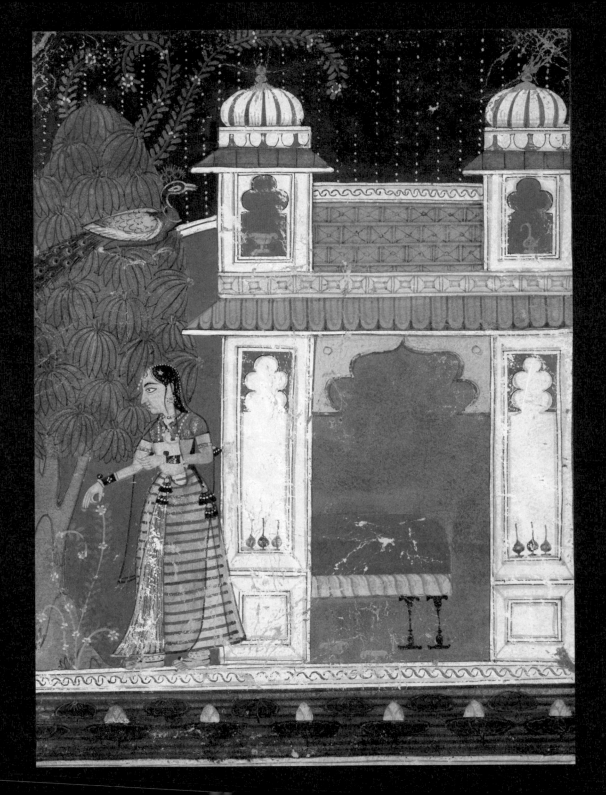

157 Head and Eyes of Drone-Fly, drawing from *Micrographia* by Robert Hooke (English, 1635–1703), the first important work on microscopy, 1664

158 Woodcut of French philosopher René Descartes' conception of vision, showing the passage of nervous impulses from the eye to the pineal gland and thence to the muscles. From a posthumous collection of his works, *Opera Philosophica* (*Tractatus de homine*), 1692

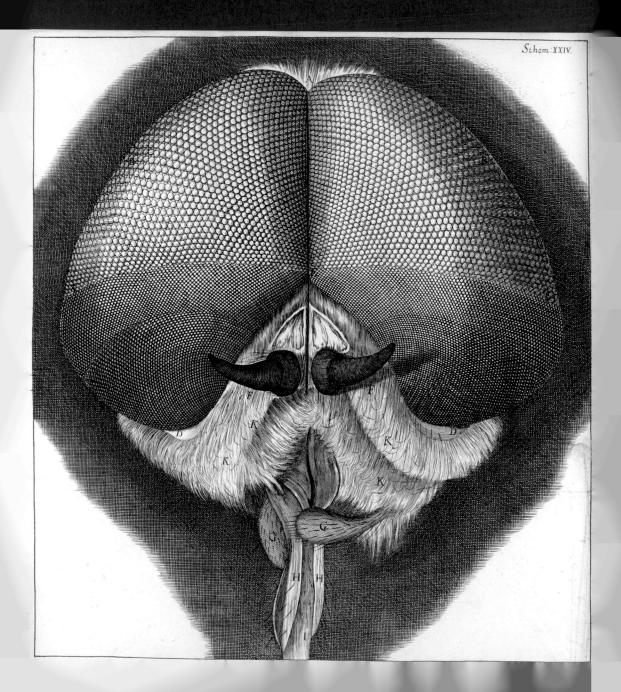

*Schem: XXIV.*

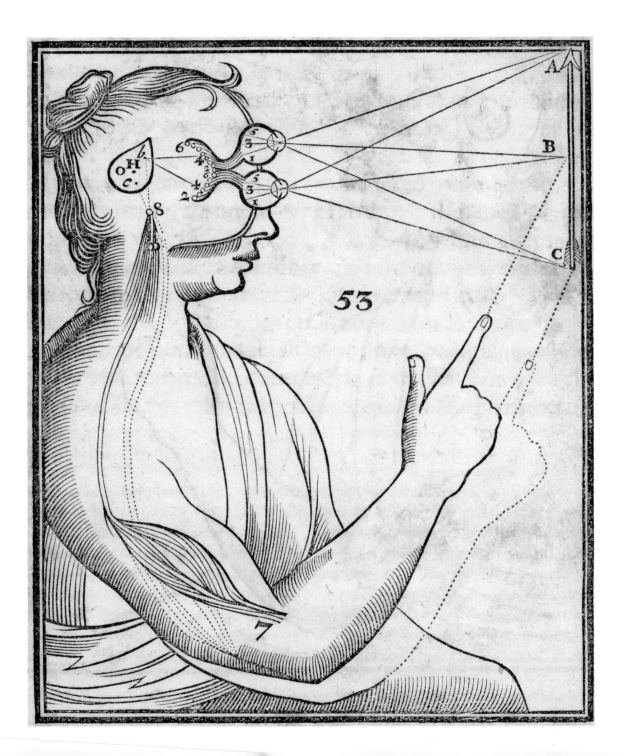

↓ 159 Nikola Tesla was a Serbian-American inventor, and here he is apparently reading next to a 'magnifying transmitter' high-voltage generator, at his lab in Colorado Springs. Dickenson V. Alley took this photograph as a promotional stunt, and it is actually an early example of image manipulation by double exposure. In the darkened laboratory, the sparks of the machine were photographed first, next the machine was turned off and Tesla sat in his chair, and the plate was exposed again, *c.* 1899

→ 160 *Elektrische Entladungen*, diagram depicting electrical discharge – the release and transmission of electricity in an applied electric field through a medium such as a gas. Artist unknown, published by the German publisher Bibliographisches Institut, 1909

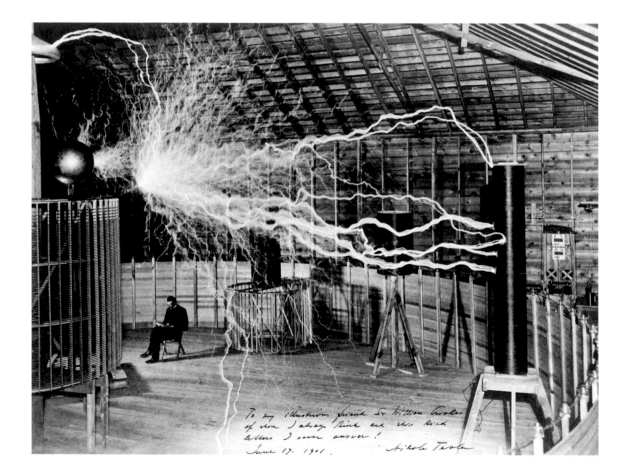

# Elektrische Entladungen.

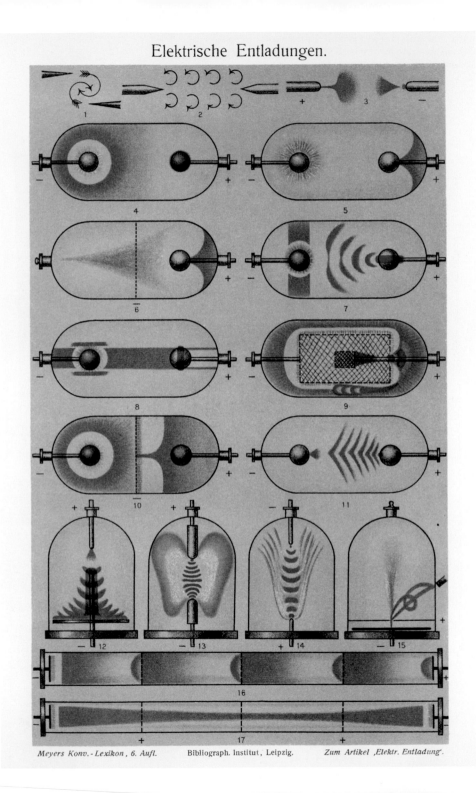

↓ **162** Design for the Water Clock of the Peacocks, from the *Kitab fi ma'rifat al-hiyal al-handasiyya* (*Book of the Knowledge of Ingenious Mechanical Devices*) by Badi' al-Zaman b. al Razzaz al-Jazari, folio from an illustrated manuscript, ink, opaque watercolour and gold on paper, Syria or Iraq, 1315

Al-Jazari invented many ingenious and elaborate mechanical devices, such as this water-powered peacock clock. When assembled and set in motion, the two peacocks sat within an outer arch, on top of which a peahen turned 180 degrees every half hour, causing the peacocks to emit a piercing whistle.

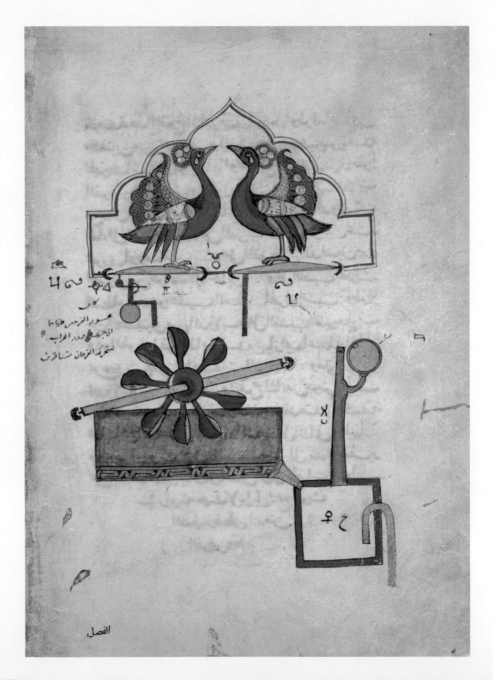

You may break, you may shatter the vase, if you will,
But the scent of the roses will hang round it still.

— Thomas Moore (1779–1852), from 'Farewell! – But Whenever You Welcome the Hour'

Algebra is applied to the clouds; the
radiation of the star profits the rose;
no thinker would venture to affirm
that the perfume of the hawthorn is
useless to the constellations.

— Victor Hugo, *Les Miserables*, 1862

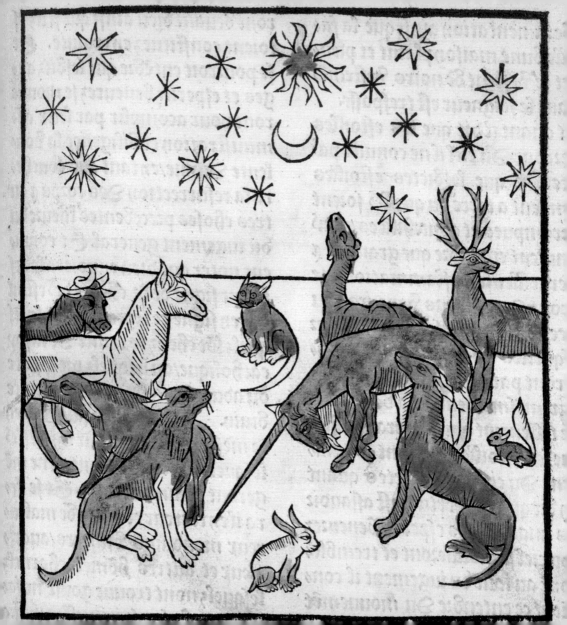

# HEAVENLY

# BODIES

A T THE DAWN OF TIME, Tirawa, the chief god of the Pawnee people of North America, lived in heaven with his wife, Atira. One day he called a council of all the gods and said, 'I shall give each of you a portion of my power and a task to fulfil in heaven for I have decided to create humans in my image and I am placing them under your protection.'

And so Tirawa placed Shakuru, the sun, in the east, and Pah, the moon, in the west. Turning to the star of the evening whose name was Bright Star, he said: 'Your home is the western part of the sky and you will be known as the mother of all things, for every living thing shall be created by you.' And to the star of the morning, Big Star: 'Your home is the eastern part of the sky and you will be a mighty warrior respected by all living things.'

Then Tirawa appointed the Pole Star the chief of the heavens and placed him in the north and placed the Star of Spirits in the south, on the opposite side of the sky. Then he placed four other stars in the north-east, the north-west, the south-east and the south-west and said to them: 'Your task will be to support the sky.'

Tirawa gave Bright Star control of all the elements and the gifts of clouds, winds, thunder and lightning and told him to prepare the earth and make it fertile and bountiful, a fitting home for the first men and the first women.

Bright Star sent Lightning to survey the earth below, giving him the sack of storms in which he had gathered all the constellations which the Morning Star drives before her. When he had travelled the length and breadth of the earth, Lightning opened the sack, took out the stars and hung them in the sky, where they remain to this day.

However, one of the stars was jealous of Bright Star's power, and felt he deserved a more prominent position in the heavens. So he summoned a wolf to steal the sack of storms while Lightning's back was turned. The wolf succeeded and opened the sack, releasing all the stars and spirits who remained within. Furious at having been kidnapped, they set upon the wolf and killed him.

Since that day, death has stalked the earth and will never leave until the end of days when every living thing will vanish and the South Star – the star of death – will have dominion over all. On that day, the moon will become blood-red and the sun's light will be snuffed out. The people of the earth will be turned into a multitude of tiny stars and will travel up to paradise along the Milky Way, which is the pathway the dead take to heaven.

| | | | |
|---|---|---|---|
| | C | kł | s̅ aint basille. |
| rvin | A | kł | s̅ aint ladze |
| vi | b | kł | s̅ aint gacien |
| | c | kł | s̅ aint seuerin. |
| rm | d | kł | s̅ aint tecle |
| m | e | kł | s̅ aint thomas. |
| | f | kł | s̅ aint uictor |
| rī | g | kł | s̅ aint bertin. |
| rir | A | kł | vigille |
| | b | kł | Le iour de noel. |
| vm | c | kł | s̅ aint estienne |
| | d | kł | s̅ aint ichn. |
| rvi | e | kł | Les innocens. |
| v | f | kł | s̅ aint thomas |
| | g | kł | s̅ aint ieruhn |
| rm | A | kł | s̅ aint siluestre. |

↓ **165** Comets, one of nine wall hangings on astronomical themes, printed lithographically on cotton, that were among many produced by the British Working Men's Educational Union in the 1850s

→ **166** Leonid Meteor Shower over Niagara Falls, illustration from *Bilder-Atlas der Sternenwelt* (*Image Atlas of the Star World*) by Edmund Weiß, Stuttgart, 1892

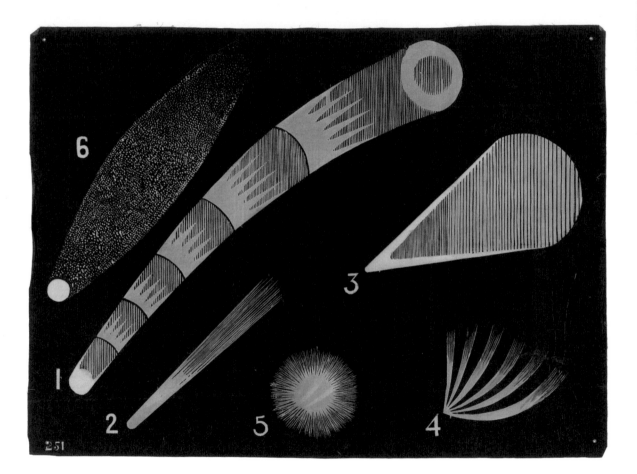

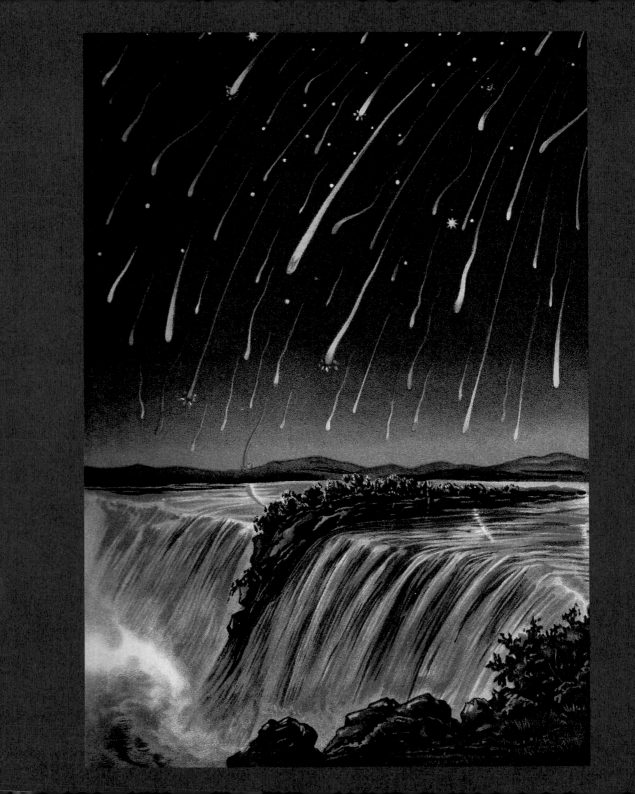

↓ 167 Labelled: The Comet of 1532, later identified as
Halley's Comet, watercolour sketch originally bound in
a sixteenth-century commonplace book

→ 168 A Comet's Journey, illustration from *Un Autre
Monde* by J. J. Grandville, Paris, 1844

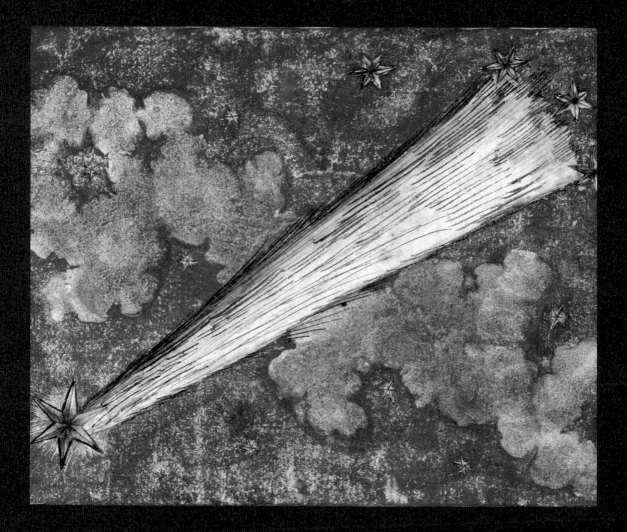

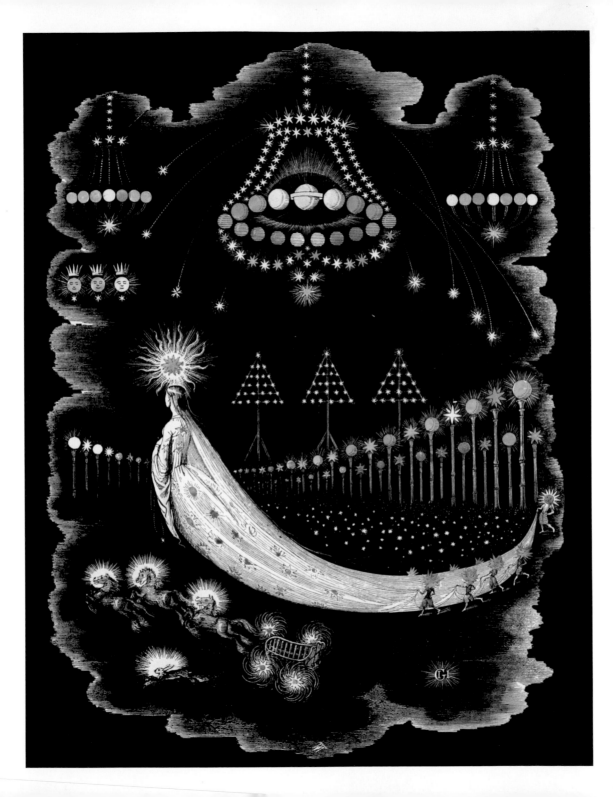

# PHASES OF THE MOON

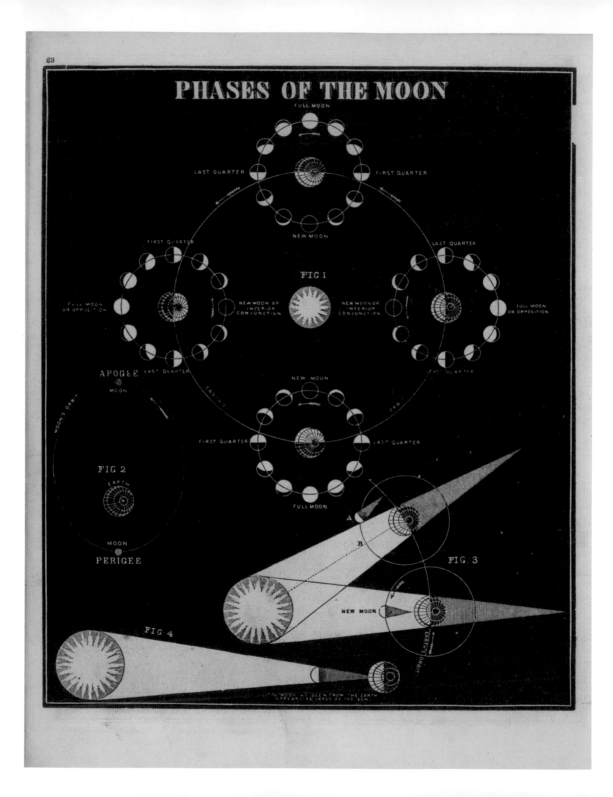

← **169** Phases of the Moon by Asa Smith, from Smith's *Illustrated Astronomy Designed for the Use of the Public or Common Schools in the United States*, fifth edition, New York, 1850

↓ **170** Solar Eclipse by Carleton Watkins (American, 1829–1916), albumen silver print, Santa Lucia Range, California, 1 January 1889

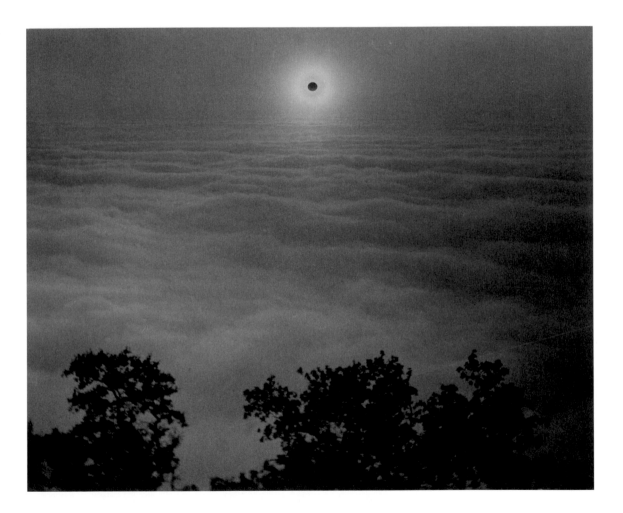

↓ **172** Solar System Quilt by Ellen Harding Baker, wool-fabric applique, wool braid, and wool and silk embroidery, 225 x 269cm, Cedar County, Iowa, USA, 1876

Sarah Ellen Harding was born in Cincinnati, Ohio, in 1847, and married Marion Baker of Cedar County, Iowa, in 1867. They lived in Cedar County until 1878, and then moved to Johnson County, where Marion had a general merchandise business in Lone Tree. Ellen had seven children before she died of tuberculosis on 30 March 1886. The design of Ellen's quilt resembles illustrations in astronomy books of the period. She used the quilt as a visual aid for lectures she regularly gave throughout the state of Iowa.

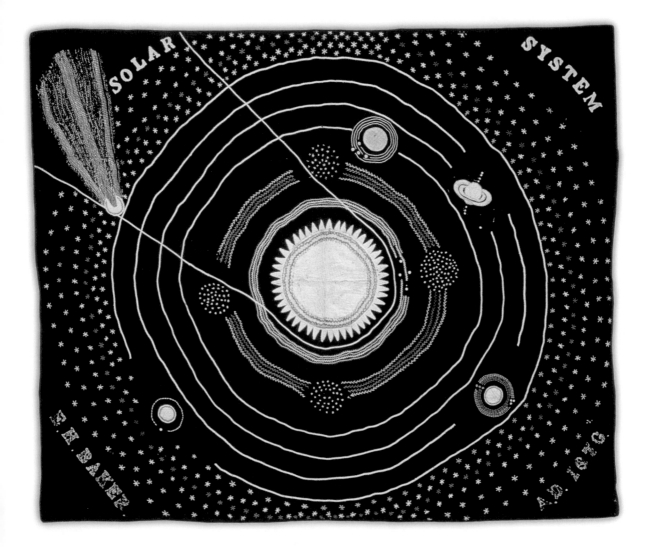

↓ **173** The Solar System from *Astronomic Picture Atlas* by
Ludwig Preyßinger, Professor of Physics and Conservator
of the Augsburg Observatory, Germany, 1851

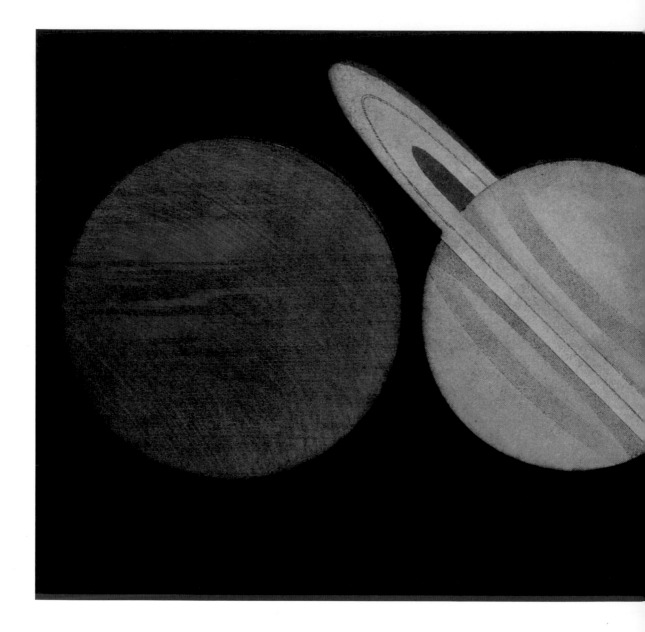

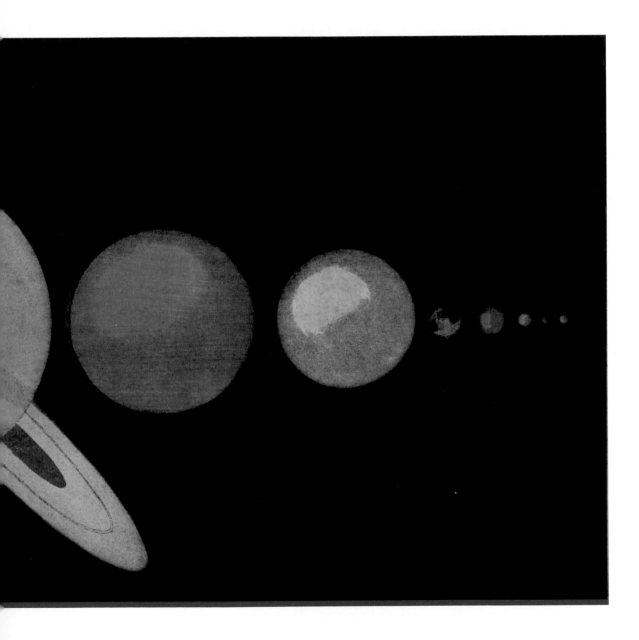

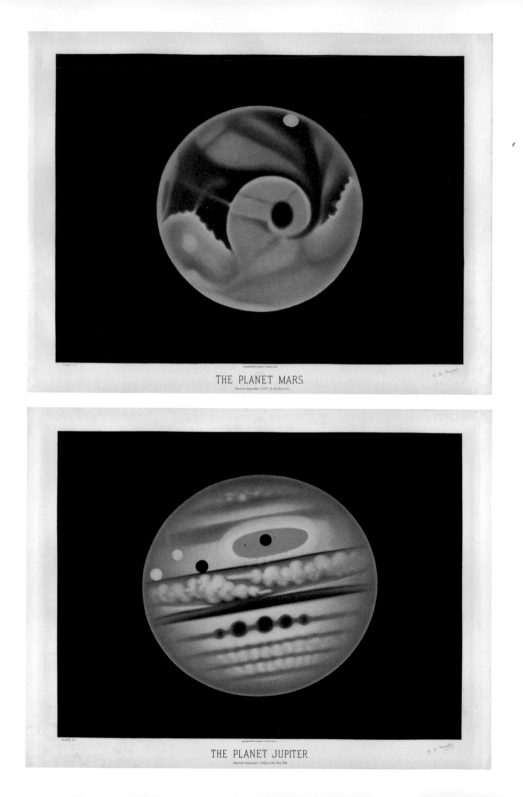

## THE PLANET MARS.

Observed September 3, 1877 at 11h.55m. P.M.

## THE PLANET JUPITER.

Observed November 1, 1880 at 9h. 30m. P.M.

See ever so far, there is limitless space outside of that,
Count ever so much, there is limitless time around that.

— Walt Whitman, 'Song of Myself', 1855

Loneliness;
After the fireworks,
A falling star.

— Masaoka Shiki (1867–1902)

It is he who hath ordained
the stars for you, that ye
may be directed thereby in
the darkness of the land and
of the sea. We have clearly
shown forth our signs, unto
people who understand.

— The Qur'an, Surah Al-An'am, 6: 97

↓ **175** Detail from a fold-out page from the *Iskandar Horoscope* showing the position of the planets at the moment of Iskandar's birth on 25 April 1384 in the form of a planisphere

Jalāl al-Dīn Iskandar Sultan ibn 'Umar Shaykh was a favourite grandson of Tīmūr alias Tamerlane (d. 1405) who conquered much of Persia and Central Asia. Iskander Sultan was an ardent bibliophile and a patron of the arts.

His enthusiasm is witnessed by a number of exquisite manuscripts produced for him and now preserved in libraries around the world. The horoscope was cast on the 22nd of Dhu-l-Hijja 813 AH (18 April 1411 CE) by the court astrologer Mahmud Ibn Yahya ibn al-Hasan al-Kashi, in the second year of Iskandar Sultan's reign, when he was 27 years of age.

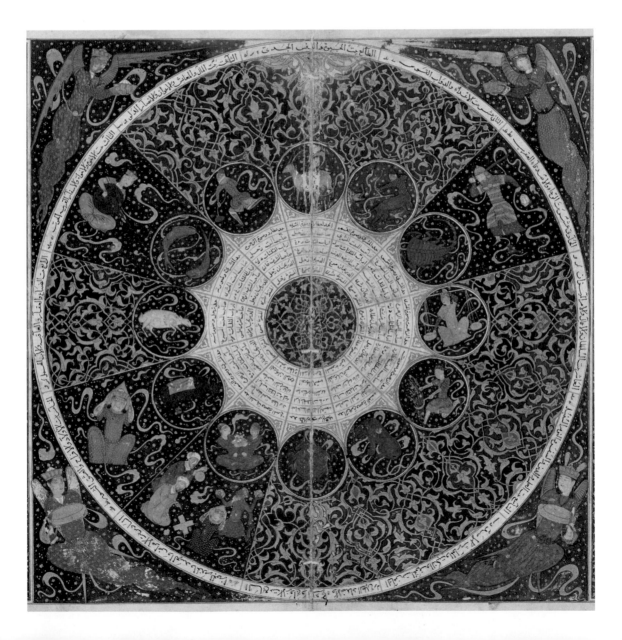

↓ **176** The Constellations Draco and Ursa Minor by Sidney Hall, from *Urania's Mirror*, a set of celestial cards accompanied by *A Familiar Treatise on Astronomy*, London, 1825

→ **177** (a & b) Diagrams for Sunday and Monday (details), from fifteenth-century German *Miscellany: Anatomical-Physiological Description of Men; Liber Synonimorum; Descriptions of Planets, Zodiacs, and Comets; Treatises on Divination from Names, etc.*, unknown artist, watercolour and ink on paper, Augsburg, Germany, shortly after 1464

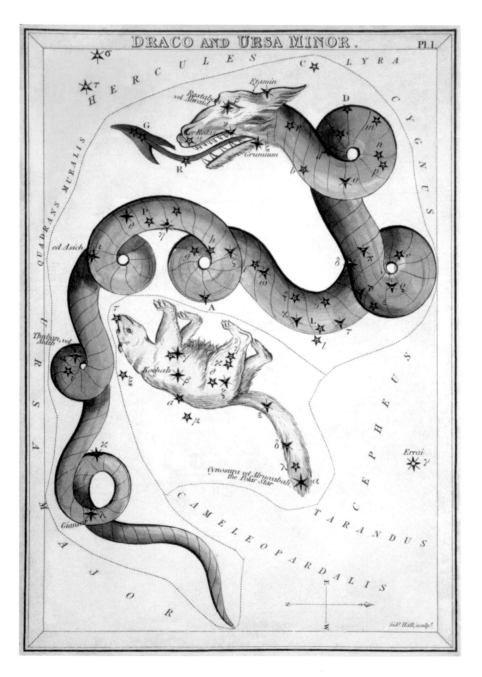

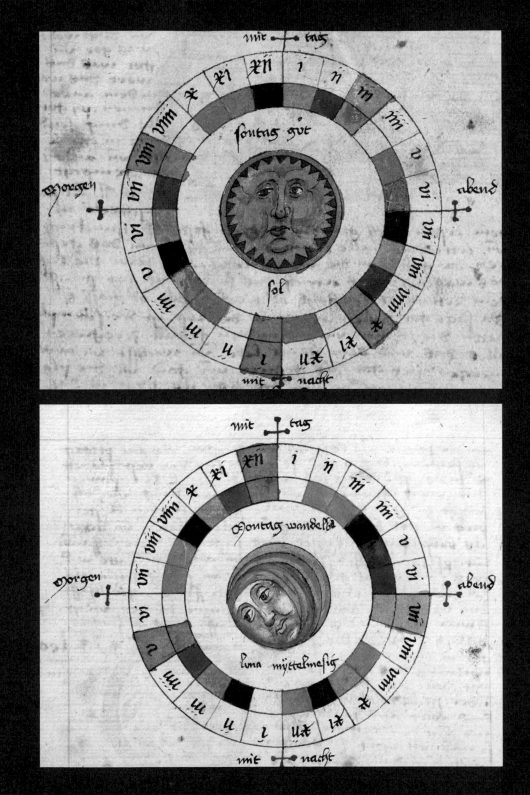

The Chinese star chart is the earliest-known manuscript atlas of the night sky from any civilisation and was produced in central China around 700 CE. It depicts over 1,300 stars visible to the naked eye – centuries before the telescope was invented. The ancient colours – black, red and white – indicate those stars observed by three Chinese astronomers from ancient times, over 1,000 years before. They are accurately plotted using a projection system to depict the curved sky on a flat piece of paper (invented by the Chinese before the 1st century BCE).

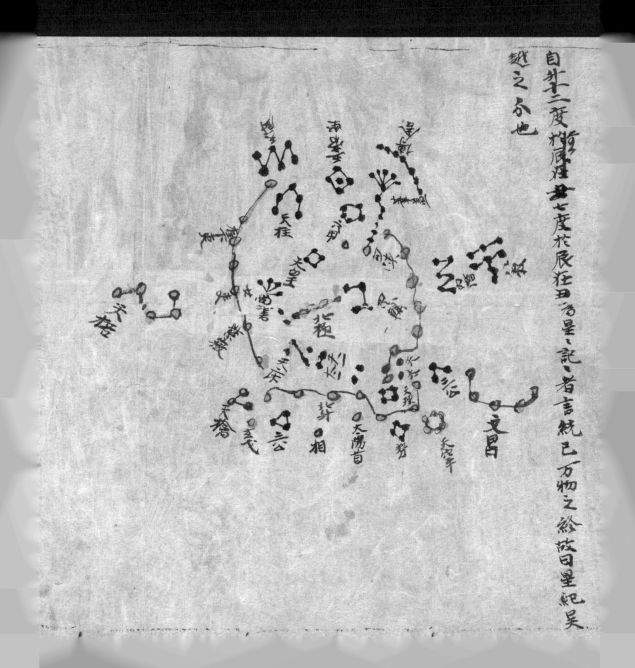

↓ 179 The Zodiac and the Planets from a French transla-
tion of Bartholomeus Anglicus *De proprietatibus rerum*
(*On the Properties of Things*), *c.* 1480

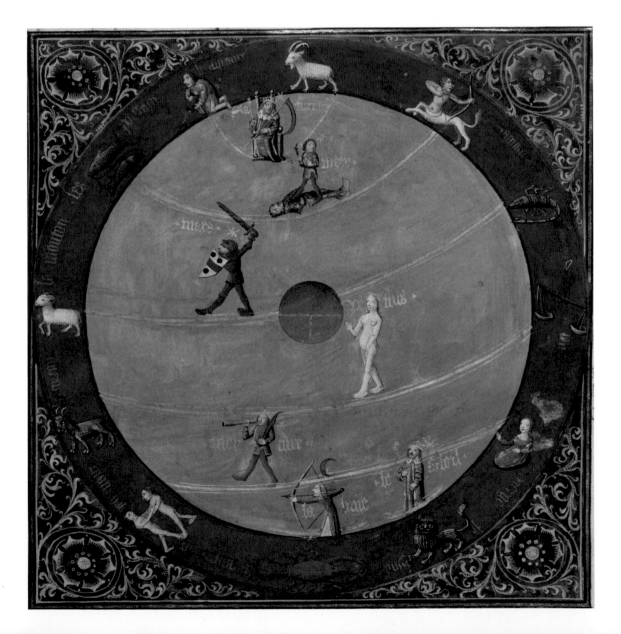

↓ 180 The Angel Ruh holding the celestial spheres in this detail of a folio leaf from a sixteenth-century manuscript of *The Wonders of Creation and the Oddities of Existence*, a treatise on the marvels of the universe written by cosmographer and geographer Zakariya ibn Muhammad al-Qazwini (1203–83)

In Islamic sacred texts Ruh (also known as Ruh al-Qudus) is both an Angel of Divine Revelation and a representation of the Human Soul in its purest form.

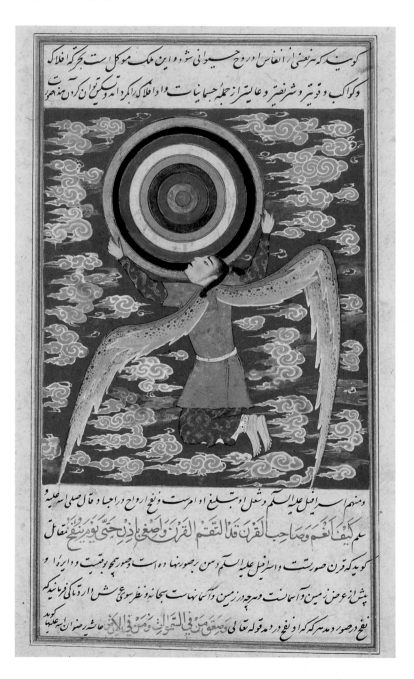

↓ 181 Celestial Spheres, the Abode of Angels, from the
*Introduction à la Cabale, dédiée au roi François Ier* by Jean
Thenaud, Nantes, 1536

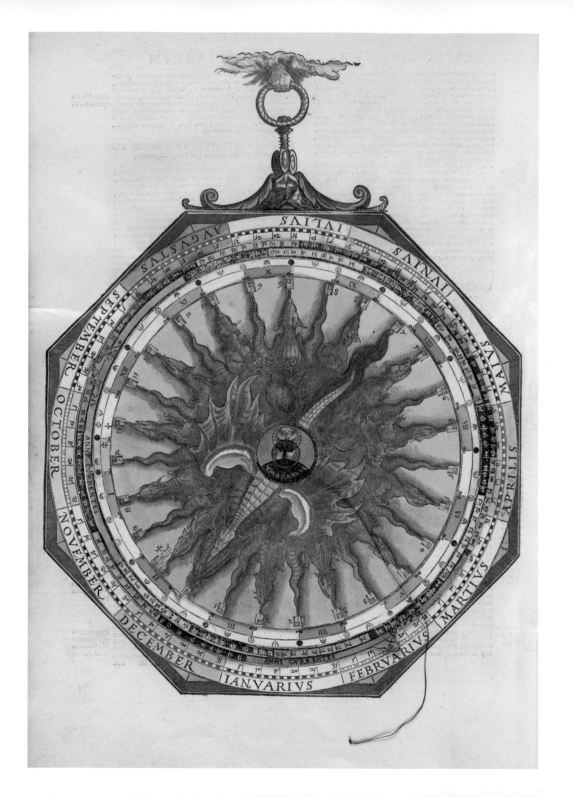

← 182 Volvelle from *Astronomicum Cæsareum* (*The Emperor's Astronomy*) by Peter Apian, Germany, 1540
This monumental work included 21 ingeniously engineered, hand-coloured, paper volvelles (used to calculate the phases of the sun and moon), with moving parts and index threads which were originally weighted with real pearls.

↓ 183 The Flammarion Engraving, wood engraving by an unknown artist that first appeared in *L'atmosphère, Météorologie Populaire* by Camille Flammarion, France, 1888

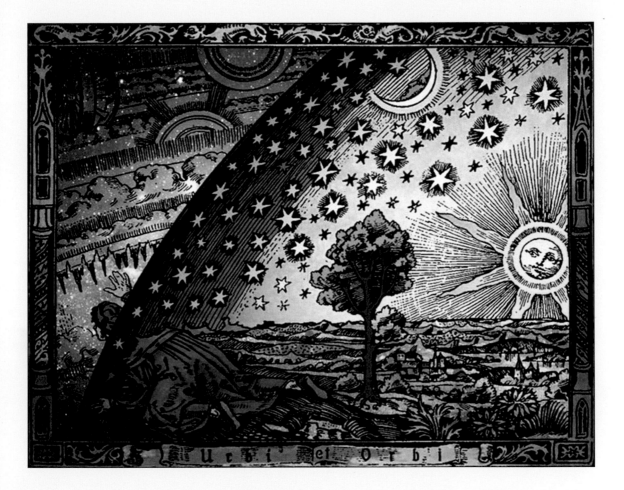

listen: there's a hell
of a good universe next door: let's go

— E. E. Cummings, 'pity this busy monster, manunkind', 1944

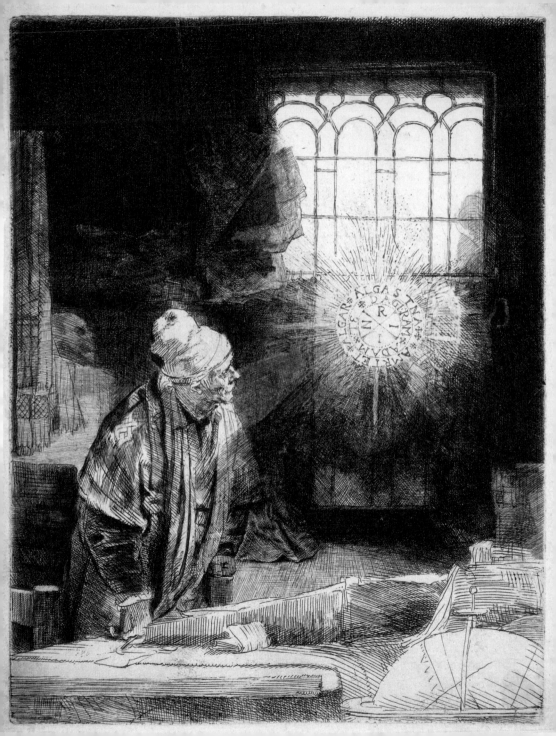

# THE INVISIBLE

# WORLD

← ← **184** *Faust* (also known as *The Scholar in his Study*) by Rembrandt van Rijn, etching, drypoint and burin on paper, *c.* 1652

→ **185** Illustration from *Recueil D'Emblemes Divers: Avec Des Discours Moraux, Philosophiques, et Politiques* by Jean Baudoin, Paris, 1638

ACCORDING TO ISLAMIC tradition, God created three races of intelligent beings – angels, who are made of light, humans, who are made of earth, and Jinn, who are made of smokeless fire.

The Jinn were created many thousands of years before Adam and, although some resemble humans in their appearance, habits and appetites, others are more closely related to angels or demons. There are good Jinn and bad Jinn, male Jinn and female Jinn. The most powerful among their ranks are incorporeal shape-shifters, composed of little more than the air itself.

Jinn sometimes appear in the form of clouds, whirlwinds or towering, yet insubstantial, pillars stretching far into the heavens. They can also manifest in human or animal form, most commonly as predatory or venomous creatures such as lions, jackals, scorpions or snakes. When Jinn assume human form, they sometimes appear as colossal, misshapen giants and their appearance reflects their intentions – those with good intentions appear devastatingly handsome, those with evil intentions appear indescribably hideous. Certain members of the shape-shifting Jinn elite also have the ability to dematerialise, disassemble and reassemble themselves at will, thus enabling them to vanish into thin air and to walk through most impenetrable rock.

The evil Jinn's staple diet consists of raw flesh and rotting fruit, and their preferred dwelling places are cemeteries, ruined buildings, cisterns, wells and crossroads. The most irredeemable Jinn are responsible for a wide variety of crimes and misdemeanours, ranging from petty acts of mischief and vandalism – such as the pilfering of provisions, loitering on roofs throwing stones at passers-by or tripping the unwary – to the most heinous crimes, such as kidnapping and stealing human souls.

In spite of these grievous character flaws, certain very wise humans have managed to subjugate and tame the Jinn and recruit them to noble causes. It is rumoured, for example, that both the pyramids of ancient Egypt and the Temple of King Solomon were built with the assistance of a vast conscripted army of Jinn.

Although the Jinn are closely related to angels they will never be admitted to paradise. While some manage to ascend as far as the borderlands of heaven, the Jinn's inability to conquer their baser nature and overcome selfish desires prevents them from travelling further. Overweening pride, wilful ignorance and a complete absence of scruples, compassion and consideration for other living things mean that the Jinn are condemned to forever haunt the shadow lands and lesser realms of God's Creation.

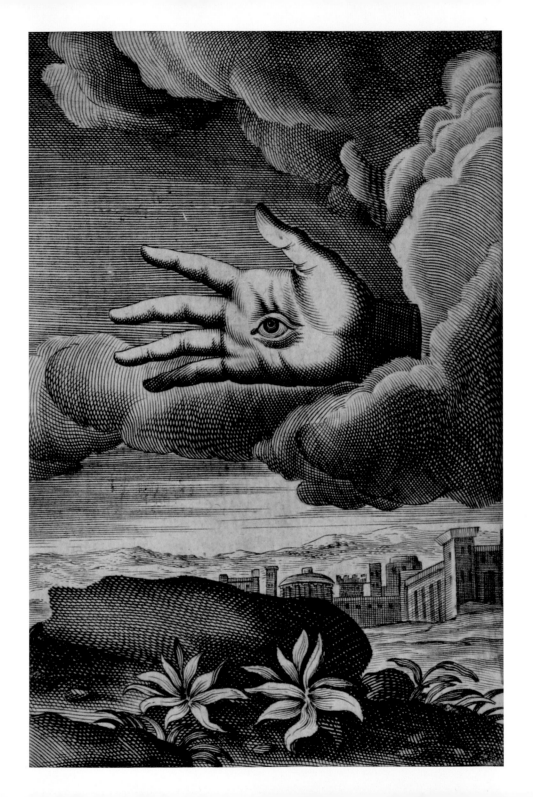

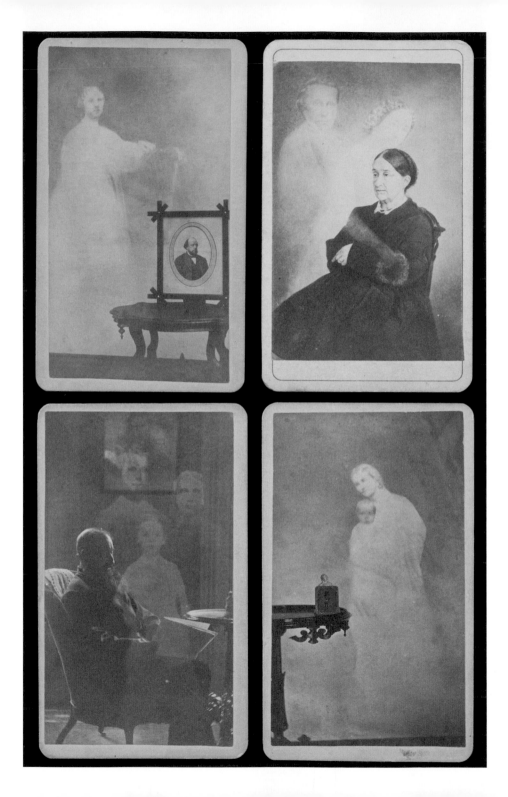

← **186** 'Spirit' photographs by William H. Mumler, (a) *Mr. Brown & his spirit sister recognised*, (b) *Mrs. Swan*, (c) Unidentified man with a long beard seated with three 'spirits' and (d) *Mr. Chapin, oil merchant – & his spirit wife & babe recognised*, albumen silver prints, Boston, Massachusetts, 1862–75

↓ **187** Puck and Fairies from *A Midsummer Night's Dream* by Joseph Noel Paton (Scottish, 1821–1901), oil on millboard, *c.* 1850

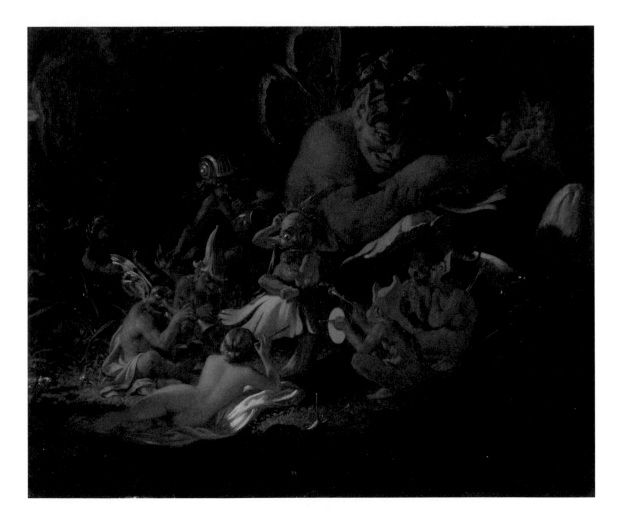

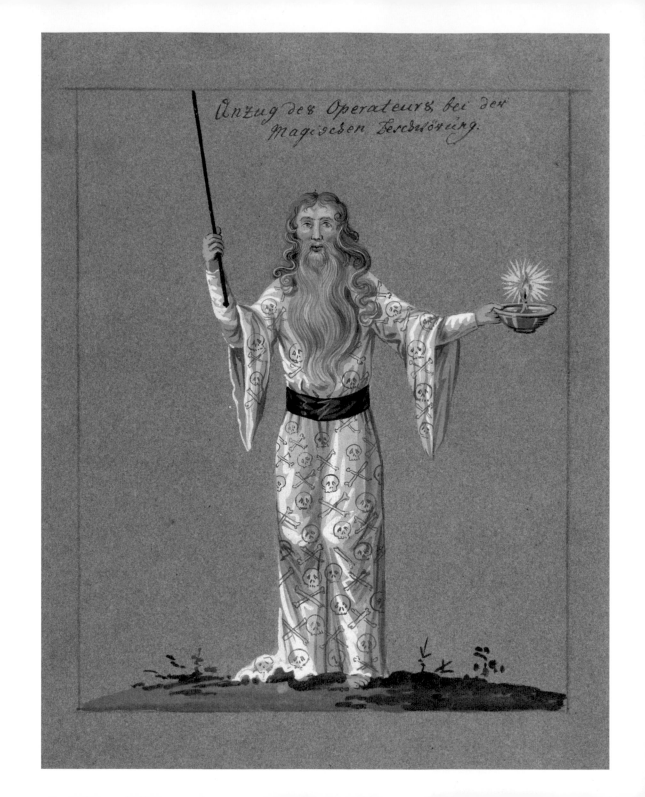

Anzug des Operateurs, bei der
magischen Beschwörung.

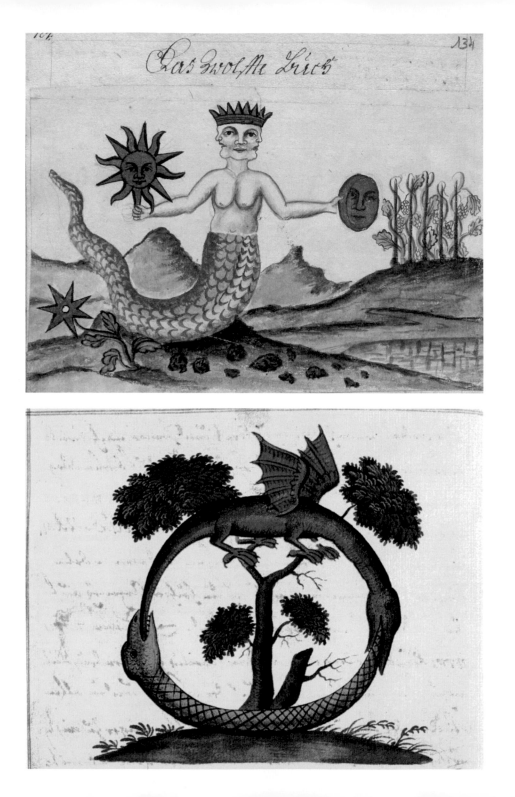

← **190** (a & b) Illustrations from *Clavis Artis, Alchemical Symbols from Zoroaster*, an alchemical manuscript published in Germany in three volumes in the late seventeenth or early eighteenth century, attributed to 'Zoroaster' (Zarathustra). It features numerous watercolour illustrations depicting alchemical images, as well as pen drawings of laboratory instruments.

↓ **191** Black Angel, unknown artist, watercolour painting from the German alchemical text *Aurora Consurgens*, *c.* 1420

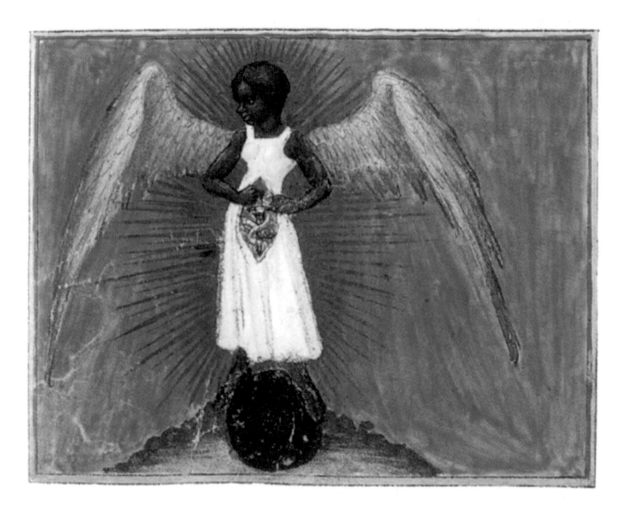

↓ 192 Detail from one of the *c.* 21 surviving alchemical scrolls associated with George Ripley (*c.* 1415–95), an Augustinian canon from Bridlington, Yorkshire Ripley was a renowned alchemist and author of esoteric works composed in verse, and these scrolls, commonly known as 'Ripley Scrolls', are sixteenth- and seventeenth-century copies of his, now lost, original work.

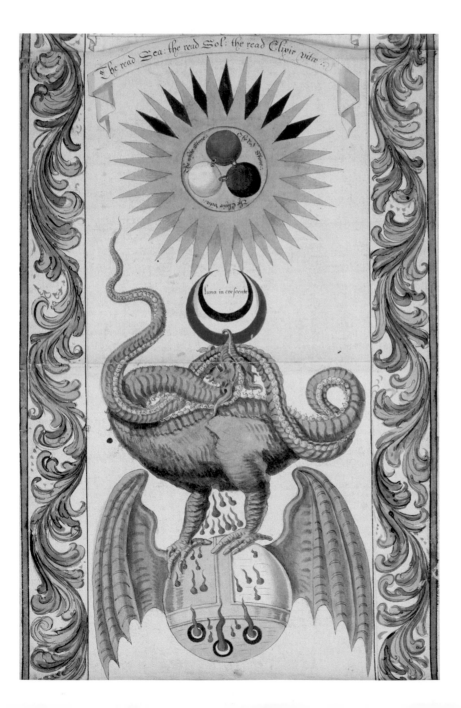

Man's perceptions are not bounded
by organs of perception; he perceives
more than sense (tho' ever so acute)
can discover.

— William Blake, *There is No Natural Religion*, 1788

In the Destroyer's steps
there spring up bright creations
that defy his power, and his dark path
becomes a way of light to Heaven.

— Charles Dickens, *The Old Curiosity Shop*, 1840–41

**↓ 193** *New Year's Eve Foxfires at the Changing Tree, Ōji* by Utagawa Hiroshige (Japanese, 1797–1858), woodblock print; ink and colour on paper, from the series 'One Hundred Famous Views of Edo', 1857
At New Year's Eve, foxes meet at the enoki tree to pay homage at the Ōji Inari shrine. The foxes serve as the messengers of the god of the rice fields, and on their way to Ōji they emit unearthly flames which farmers regard as omens by which they can calculate the likely success or failure of the coming year's harvest.

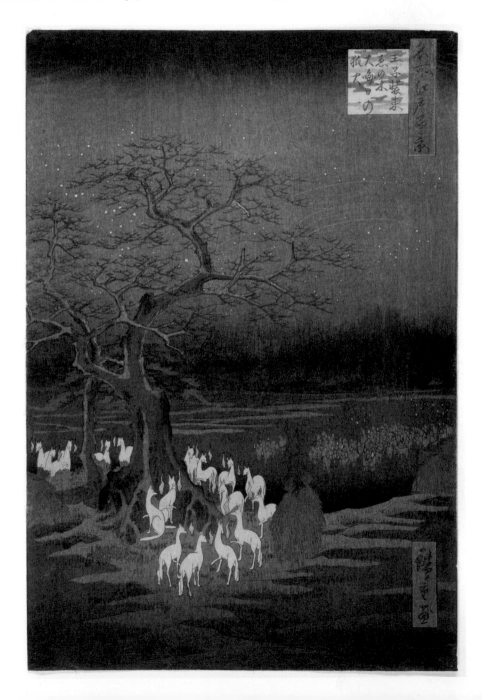

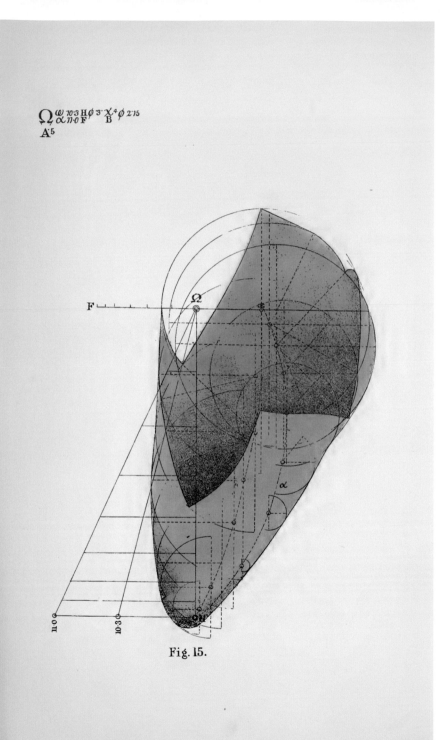

Ω   $\omega$ 10·3 H $\phi$ 3″ χ⁴ $\phi$ 2·15
   $\alpha$ 11·0 F′   B
A⁵

F

Ω

$\alpha$

11·0

10·3

Fig. 15.

▸ **194** Diagram from *Geometrical Psychology, or, The Science of Representation: An Abstract of the Theories and Diagrams of B. W. Betts* by Louisa S. Cook, 1887, which details New Zealand-born psychologist Benjamin Betts' attempts to create mathematical models of human consciousness using geometric forms, many of which are almost floral in structure

▸ **195** *Il y eut peut-être une vision première essayée dans la fleur* (*There Was Perhaps a First Vision Attempted in the Flower*) by Odilon Redon (French, 1840–1916), lithograph, 1883

↓ 196  Mano Poderosa (The All-Powerful Hand), or Las
Cinco Personas (The Five Persons), artist unknown, oil
on metal (possibly tin-plated iron), Mexican, nineteenth
century

→ 197  The Alchemist Who Has Achieved Illumination,
illustration from *Clavis Artis, Alchemical Symbols from
Zoroaster*, German, late seventeenth or early eighteenth
century

↓ **198** Group X, No. 1, Altarpiece (Grupp X, nr 1, Altarbild), from *Altarpieces* (Altarbilder), by Hilma af Klint, oil and metal leaf on canvas, 1915
In her series of Altarpieces, Hilma af Klint depicts the relationship between the physical and the spiritual world. The pyramid shape in this example points towards spiritual enlightenment and salvation, represented by the perfect golden circle.

→ **199** A black sun with a face descends behind the horizon of a marshy landscape from the alchemical text *Splendor Solis*, attributed to 'Salomon Trismosin' and probably created in Germany during the sixteenth century
The black sun represents the state of putrefaction in alchemical processes.

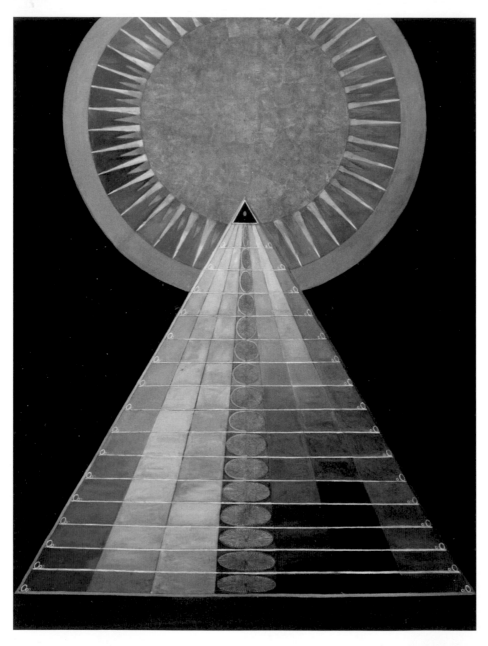

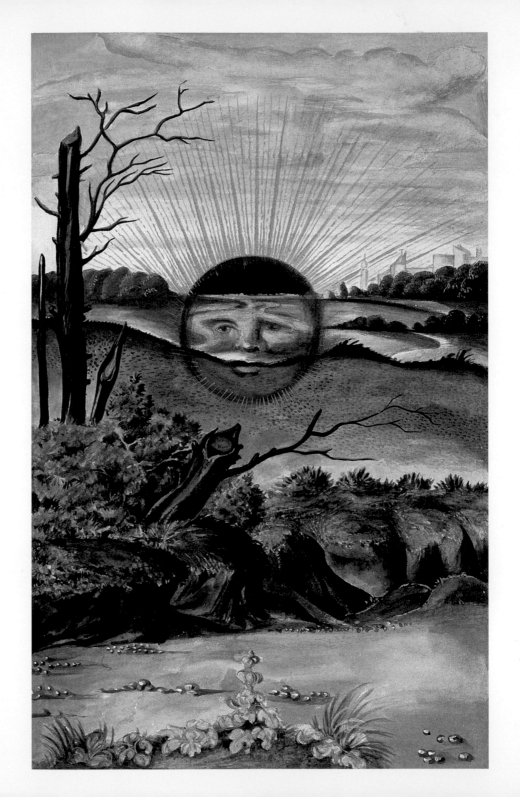

When sorrow lays us low
for a second we are saved
by humble windfalls
of mindfulness or memory:
the taste of a fruit, the taste of water,
that face given back to us by a dream,
the first jasmine of November,
the endless yearning of the compass,
a book we thought was lost,
the throb of a hexameter,
the slight key that opens a house to us,
the smell of a library, or of sandalwood,
the former name of a street,
the colours of a map,
an unforeseen etymology,
the smoothness of a filed fingernail,
the date we were looking for,
the twelve dark bell-strokes, tolling as we count,
a sudden physical pain.

Eight million Shinto deities
travel secretly throughout the earth.
Those modest gods touch us –
touch us and move on.

— Jorge Luis Borges (1899–1961), 'Shinto'

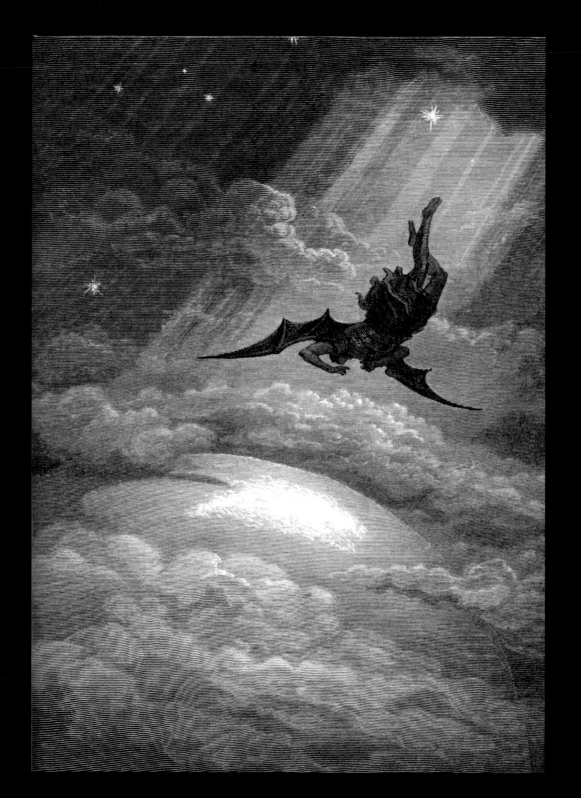

# GODS

# AND MONSTERS

THE EIGHTEENTH-CENTURY Swedish philosopher and visionary Emanuel Swedenborg argued that every devil, just like every angel, began its life as a mortal human being. No just or wrathful judge condemns devils to hell or raises angels up to heaven. The fate of every soul lies in his, or her, own hands and the path they take is entirely of their choosing.

Every soul is welcome in heaven but devils prefer eternal night and bottomless perdition to the glories of paradise, and feel at home among the bogs, murk and barren wastes of hell. The pure air of heaven chokes them, while the scorching light of revelation provides no hiding place for their inner ugliness and their hateful, hollow cores.

In death, as in their former lives, the devils are happy in their misery, cursed with an inability to experience profound emotions – sorrow, regret, joy and contentment are completely unknown to them (although every devil knows that they are far happier in hell than they would be in heaven). The devils take great pride in their appearance, even though most have the faces of hideous beasts or misshapen monsters, while others have no face at all. They regard themselves as fearless, brave and bold, yet flinch and flee in terror whenever an occasional shaft of heavenly light pierces the infernal gloom.

They exist in a perpetual state of fear, rage, distrust and simmering mutual hatred, punctuated by sporadic outbreaks of internecine violence. Occasionally, a truce is called and the devils come together to scheme, conspire and hatch plots against each other or against enemies both real and imagined. Life in hell has been like this since the dawn of time, and it will be like this for ever. Such is the dismal fate of all those souls who, of their own free will, wander down the path of darkness.

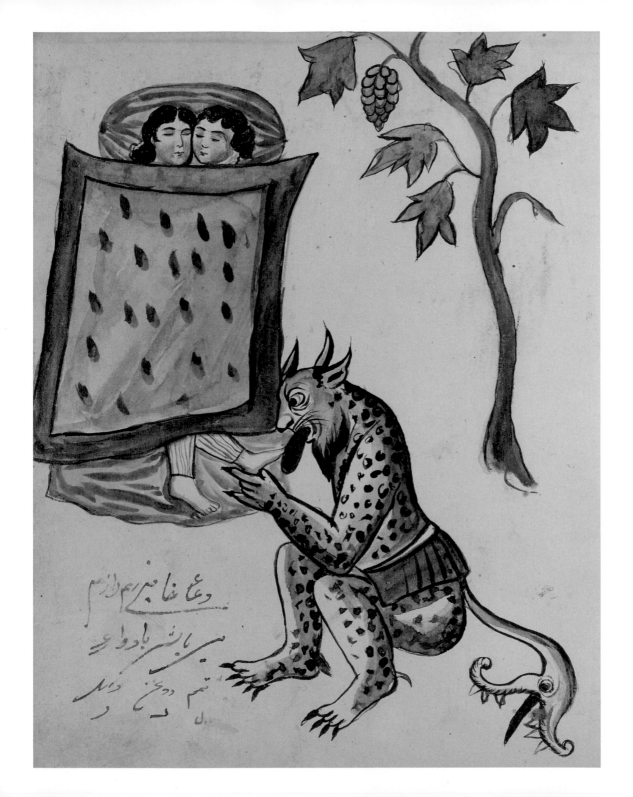

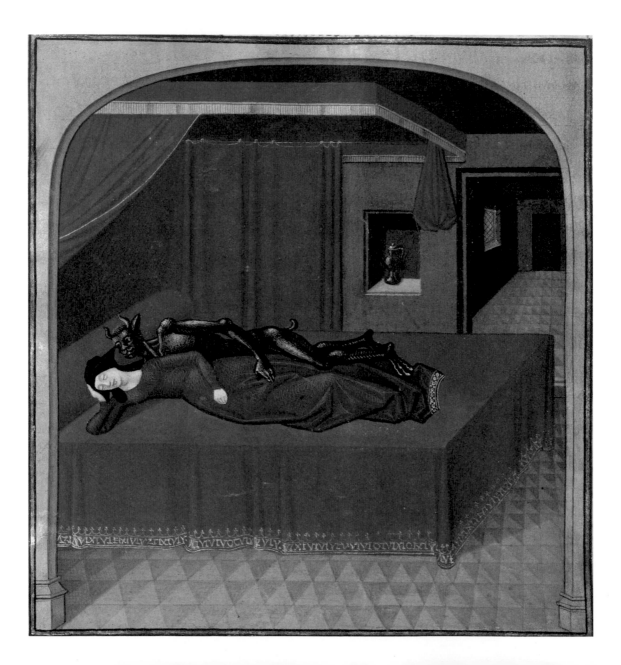

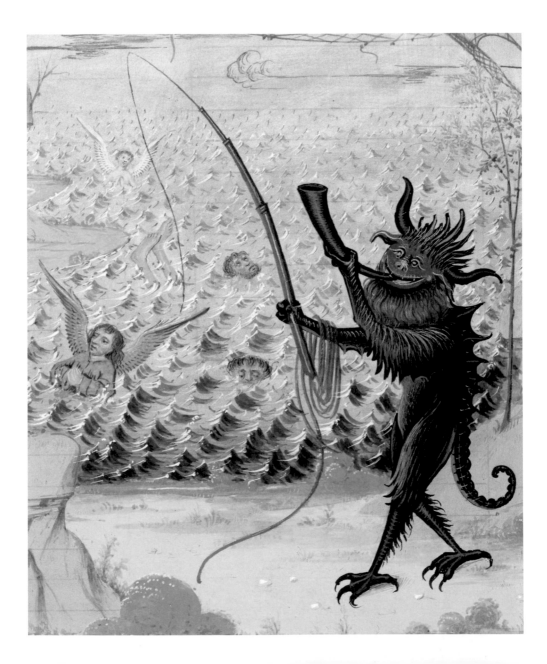

↓ 204 The Seven-Headed Beast from the Sea, from the *Trinity Apocalypse*, an illustrated version of the Book of Revelation of St John created in England in the mid-thirteenth century

→ 205 The Seven-Headed Beast from the Sea, from the *The Beatus of Facundus* (also known as the *Beatus of León*), a lavishly illustrated eleventh-century version of a commentary on the Book of Revelation originally composed by a monk named Beatus in a monastery in northern Spain during the eighth century

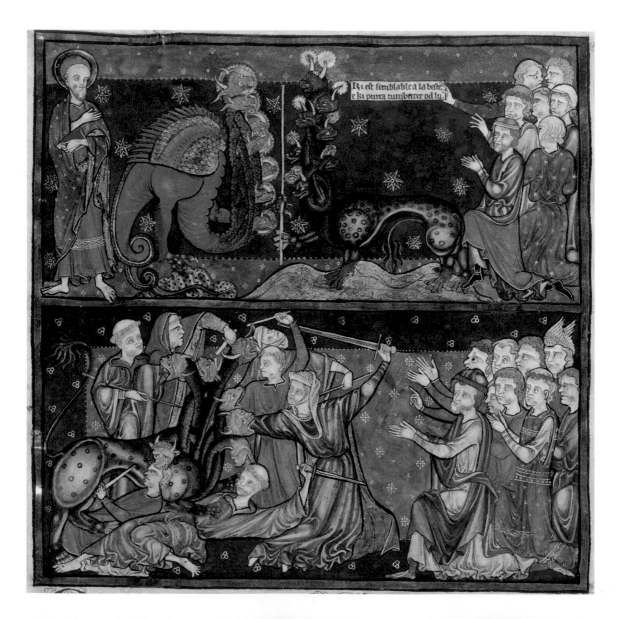

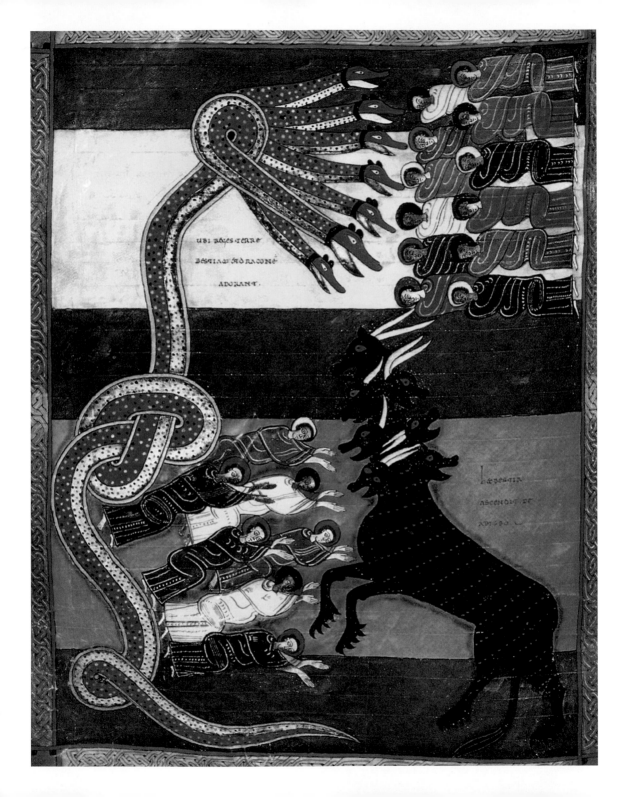

que bien y entraffent de
front a une fois dix mille
chenalliers armez tous
a chenal. Celle horrible
befte auoit en fa gueule
deux grans diables tres
hideulz et cruelz a veoir
dont lun auoit fichiee fa
tefte ene ce dens de hault
Et ce dens de bas eftoiet
fes pies fichiee Et lautr
quy famouftroit plus en
parfont eftoit au cotraire
Car il auoit fa tefte atta
chie ce dens de bas et fes
pies fe fichoient parml
les dens deffeure. Et la

eftoient ces deux diables
en la gueule de celle befte
enfement come deux cou
lombes Et faifoient en
icelle gueule troie portee
Vngt merueillens feu en
grandeur quy iamaie ne
pouoit eftandre yffoit de
icelle gueule quy fe depar
toit en troie partiee. Et
lee amee dempnees entroi
ent en celle gueule tout
parml la flambe La pu
anteur fi grande en ptoit
que il nen eftoit nulle pa
reille Et fi ouoit lefperit
du chenalier lee douloureuse

← **206** Hell Mouth by Simon Marmoin (Flemish, active 1450–89) from *Les Visions du chevalier Tondal* by David Aubert, tempera colours, gold leaf, gold paint and ink on parchment, 1475

↓ **207** Offering Cabinet (Torgam) with a fearsome, protective deity or red Mahākāla, wood with mineral pigments, Tibet, nineteenth or twentieth century

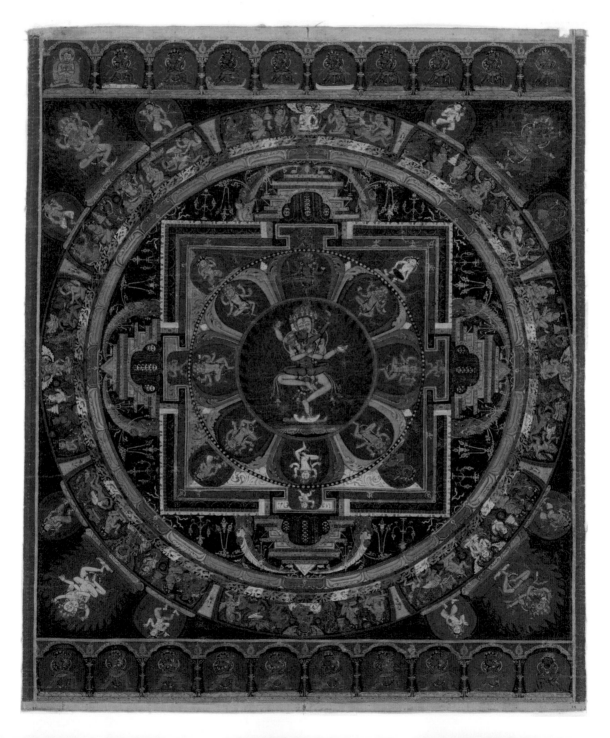

There is not any book
Or face of dearest look
That I would not turn from now
To go into the unknown
I must enter, and leave, alone,
I know not how.

— Edward Thomas (1878–1917), 'Lights Out', 1917

. . . when all the world dissolves,
And every creature shall be purified,
All places shall be hell that are not heaven.

— Christopher Marlowe, Mephistophilis in
*The Tragical History of Doctor Faustus*, first performed 1588

→ 209 *The Fall of the Rebel Angels* by Pieter Bruegel the Elder, oil on oak, 1562

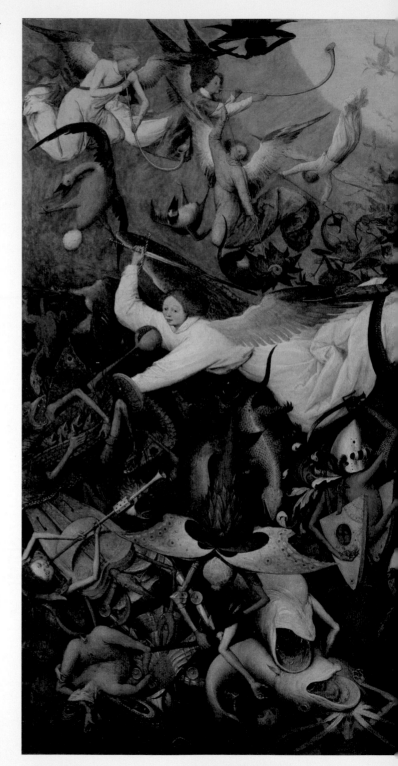

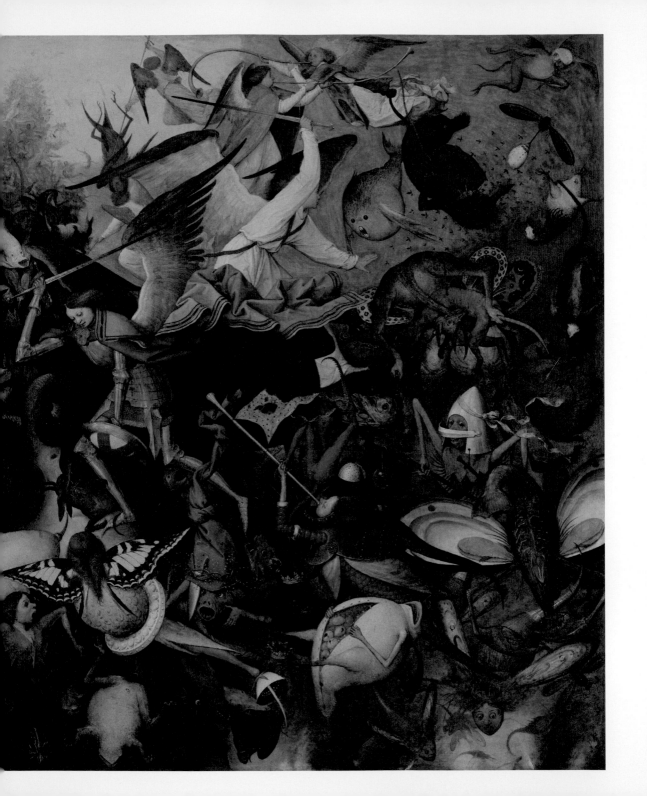

↓ 210 Eskandar (Alexander the Great) Contemplates the
Talking Tree, from the *Shahnameh* by Ferdowsi, illuminated
by Nasr al-Soltani, opaque watercolours, ink and gold on
paper, Shiraz, Iran, *c.* 1430
Outside a city at the edge of the known world is a tree with
miraculous powers, for the fruits it produces are the talking
heads of men, women and monstrous animals that are
blessed with the powers of prophecy. When Alexander the
Great visited the tree he heard the prophesy of his death.

→ 211 The Prophet, Khizr Khan Khwaja, from an album
of miniatures and portraits compiled by an unknown artist
in Mughal India, *c.* 1760
According to both Muslim and certain Hindu traditions,
the prophet Khwaja Khizr Khan discovered the source of
the water of life. He is considered the patron and guardian
of the waters, particularly the river Indus. Traditionally
dressed in green and mounted on a fish on which he travels,
the Prophet is also regarded as the patron saint of travellers.

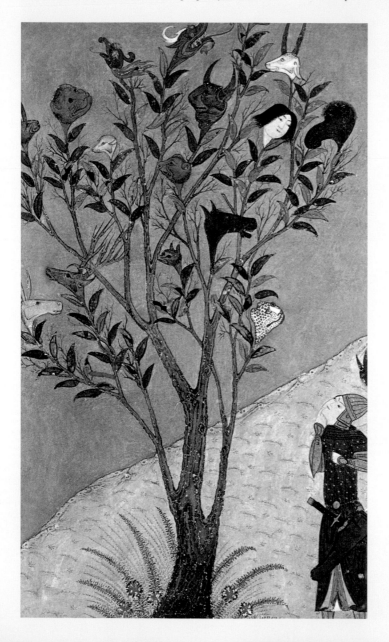

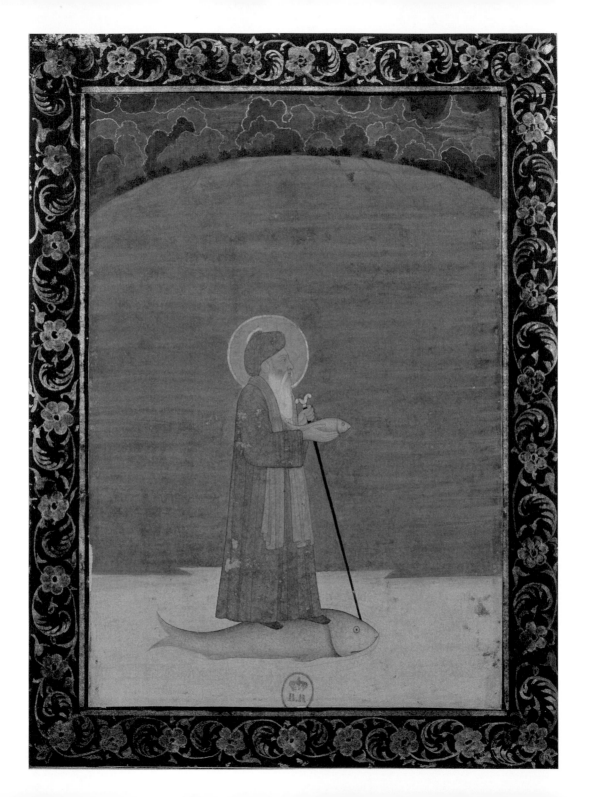

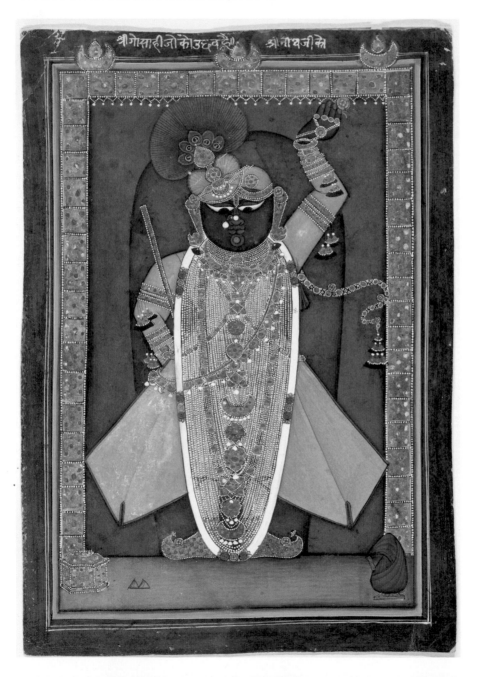

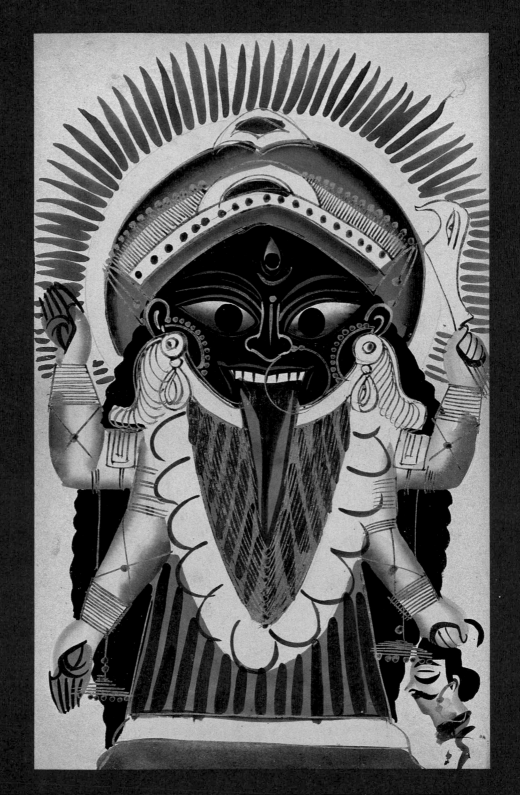

عن علي كرم الله تعالي وجهه

كان اذا وصف النبي صلى الله عليه وسلم قال لم يكن
بالطويل الممغط ولا بالقصير المتردد وكان ربعة من القوم
ولم يكن بالابيض الامهق ولا بالآدم
بعيد ما بين المنكبين وكان ازهر اللون حسن الجسم ولم يكن بالجعد القطط ولا بالسبط
كان جعدا رجلا ولم يكن
بالمطهم ولا بالمكلثم
وكان في وجهه تدوير ابيض مشربا ادعج العينين اهدب الاشفار
جليل المشاش والكتد اجرد ذو مسربة شثن الكفين والقدمين
اذا مشى تقلع كانما يمشي في صبب واذا التفت التفت معا بين كتفيه
خاتم النبوة اجود الناس صدرا واصدقهم لهجة والينهم عريكة واكرمهم
عشرة من رآه بديهة هابه ومن خالطه معرفة احبه
يقول ناعته لم ار قبله ولا بعده مثله

← **214** Hilye (Calligraphic Portrait of the Prophet Muhammad) by Niyazi Efendi, ink, opaque watercolour and gold on paper, Turkey, 1270 A.H. (1853–54 CE)

↓ **215** Herald Angel, detail of a detached leaf from the *Emerson-White Book of Hours* by the Master of the Houghton Miniatures (Flemish, active in Ghent *c.* 1476–80), tempera colours and gold paint on parchment

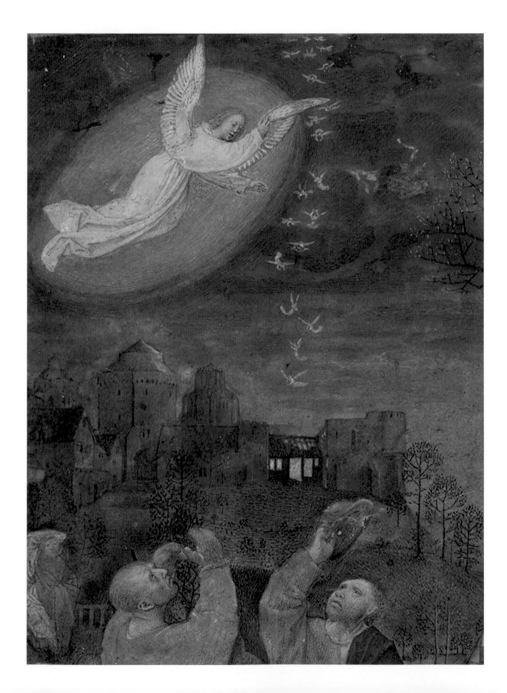

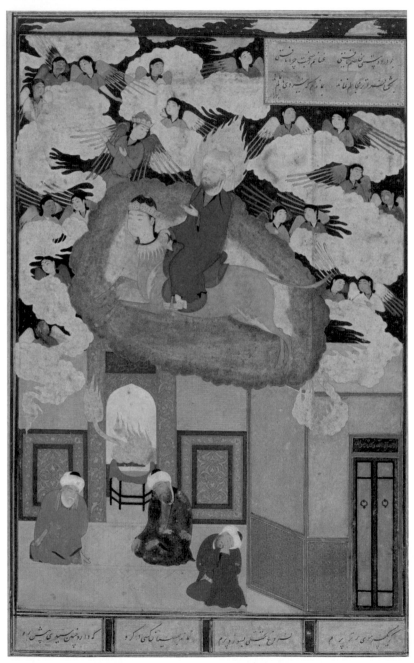

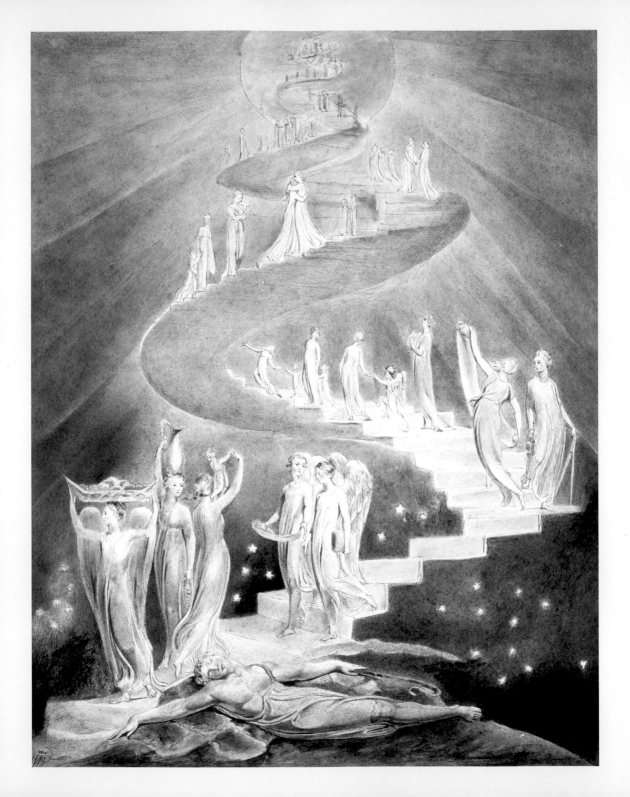

Though Earth and moon were gone
And suns and universes ceased to be
And thou wert left alone
Every Existence would exist in thee

There is not room for Death
Nor atom that his might could render void
Since thou art Being and Breath
And what thou art may never be destroyed.

— Emily Brontë, 'No Coward Soul is Mine', 1846
    (Emily Dickinson asked for this poem to be read at her funeral.)

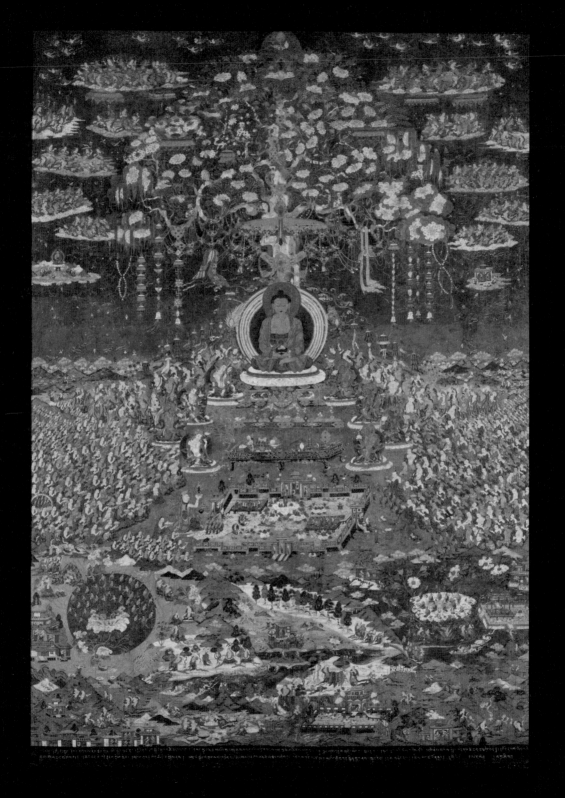

# VISIONS
# OF ETERNITY

IN CHINESE BUDDHIST MYTHOLOGY, those righteous souls who have lived blameless, exemplary lives are sent to one of two heavenly realms – the Kunlun Mountain, home of the Immortals, or the Land of Extreme Felicity in the West.

Kunlun Mountain is located far away from China at the very centre of the earth and is ruled over by the Lady Queen of the West, wife of the August Personage of Jade, the supreme ruler of heaven and lord of all creation. At the summit of the mountain sits the magnificent nine-storey palace of the Immortals, built entirely of jade. The palace is surrounded by enchanted gardens, in which grows the Peach Tree of Immortality.

The Immortals entertain themselves with endless feasting, entertainments and amusements of every imaginable (not to mention unimaginable) kind and an eternal pursuit of pleasure and spiritual gratification. The only humans permitted to visit Kunlun are those exceedingly rare, supremely virtuous men and women who are granted a taste of the miraculous fruit of the Peach Tree of Immortality even while their lives as mortals are not yet over.

The remaining righteous souls are sent to the Land of Extreme Felicity in the West. This land, which lies at the far western perimeter of the universe, is separated from our own mortal plane by an infinity of worlds resembling our own. It is a land of pure delight, shielded from the realms beyond by insurmountable walls featuring seven rows of terraces, lined with seven rows of trees whose branches are formed of precious gems and crystals which create sublime music when the heavenly winds pass through them. The lakes and the streams that are found in the Land of Extreme Felicity are abloom with magnificent lotuses and water lilies. The banks of the lakes and streams are paved with jewels and the sand which forms their beds is purest gold. Exotic birds with dazzling, many-coloured plumage and heavenly voices praise the five Virtues and the four Noble Truths with their songs. A constant shower of pure white blossom falls from the sky, perfuming the air and dizzying the senses.

Every morning at dawn the righteous offer flowers to all the Buddhas of all the infinite worlds. Everything that surrounds them, everything they see in this paradise reminds them of Buddha, the law and the universal force of divine love. They may have lived and struggled through many lifetimes and many transmigrations of the soul, facing untold hardship, sorrow, pain and loss along the way, but now, at last, their suffering is at an end.

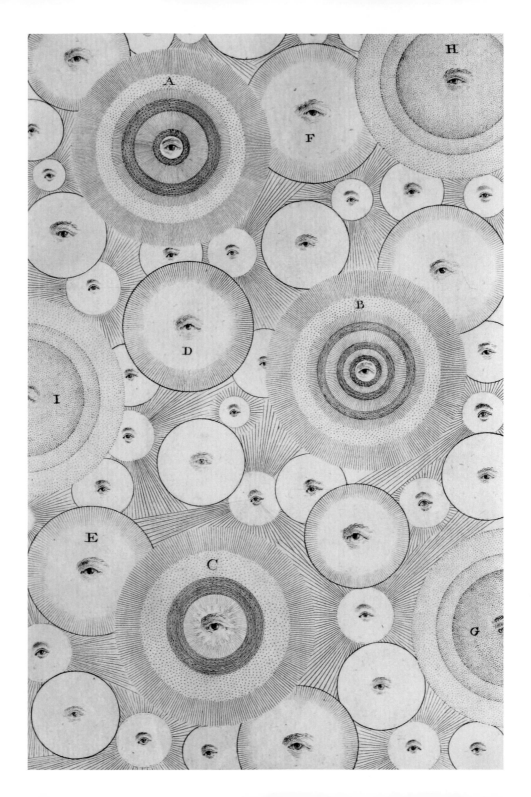

↓ **220** *The Saintly Throng in the Form of a Rose* by Gustave Doré, illustration for Dante's *Divine Comedy*, woodcut, 1868
In the Empyrean, the highest heaven, Dante and his beloved Beatrice are shown the dwelling place of God. It appears in the form of an enormous rose, the petals of which house the souls of the faithful. Around the centre of the rose angels fly like bees carrying the nectar of divine love.

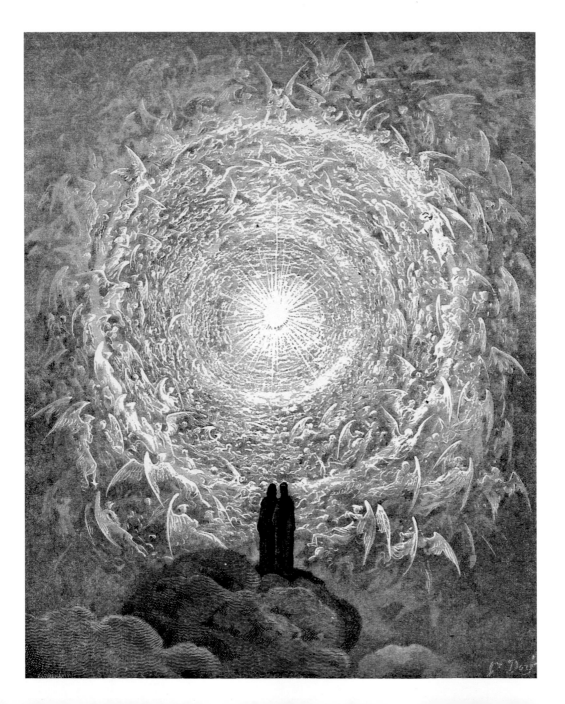

221 Design for Mozart's *The Magic Flute*: The Hall of Stars in the Palace of the Queen of the Night, Act 1, Scene 6. Aquatint printed in colour and hand coloured, print by Karl Friedrich Thiele, after Karl Friedrich Schinkel's original production designs from 1816, 1847–49

→→ 222 (a & b) The Communion of Saints from the *Book of Hours of Louis de Laval*, illuminations by Jean Colombe and others, France, *c.* 1470–80

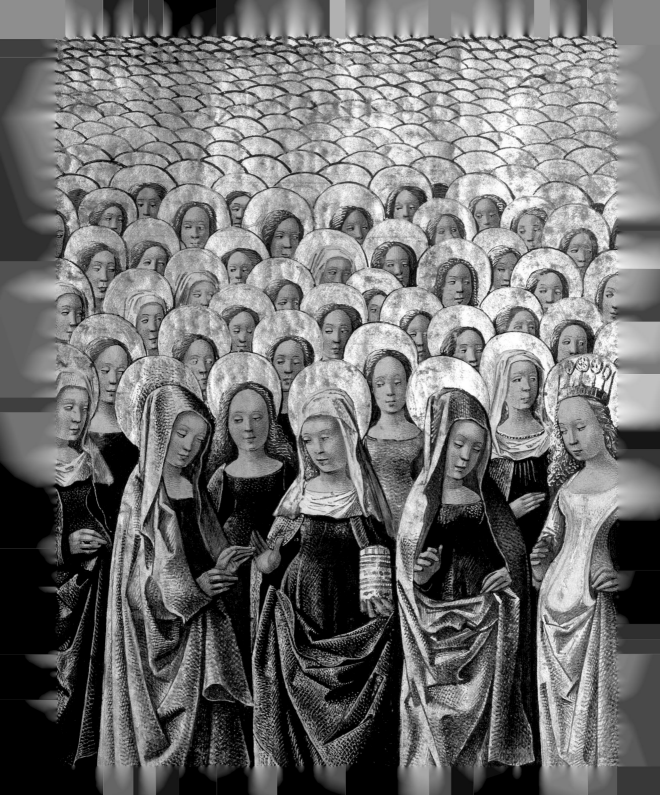

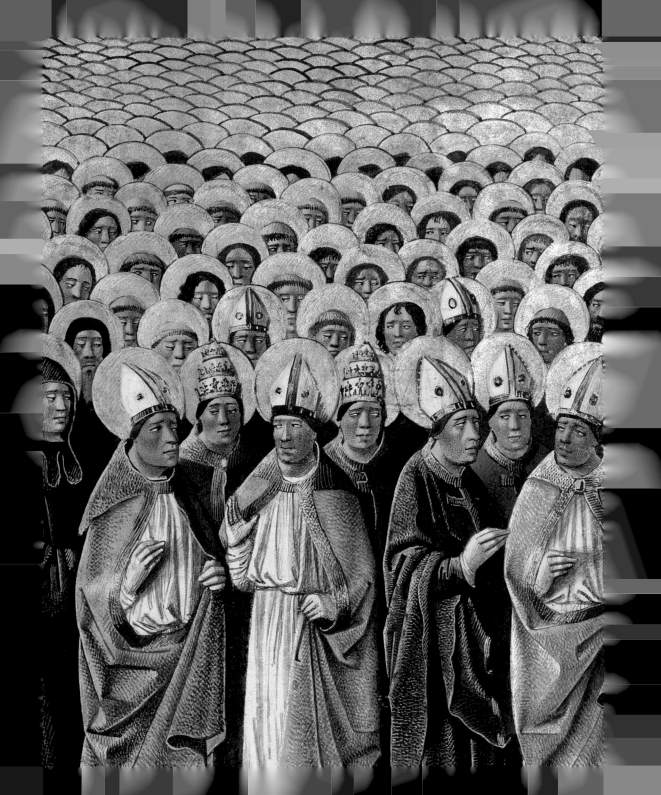

223 A vision of the Cabalistic universe from the
Introduction à la Cabale, dédiée au roi François Ier by
Jean Thenaud, Nantes, 1536

224 Lokapurusha (Cosmic Man), Jain pai
anonymous artist, opaque watercolour, Raja
nineteenth century

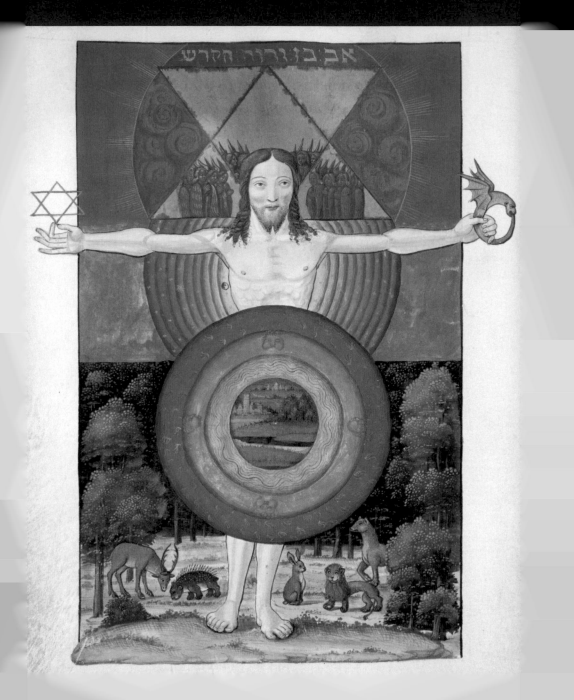

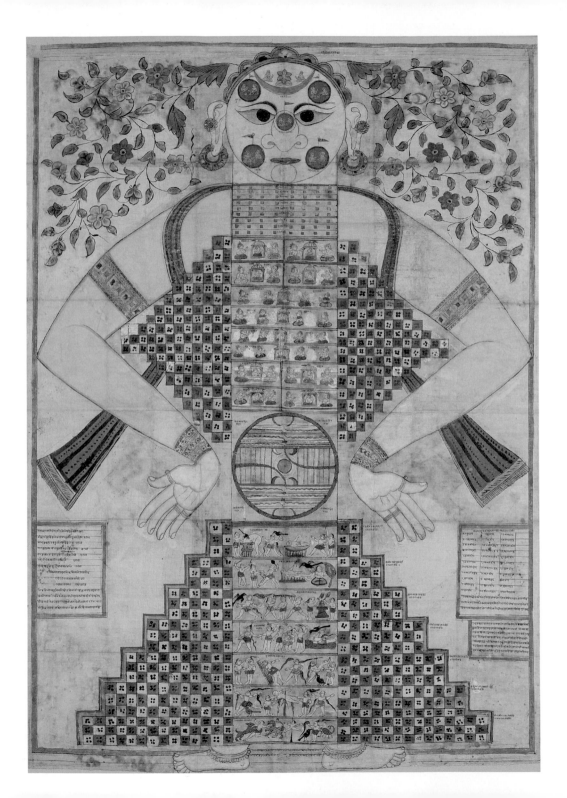

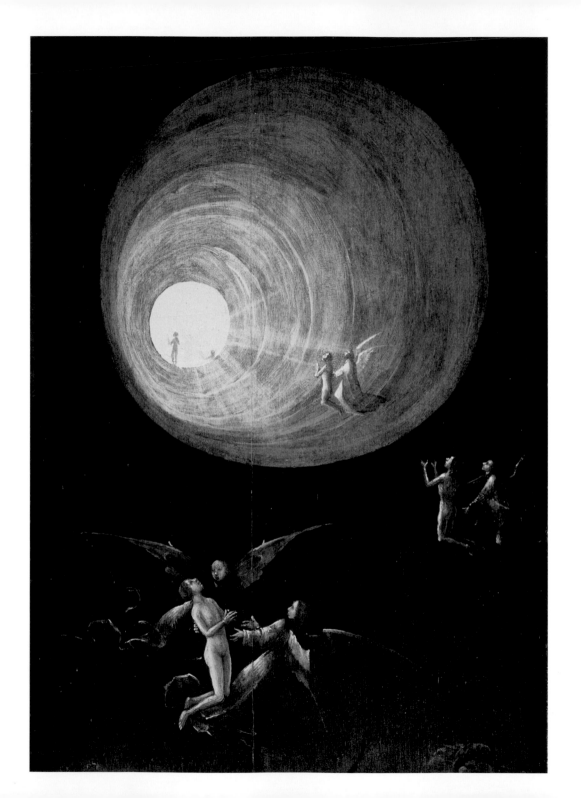

← 225 *Ascent of the Blessed* (detail) by Hieronymus Bosch, oil on panel, *c.* 1500–04
This painting is part of a polyptych of four panels entitled *Visions of the Hereafter*. The others are *Terrestrial Paradise*, *Fall of the Damned into Hell* and *Hell*.

↓ 226 (a) *Ensō (Proper)* by Nakahara Nantenbo (Japanese, 1839–1935), ink on paper, no date (b) *Ensō* by Taidō Shūfū (Japanese, 1776 –1836), hanging scroll, ink on paper, nineteenth century

227 *Suprematist Composition: White on White* by Kazimir Malevich, oil on canvas, 1918

228 *Black Square* by Kazimir Malevich, oil on linen, early 1920s

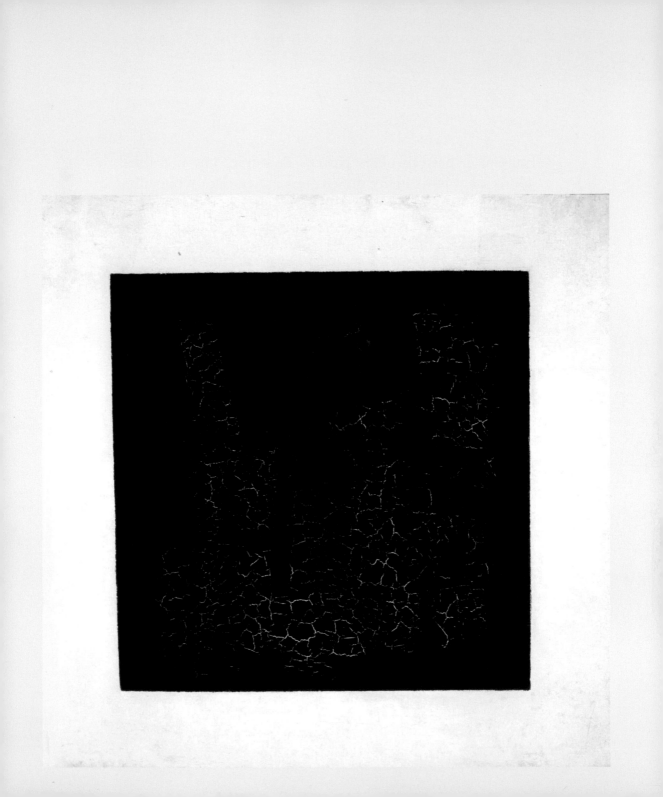

Imagine a pattern. This pattern is stable, but not fixed. Think of it in as many dimensions as you like – but it has more than three. This pattern has many threads of many colours, and every thread is connected to, and has a relationship with, all of the others. The individual threads are every shape of life. Some – like human, kangaroo, paperbark – are known to western science as 'alive'; others like rock, would be called 'non-living'. But rock is there, just the same. Human is there too, though it is neither the most or the least important thread – it is one among many; equal with the others. The pattern made by the whole is in each thread, and all the threads together make the whole. Stand close to the pattern and you can focus on a single thread; stand a little further back and you can see how that thread connects to others; stand further back still and you can see it all – and it is only once you see it all that you can recognise the pattern of the whole in every individual thread. The whole is more than its parts, and the whole is in all its parts. This is the pattern that the ancestors made. It is life, creation spirit, and it exists in country.

—Ambelin Kwaymullina (1975–)

# READING LIST

The introductions to the chapters of this book are my own free and loose interpretations and reworkings of myths, legends, fables and tall tales from all over the world, drawing upon multiple sources, a selection of which are listed below.

Just as the earliest encyclopedists, chroniclers and cataloguers of wonders both natural and unnatural were prone to hyperbole, shameless showboating and wild flights of fancy and fantasy, I too have taken the occasional liberty with some of my source material. I hope that any purists among you will see fit to excuse this slight indulgence.

Stephen Ellcock, July 2019

Aleksandr Afanas'ev (ed.), Norbert Gutterman (trans.), *Russian Fairy Tales*, Pantheon Books, New York, 1945

Apollodorus, Robin Hard (trans.), *The Library of Greek Mythology*, Oxford University Press, World's Classics, Oxford, 2008

Lucius Apuleius, Robert Graves (trans.), *The Golden Ass*, Penguin Classics, Penguin Books, London, 1950

Peter Christen Asbjørnsen, *Christmas Fireside Stories*, Sampson Low, Marston & Co. Ltd., London, 1919

Michael Ashkenazi, *Handbook of Japanese Mythology*, Oxford University Press, New York, 2008

Georges Bataille, Michelle Kendall (trans.), Stuart Kendall (trans.), *The Cradle of Humanity: Prehistoric Art and Culture*, Zone Books, New York, 2005

Mojdeh Bayat and Mohammad Ali, *Tales from the Land of the Sufis*, Shambhala Publications, Boulder, 2001

Jorge Luis Borges, Norman Thomas di Giovanni (trans.), *The Book of Imaginary Beings*, Vintage Classics, London, 2002

Katharine Briggs, *A Dictionary of Fairies: Hobgoblins, Brownies, Bogies and other Supernatural Creatures*, Penguin Books, London, 1979

Sir Thomas Browne, L. C. Martin (ed.), *Religio Medici and other works*, Oxford University Press, Oxford, 1964

Roberto Calasso, *The Marriage of Cadmus and Harmony*, Jonathan Cape, London/Alfred A. Knopf, New York, 1993

Italo Calvino, William Weaver (trans.), *The Complete Cosmicomics*, Penguin Books, London, 2009

Italo Calvino, George Martin (trans.), *Italian Folktales*, Penguin Classics, London, 2000

Norman Cohn, *The Pursuit of the Millennium: Revolutionary Millenarians and Mystical Anarchists of the Middle Ages*, Paladin Books, London, 1970

Basil Hall Chamberlain (trans.), *The Kojiki: Records of Ancient Matters*, Tuttle Classics of Japanese Literature, new edition, Tuttle Publishing, San Francisco, 2005

Lorraine Daston and Katharine Park, *Wonders and the Order of Nature, 1150–1750*, Zone Books, New York, 1998

H. R. Ellis Davidson, *Gods and Myths of Northern Europe*, revised edition, Penguin Books, London, 1990

Umberto Eco, William Weaver (trans.), *Serendipities: Language and Lunacy*, Weidenfeld & Nicolson, London/ Columbia University Press, New York, 1999

Lewis Richard Farnell, *The Cults of the Greek States*, five volumes, Cambridge University Press, Cambridge, 2010, originally published between 1896 and 1909

Charles Fort, *The Book of the Damned*, Abacus Books, London, 1973

Douglas Fraser (ed.), *African Art as Philosophy*, Interbook, New York, 1974

Sir James George Frazer, *The Golden Bough: A Study in Magic and Religion*, third edition, Macmillan, London, 1906–1915

Eduardo Galeano, Mark Fried (trans.), *Children of the Days*, Allen Lane, London/Nation Books, New York, 2013

Robert Graves, *The Greek Myths*, two volumes, Penguin Books, London, 1955

Robert Graves, *The White Goddess*, Faber & Faber, London, 1948 (expanded 1966)

Lady Augusta Gregory, *A Book of Saints and Wonders*, John Murray, London, 1907

Felix Guirand (ed.), Richard Aldington (trans.), Delano Ames (trans.), *The New Larousse Encyclopedia of Mythology*, Hamlyn Books, London, 1963

Lafcadio Hearn (trans.), *The Goblin Spider* (Japanese Fairy Tale), Hasegawa, 1899

Hesiod, (trans.), *Theogony and Works and Days*, Oxford World's Classics, Oxford, 2008

Ronald Hutton, *The Pagan Religions of the Ancient British Isles: Their Nature and Legacy*, Blackwell Publications, Oxford, 1991

Ronald Hutton, *The Stations of the Sun: A History of the Ritual Year in Britain*, Oxford University Press, Oxford, 1996

Robert Irwin (introduction), Malcolm Lyons (trans.), Ursula Lyons (trans.), *The Arabian Nights: Tales of 1,001 Nights*, three volumes, Penguin Classics, London, 2010

John Lemprière, *Lemprière's Classical Dictionary*, H. G. Bohn, London, 1853

Jean-Loïc Le Quellec, Paul Bahn (trans.), *Rock Art in Africa: Mythology and Legend*, Flammarion, Paris, 2004

Charles Mackay, *Extraordinary Popular Delusions and the Madness of Crowds*, Richard Bentley, London, 1841

Sybil Marshall, *Everyman's Book of English Folk Tales*, J.M. Dent & Sons, London, 1981

Joachim Neugroschel (author, trans.), *Great Works of Jewish Fantasy*, Cassell & Co, London, 1976

Ovid, Mary M. Innes (trans.), *Metamorphoses*, Penguin Classics, London, 1955

Geraldine Pinch, *Egyptian Mythology: A Guide to the Gods, Goddesses, and Traditions of Ancient Egypt*, Oxford University Press, Oxford, 2004

Pliny the Elder, John Healey (trans.), *Natural History*, Penguin Classics, London, 1991

J. M. Roberts, *Mythology of the Secret Societies*, Paladin Books, London, 1974

John Romer, E. A. Wallis Budge (trans.), *The Egyptian Book of the Dead*, Penguin Classics, London, 2008

J.D. Smith (ed.), *The Mahabharata*, Penguin Classics, London, 2009

Pu Songling, John Minford (trans.), *Strange Tales from a Chinese Studio*, Penguin Classics, London, 2006

Keith Thomas, *Man and the Natural World*, Allen Lane, London, 1983

Keith Thomas, *Religion and the Decline of Magic*, Weidenfeld & Nicolson, London, 1971

M. Valmiki, Arshia Sattar (trans.), *The Ramayana*, Penguin Classics, 2000

Jacobus de Voragine, Christopher Stace (trans.), *The Golden Legend* (Selections), Penguin Classics, London, 1999

Jessie L. Weston, *From Ritual to Romance: An Account of the Holy Grail from Ancient Ritual to Christian Symbol*, Cambridge, 1920

Frances A. Yates, *The Art of Memory*, Routledge and Kegan Paul, London, 1966

# IMAGES: CREDITS, SOURCES AND COPYRIGHT

We have made every attempt to ascertain and contact rights holders. Please contact the publishers direct with any comments or corrections: info@septemberpublishing.org.

Cover: Detail of poster for the Internationale Hygiene-Ausstellung by Franz Ritter von Stuck (1863–1928), Dresden, Germany, 1911. US National Library of Medicine Digital Collections.

Title page: Detail from *Regula Emblematica Sancti Benedicti* by Bonifaz Gallner, Vienna, Austria, 1780. Getty Research Institute via Archive.org.

## CREATION
1. Wellcome Collection (CC BY 4.0); 2. Wellcome Collection (CC BY 4.0); 3. AF Fotografie / Alamy Stock Photo; 4 (a & b). Courtesy: Joost van den Bergh, London & Alexander Gorlizki; 5. National Library of Spain; 6. © British Library Board. All Rights Reserved / Bridgeman Images; 7. Digital image courtesy of the Getty's Open Content Program; 8. National Library of Spain.

## THE FIRMAMENT
9. Wellcome Collection (CC BY 4.0); 10. LACMA (Los Angeles County Museum of Art); 11. From the New York Public Library; 12. H. O. Havemeyer Collection, Bequest of Mrs. H. O. Havemeyer, 1929 at The Metropolitan Museum of Art, New York CC0 1.0; 13 (a). Digital image courtesy of the Getty's Open Content Program; 13 (b). Library of Congress, Washington DC; 14. The Metropolitan Museum of Art, New York; 15. Courtesy National Gallery of Art, Washington. Corcoran Collection (Museum Purchase, through the gift of Mr. and Mrs. Lansdell K. Christie); 16. Morris K. Jesup Fund, 2013. The Metropolitan Museum of Art, New York; 17. Digital image courtesy of the Getty's Open Content Program; 18. Yale Center for British Art, Paul Mellon Collection; 19. Yale Center for British Art, Paul Mellon Collection; 20. Art Institute of Chicago CC0; 21. © Museum Folkwang Essen – ARTOTHEK; 22. Library Book Collection / Alamy Stock Photo; 23. Yale Center for British Art, Paul Mellon Collection; 24. LACMA (Los Angeles County Museum of Art); 25. LACMA (Los Angeles County Museum of Art).

## THE FACE OF THE WATERS
26. From the Spencer Collection, The New York Public Library; 27. John G. Johnson Collection, 1917. Philadelphia Museum of Art; 28. The Dove and the Raven, from 'Holkham Bible Picture Book', c.1320-30 (w/c on paper), English School, (14th century) / British Library, London, UK / © British Library Board. All Rights Reserved / Bridgeman Images; 29. Bibliothèque nationale de France; 30. Rijksmuseum, Amsterdam; 31. Library of Congress, Washington DC; 32. Library of Congress, Washington DC; 33. Raw Pixel; 34. Wikimedia Commons; 35. Raw Pixel; 36. Library of Congress, Washington DC; 37. RS_9933 © The Royal Society; 38. Gift of Barbara and Lawrence Fleischman, digital image courtesy of the Getty's Open Content Program; 39. Louis E. and Theresa S. Seley Purchase Fund for Islamic Art and Rogers Fund, 2003. The Metropolitan Museum, New York; 40. Rogers Fund 1919. The Metropolitan Museum of Art, New York; 41. LACMA (Los Angeles County Museum of Art); 42. Courtesy of the University of St Andrews Library: The Book of Wonders ms32(o); 43. Wellcome Collection (CC BY 4.0); 44. Purchase, Joseph Pulitzer Bequest, 1933. The Metropolitan Museum of Art, New York; 45. Gift of Louis P. Church, 1917-4-296-a. Photo: Matt Flynn© 2019. Cooper-Hewitt, Smithsonian Design Museum/Art Resource, NY/Scala, Florence; 46. The Fletcher Fund, 1926. The Metropolitan Museum of Art, New York; 47. The Picture Art Collection / Alamy Stock Photo.

## THE FACE OF THE EARTH
48. The Picture Art Collection / Alamy Stock Photo; 49. Engineer, Research and Development Centre, US Army Corps of Engineers; 50. Heritage Image Partnership Ltd / Alamy Stock Photo; 51. ART Collection / Alamy Stock Photo; 52. David Rumsey Map Collection, www.davidrumsey.com; 53. Fletcher Fund, 1928, The Metropolitan Museum of Art, New York; 54. Henry L. Phillips Collection, Bequest of Henry L. Phillips, 1939. The Metropolitan Museum of Art, New York; 55 (a & b). David Rumsey Map Collection, www.davidrumsey.com; 56 (a, b, c & d). Smithsonian Libraries, Washington DC; 57. Yale Center for British Art, Paul Mellon Collection; 58. Grotto in an iceberg, January 1911 (b/w photo), Ponting, Herbert (1870-1935) / Private Collection / Avant-Demain / Bridgeman Images; 59. Wellcome Collection (CC BY 4.0); 60. Smithsonian American Art Museum, Museum purchase; 61. Wellcome Collection (CC BY 4.0); 62. Gado Images / Alamy Stock Photo; 63. Gift of Eugene V. Thaw, The Metropolitan Museum of Art, New York; 64. H. O. Havemeyer Collection, Bequest of Mrs. H. O. Havemeyer, 1929, The Metropolitan Museum of Art, New York.

## THE VEGETABLE KINGDOM
65. © The Albertina Museum, Vienna; 66. Gift of Irwin Untermyer, 1964. The Metropolitan Museum of Art, New York; 67. From the New York Public Library; 68. Missouri Botanical Garden, Peter H. Raven Library via Biodiveristy Heritage Library; 69. Yale Center for British Art, Paul Mellon Collection; 70. Wellcome Collection (CC BY 4.0); 71. The Minnich Collection, The Ethel Morrison Van Derlip Fund, 1966. Minneapolis Institute of Art; 72. Picryl; 73. Collection PoD / Alamy Stock Photo; 74. From the Spencer Collection, The New York Public Library; 75. Digital image courtesy of the Getty's Open Content Program; 76. Library of Congress, Washington DC; 77. Digital image courtesy of the Getty's Open Content Program; 78. Purchased with funds provided by Phil Berg, LACMA (Los Angeles County Museum of Art); 79. AA des Tombes Bequest, The Hague, Rijksmuseum, Amsterdam; 80. Art Collection 3 / Alamy Stock Photo; 81 (a, b & c). Lawrence J. Schoenberg of Manuscripts, Kislak Center for Special Collections, Rare Books and Manuscripts; 82. Collection PoD / Alamy Stock Photo; 83. Raw Pixel; 84. Gift of George E. Schoellkopf, 2013, The Metropolitan Museum of Art, New York; 85 (a & b). Raw Pixel;

86. Yale Center for British Art, Paul Mellon Collection; 87. bpk / Kupferstichkabinett, SMB / Dietmar Katz; 88. Courtesy National Gallery of Art, Washington DC (Andrew Mellon Fund); 89. The Minnich Collection, The Ethel Morrison Van Derlip Fund, 1966. Minneapolis Institute of Art; 90. Gilman Collection, Purchase, Denise and Andrew Saul Gift, 2005. The Metropolitan Museum of Art, New York.

## THE ANIMAL KINGDOM

91. Ms 399 fol.241 The Properties of Animals, from *Livre des Proprietes des Choses* by Barthelemy l'Anglais (vellum), French School, (15th century) / Bibliotheque Municipale, Amiens, France / Bridgeman Images; 92. Spain: Noah's Ark. From a 12th-century version of *The Commentary on the Apocalypse* by Beatus of Liebana / Pictures from History / Bridgeman Images; 93. Wikimedia Commons; 94. University of Aberdeen; 95. Raymond and Frances Bushell Collection, LACMA (Los Angeles County Museum of Art); 96. Digital image courtesy of the Getty's Open Content Progam; 97. Royal 12 F.XIII, f.24 A crocodile. Bestiary (ff. 3-141), Lapidary (ff. 141v-149) 2nd quarter of the 13th century, English School (13th century) / British Library, London, UK / © British Library Board. All Rights Reserved / Bridgeman Images; 98. A chameleon, c.1612 (ink & gouache on paper), Mansur (Ustad Mansur) (fl.c.1590-1630) / Royal Collection Trust © Her Majesty Queen Elizabeth II, 2019 / Bridgeman Images; 99. Common or spectacled caiman and South American false coral snake, c.1705-10 (w/c & bodycolour on vellum), Merian, Maria Sibylla Graff (1647-1717) / Royal Collection Trust © Her Majesty Queen Elizabeth II, 2019 / Bridgeman Images; 100. Snake illustration by Albertus Seba / Natural History Museum, London, UK / Bridgeman Images; 101. Brooklyn Museum; 102. Gift of Louis W. Hill, Jr. Minneapolis Institute of Art; 103. Rogers Fund, 1907. The Metropolitan Museum of Art, New York; 104. The Louvre, Paris; 105. Digital image courtesy of the Getty's Open Content Progam; 106. Bequest of Miss Adelaide Milton de Groot, 1967. The Metropolitan Museum of Art, New York; 107. Digital image courtesy of the Getty's Open Content Program; 108. The Norton Simon Foundation; 109. Digital image courtesy of the Getty's Open Content Progam; 110. Gift of George D. Pratt, 1925. The Metropolitan Museum of Art, New York; 111. Fletcher Fund, 1931. The Metropolitan Museum of Art, New York; 112. The Nasli M. Heeramaneck Collection of Ancient Near Eastern and Central Asian Art, gift of The Ahmanson Foundation, LACMA (Los Angeles County Museum of Art); 113. Courtesy of the University of St Andrews Library: The Book of Wonders ms32(o); 114. LACMA (Los Angeles County Museum of Art) via CC0; 115. © Photographic Archive Museo Nacional del Prado; 116. Squirrels on a plane tree, with a hunter attempting to climb the tree. / British Library, London, UK / © British Library Board. All Rights Reserved / Bridgeman Images; 117. The Alice and Nasli Heeramaneck Collection, Gift of Alice Heeramaneck, 1981. The Metropolitan Museum of Art, New York.

## THE HUMAN REALM

118. France: 'L'Homme anatomique ou L'Homme zodiacal' (Anatomical Man or Zodiacal Man), 'Tres Riches Heures du duc de Berry', 1412-1489 CE / Pictures from History / Bridgeman Images; 119. Purchase, Rogers Fund and The Kevorkian Foundation Gift, 1955. The Metropolitan Museum of Art, New York; 120. Digital image courtesy of the Getty's Open Content Progam; 121. Azoor Photo / Alamy Stock Photo. Now on display in the National Archaeological Museum (Museo Archeologico Nazionale di Napoli) in Naples, Campania, Italy.; 122. Wellcome Library via Archive.org; 123. LACMA (Los Angeles County Museum of Art); 124. 59.1.95 Collection of The Corning Museum of Glass, Corning, New York; 125. 66.1.78 Collection of The Corning Museum of Glass, Corning, New York; 126. Bibliothèque nationale de France; 127. Universal Man and a portrait of Hildegard of Bingen, illumination from the Lucca Codex, c.1410 (vellum), Italian School, (15th century) / Biblioteca Statale, Lucca, Italy / Werner Forman Archive / Bridgeman Images; 128 (a). Fascimile of September: harvesting grapes by the Limbourg brothers, from the 'Tres Riches Heures du Duc de Berry' (vellum) (for original see 8441), French School, (15th century) (after) / Victoria & Albert Museum, London, UK / Bridgeman Images; 128 (b). Facsimile of February: farmyard scene with peasants, copied from 'from the 'Tres Riches Heures du Duc de Berry' (vellum) (for original see 8434), Limbourg Brothers (fl.1400-1416) (after) / Victoria & Albert Museum, London, UK / Bridgeman Images; 129. Rijksmuseum, Amsterdam; 130. Yale Center for British Art, Paul Mellon Collection; 131 (a, b, c & d). Rogers Fund, The Metropolitan Museum of Art, New York; 132. LACMA (Los Angeles County Museum of Art) via CC0; 133. Wellcome Collection (CC BY 4.0); 134. The American Geographical Society Library Digital Map Collection, part of University of Wisconsin-Milwaukee Libraries, via World Digital Library; 135. Thanks to Hope Wallace Karney and thegraphicsfairy.com; 136. Wellcome Collection (CC BY 4.0); 137 (a, b & c). US National Library of Medicine Digital Collections; 138 (a & b). The Getty Research Institute, California; 139. Wellcome Collection (CC BY 4.0); 140. Wellcome Collection CC BY 1.0; 141. Digital image courtesy of the Getty's Open Content Progam; 142. Digital image courtesy of the Getty's Open Content Program.

## THE REALM OF SCIENCE AND THE SENSES

143. The Collection of Skokloster Castle, Sweden; 144. Wellcome Collection (CC BY 4.0); 145. Archive PL / Alamy Stock Photo; 146. Purchase, Seven Ames Gift, 2012. The Metropolitan Museum of Art, New York; 147. Historic Images / Alamy Stock Photo; 148 (a & b). Harris Brisbane Dick Fund, 1924. The Metropolitan Museum of Art, New York; 149. Wellcome Collection (CC BY 4.0); 150. Digital image courtesy of the Getty's Open Content Program; 151. Wellcome Collection (CC BY 4.0); 152. The Elisha Whittelsey Collection, The Elisha Whittelsey Fund, 1951, The Metropolitan Museum of Art, New York; 153. US National Library of Medicine Digital Collections; 154. Image courtesy of the Hagströmer Medico-Historical Library, Karolinska Institutet; 155. Bridgeman – Spring, maiden gathering flowers, from the villa of Varano in Stabiae, c.15 BCE-60 CE (fresco), Roman, (1st century AD) / Museo Archeologico Nazionale, Naples, Campania, Italy / Bridgeman; 156. Gift of Mr and Mrs Alvin N. Haas, 1979. The Metropolitan Museum of Art, New York; 157. Wellcome Collection (CC BY

4.0); 158. US National Library of Medicine Digital Collections; 159. Wellcome Collection (CC BY 4.0); 160. Raw Pixel; 161. Image courtesy of the Hagströmer Medico-Historical Library, Karolinska Institutet; 162. Rogers Fund, 1955. The Metropolitan Museum of Art, New York.

THE HEAVENLY BODIES
163. Rosenwald Collection, Rare Book and Special Collections Division of the Library of Congress; Washington, DC; 164. Cliché Bibliothèque municipale de Lyon Ms 5140, F 13v – Capricorne; 165. © National Maritime Museum, Greenwich, London; 166. Wikimedia Commons; 167. Science Museum / Science and Society Picture Library; 168. Getty Research Institute via Archive.org; 169. David Rumsey Map Collection, www.davidrumsey.com; 170. Digital image courtesy of the Getty's Open Content Program; 171. Digital image courtesy of the Getty's Open Content Program; 172. Division of Cultural and Community Life, National Museum of American History, Smithsonian Institute; 173. David Rumsey Map Collection, www.davidrumsey.com; 174 (a & b). From the New York Public Library; 175. Wellcome Collection (CC BY 4.0); 176. Library of Congress, Washington DC; 177. (a & b) Digital images courtesy of the Getty's Open Content Program; 178. Chinese star chart (detail) / British Library, London, UK / © British Library Board. All Rights Reserved / Bridgeman Images; 179. Bibliothèque nationale de France; 180. The angel Ruh holding the celestial spheres, illustration from the *Aja'ib al-Makhluqat* (*Wonders of Creation*) by Qazwini, c.1550-1600 (ink, colour and gold on paper), Persian School, (16th century) / Ashmolean Museum, University of Oxford, UK / Bridgeman Images; 181. Bibliothèque de Genève, BGE - Ms. fr. 167 f 105r; 182. from the Rare Book Division, The New York Public Library; 183. Archive.org.

THE INVISIBLE WORLD
184. Bequest of Mary Stillman Harkness, 1950. The Metropolitan Museum of Art, New York; 185. University of Heidelberg; 186 (a, b, c & d). Digital image courtesy of the Getty's Open Content Program; 187. Yale Center for British Art, Paul Mellon Fund; 188. Wellcome Library (CC BY 4.0); 189. William Randolph Hearst Collection, LACMA (Los Angeles County Museum of Art); 190 (a & b). The Picture Art Collection / Alamy Stock Photo; 191. The Picture Art Collection / Alamy Stock Photo; 192. Wellcome Library (CC BY 4.0); 193. The Howard Mansfield Collection, Purchase, Rogers Fund, 1936. The Metropolitan Museum of Art, New York; 194. The Medical Heritage Library at The Francis A. Countway Library of Medicine via openlibrary.org; 195. Courtesy National Gallery of Art, Washington; 196. Museum Expedition 1944, Purchased with funds given by the Estate of Warren S.M. Mead, Brooklyn Museum; 197. The Picture Art Collection / Alamy Stock Photo; 198. Altarpiece, Group X, Number 1, 1915 (oil & metal leaf on canvas), Klint, Hilma af (1862-1944) / Private Collection / Bridgeman Images; 199. Wellcome Collection (CC BY 4.0).

GODS AND MONSTERS
200. Adelaide Education Authority via Wikimedia Commons; 201. Islamic Manuscripts, Third Series no. 349 (C0723); Manuscripts Division, Department of Rare Books and Special Collections, Princeton University Library; 202. Bibliothèque nationale de France; 203. Bibliothèque de Genève, BGE Ms. fr. 182, fol. 162v; 204. R.16.2, fol. 14r, with acknowledgement to the Master and Fellows of Trinity College Cambridge; 205. Spain: The Dragon gives his power to the Beast. From the Beatus of Leon version of the Apocalypse (1047 CE). / Pictures from History / Bridgeman Images; 206. Digital image courtesy of the Getty's Open Content Program; 207. LACMA (Los Angeles County Museum of Art); 208. Gift of Stephen and Sharon Davies Collection, 2015. The Metropolitan Museum of Art, New York; 209. © Royal Museums of Fine Arts of Belgium, Brussels; 210. Science History Images / Alamy Stock Photo; 211. Bibliothèque nationale de France; 212. Purchase, Bequest of Cora Timken Burnett, by exchange, 2005. The Metropolitan Museum of Art, New York; 213. Wellcome Collection (CC BY 4.0); 214. LACMA (Los Angeles County Museum of Art); 215. Digital image courtesy of the Getty's Open Content Program; 216. Purchase, Louis V. Bell Fund and The Vincent Astor Foundation Gift, 1974. The Metropolitan Museum of Art, New York; 217. British Museum, London, UK / Bridgeman Images.

VISIONS OF ETERNITY
218. Purchase, Barbara and William Karatz Gift and funds from various donors, 2004. The Metropolitan Museum of Art, New York; 219. Library of Congress, Washington DC; 220. Project Gutenburg; 221. The Elisha Whittelsey Collection, The Elisha Whittelsey Fund, 1954. The Metropolitan Museum of Art, New York; 222 (a & b). Bibliothèque nationale de France; 223. Bibliothèque de Genève, BGE - Ms. fr. 167 f. 27v; 224. Courtesy: Joost van den Bergh, London; 225. Venice, Palace Grimani. © 2019. Photo Scala, Florence; 226 (a & b). Gift of the Friends of the Institute's Teahouse Fund. Minneapolis Institute of Art; 227. The Picture Art Collection / Alamy Stock Photo; 228. Heritage Image Partnership Ltd / Alamy Stock Photo.

Reading list: *Heilige Swietbertus van Teisterbant* (detail) by Frederick Bloemaert, after Abraham Bloemaert, Utrecht, Netherlands, c. 1635–50. Rijksmuseum, Amsterdam.

# QUOTATIONS: CREDITS, SOURCES AND COPYRIGHT

Traherne: in *Christian Ethicks, or, Divine Morality Opening the Way to Blessedness, by the Rules of Vertue and Reason,* London, 1675
Valéry: Musée de l'Homme, Paris, 1937
Proust: first English translation by C. K. Scott Moncrieff, Chatto & Windus, London, 1981

## THE FIRMAMENT
Issa: translated by Nobuyuki Yuasa in *The Year of My Life: A Translation of Issa's Oraga Haru,* 2nd edition, University of California Press, Berkeley, 1972
Bashō: Haiku 36, English translation by R. H. Blyth, in *Haiku. Vol 1: Eastern Culture,* The Hokuseido Press, Japan, 1949
Manley Hopkins: *The Poems of Gerard Manley Hopkins,* eds W. H. Gardner and N. H. MacKenzie, Oxford University Press, 1918
Rilke: translated by Robert Bly in *The Soul Is Here for Its Own Joy: Sacred Poems from Many Cultures,* Ecco Press, Hopewell, NJ, 1995

## THE FACE OF THE WATERS
Wilde: *Lippincott's Monthly Magazine,* London, 1890
Symons: from *Cities and Sea-Coasts and Islands,* The Marlboro Press/Northwestern, Evanston, Illinois, 1998
Yeats: first published in the *National Observer,* 1890

## THE FACE OF THE EARTH
Ruskin: *The Complete Works of John Ruskin,* vol. XXI, George Allen & Unwin, London, 1903
MacDiarmid: *Complete Poems,* vol. 1, W. R. Aitken, London, 1978
Princess Shikishi: translated by Steven D. Carter in *Traditional Japanese Poetry: An Anthology,* Stanford University Press, 1991
Hemingway: first published in *Esquire* magazine, Chicago, 1936
Galilei: translated by Stillman Drake, Stephen Jay Gould, series editor, Modern Library, New York, 2001

## THE VEGETABLE KINGDOM
Smart: *A Translation of the Psalms of David Attempted in the Spirit of Christianity, and Adapted to Divine Service,* London, 1765
Berger: Penguin, London, 1972
Murdoch: Chatto & Windus, London, 1970
Clare: 'Nature', *John Clare Complete Works,* Delphi Classics, Hastings, 2013

## THE ANIMAL KINGDOM
Darwin: *The Variation in Animals and Plants under Domestication,* vol. 2, John Murray, London, 1868, p. 404
Carson: Houghton Miffin, Boston, 1962
Beston: Doubleday and Doran, New York, 1928
Khwaja Abdullah Ansari: Quoted in *Tales of the Mystic East: An Anthology of Mystic and Moral Tales Taken from the Teachings of the Saints* by Huzar Maharaj Sawan Singh Hi, Radha Soami Satsang, Beas, India, 1997

Dostoevsky: translated by Constance Garnett, Heinemann, London, 1912; first published as a serial in *The Russian Messenger* from January 1879 – November 1880
Aurelius: *The Fourth Book of the Meditations of Marcus Aurelius Antoninus,* translated by Hastings Crossley, Macmillan, London, 1882

## THE HUMAN REALM
Valéry: translated by Robert Pickering in *Cashiers/Notebooks: 2,* Peter Lang, Bern, 2001. Reproduced with permission of Peter Lang Copyright AG.
Browne: *Religio Medici,* London, 1643
Beckett: *No Author Better Served: The Correspondence of Samuel Beckett and Alan Schneider,* Harvard University Press, Cambridge, Mass., 1998
Baldwin: Dial Press, New York, 1963
Shelley: Lackington, Hughes, Harding, Mavor & Jones, London, 1818

## THE REALM OF SCIENCE AND THE SENSES
Da Vinci: from *The Notebooks of Leonardo da Vinci,* translated by Jean Paul Richter, London 1883
Tesla: from interview in *New York Herald,* 1896
Moore: in *Irish Melodies,* William Power, Dublin, 1807
Hugo: translation by Isabel Florence Hapgood, T. Y. Crowell and Co., New York, 1887

## THE HEAVENLY BODIES
Whitman: *Leaves of Grass,* David McKay, Philadelphia, 1884
Shiki: translated by R. H. Blyth in *Haiku. Vol 1: Eastern Culture,* The Hokuseido Press, Tokyo, 1949
Qur'an: translated into English by George Sale, 1734
Cummings: in *E. E. Cummings: Complete Poems 1904–1962,* W. W. Norton, New York, 2016

## THE INVISIBLE WORLD
Blake: an illuminated manuscript originally etched by William Blake in 1788; as far as is known it was first printed in 1794
Dickens: serialised in *Master Humphrey's Clock,* 1840–41
Borges: translated by Hoyt Rogers, in Jorge Luis Borges, *Selected Poems,* edited by Alexander Coleman, copyright © 1999 by Maria Kodama. Used by permission of Viking Books, an imprint of Penguin Publishing Group, a division of Penguin Random House LLC. All rights reserved.

## GODS AND MONSTERS
Thomas: Edward Thomas died at the Battle of Arras on 9 April 1917
Marlowe: *The Tragical History of Doctor Faustus,* edited by the Revd Alexander Dyce from the Quarto of 1604
Brontë: in *Poems by Currer, Ellis, and Acton Bell,* Aylott and Jones, London, 1846

## VISIONS OF ETERNITY
Kwaymullina: from 'Seeing the Light: Aboriginal law, learning and sustainable living in country', *Indigenous Law Bulletin,* 2005, vol. 6, no. 11